ÉLISABETH COUTURIER

# talk about contemporary photography

Flammarion

CONTENTS

# PREFACE

So, what was the spark? What first fired my enthusiasm for contemporary photography? I am constantly being drawn back to the question of what started this enduring passion.

Well, I definitely remember the zeal with which, as a teenager, I lined the walls of my bedroom with fashion photographs cut out of magazines like *ELLE* and *Vogue*. Carefully selected, they were signed by Richard Avedon, Guy Bourdin, William Klein, Serge Lutens, Sarah Moon, and Jeanloup Sieff. I also think back to the pleasure I took, when, as an art student, I would sit in the library and flick through the pages of periodicals such as *Interview*, *Photo*, *GEO*, *LIFE*, and *Paris Match*. But I have to go forward in time, to the years 1980–90, to when I, by then a fledgling art critic, began to look at photography with fresh eyes. For while "video art"—accompanied by a raft of manifestos and international exhibitions—had been the in thing a few years earlier, photography was making a more discreet entrance into contemporary art galleries. At least, it started off being discreet.

Of course, I'd seen black-and-white prints showing the incredible performances carried out at the beginning of the 1970s by the kamikazes of the avant-garde—in particular Chris Burden, who, in a test of his courage (and his limits), had his assistant stand twenty feet from him and fire a bullet into his arm, or got himself incarcerated in a student locker for five days. But I paid little attention to the (modest) quality of the images recording these more than extreme actions. Then there were the spectacular and ambitious projects undertaken in the natural world by the masters of land art. I am thinking particularly of Christo and Jeanne-Claude, who fringed islands in Miami's Biscayne Bay with a ruff of pink plastic, and Robert Smithson, with his stone *Spiral Jetty* 1,500 feet (460 meters) long and 15 feet (4.6 meters) wide laid out in the Utah desert. Painstakingly crafted, the photographs of these in situ installations, in color and less domestic in format, had also found their way into cutting-edge art venues.

None of this amounted to a radical challenge, though. Hilla and Bernd Becher, on the other hand, marked a true turning point with conceptually austere and scientifically rigorous prints of blast furnaces in the Ruhr Basin, shot as if they were sculptures. I gained a still clearer sense of a major shift afoot in the history of the appropriation of the medium by artists while writing an article on Cindy Sherman's series *Untitled Film Stills* for *ArtPress*. This sequence of small-format black-and-white prints heralded a new dawn: this girl's love of dressing up for the camera lens did not stem from an impulse to classify. Beyond being a record of a temporary performance, each photo in *Untitled Film Stills* functions as a hoax. Ostensibly taken "on set" at a movie shoot, in fact these photographs show episodes from films that were never made. Drawing the viewer into a wholly imaginary narrative, they transgress the myth that photography offers proof of the real. The same feeling of something new being underway struck me on discovering the light boxes of Jeff Wall and the first photographic tableaux of Jean-Marc Bustamante, which

"hold the wall" as powerfully as any painting.

Then the great flood tide of the Düsseldorf School broke, which—with the panoramic views of Andreas Gursky, the obsessive portraits of Thomas Ruff, the trick interiors of Thomas Demand, and the immense libraries of Candida Höfer—secured the position of photography as the dominant avant-garde media. The whiff of scandal also played a part, with the male nudes of Robert Mapplethorpe, the visual subversion of Richard Prince, and the sulfurous images of Andres Serrano.

Thus, after more than four decades—having originally emerged from performance, and irrigated by principles with roots in minimal or conceptual art—photography has now developed into one of the most intriguing phenomena in the present-day creative landscape. While photography also promotes the return of the figure, in what is a notable turnaround, its experimental, dissident, and modern "spirit" now feeds into photojournalism, fashion photography, and advertising alike. A number of "schools" have come into being and, thanks to globalization, the spotlight has turned on less well-known centers of photographic practice—Africa, Scandinavia, and China.

The burgeoning success of contemporary photography, whose development I have followed step by step, demonstrates once again the unabated power of art to regenerate itself. It shows how a medium, when taken up by talented visual artists, can gain a new lease of life. But there should be no misconception: in their drive to innovate, many of them hark back to the history of traditional photography. There they discover masters worthy of admiration and models they can happily emulate. This was also the path I took. And it is this photographic adventure, full of unexpected twists and turns, that will be recounted in the following pages.

ÉLISABETH COUTURIER

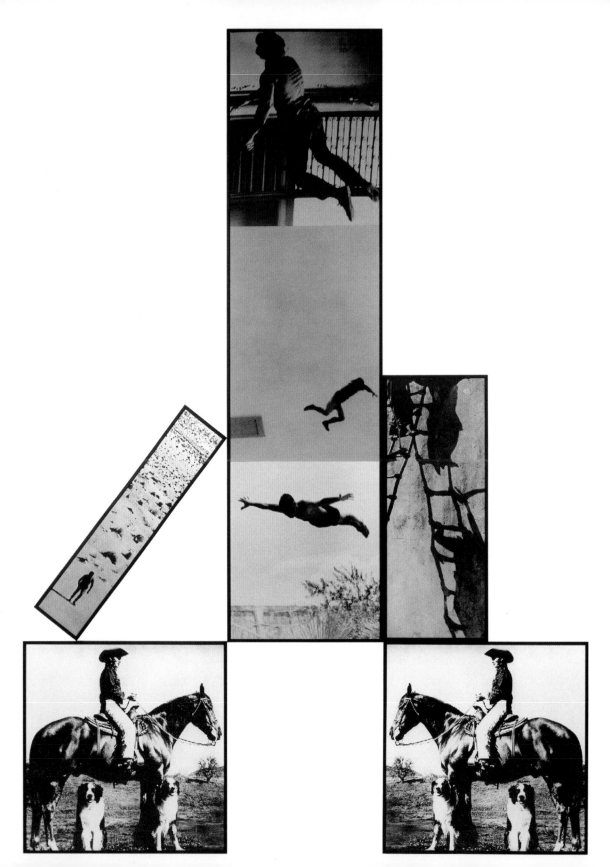

# 1

## WHAT IS
## CONTEMPORARY PHOTOGRAPHY?

# HOW CAN YOU RECOGNIZE IT?

You may be under the impression that modern photography equates to rows of standard-format black-and-white prints. You'd be wrong. Since the 1980s, everything's been turned upside down. The way categories as time-honored as the family snapshot, documentary, and reportage are presented has been subjected to a radical shake-up. But why? Because avant-garde artists now treat photography (officially invented by Daguerre in 1839) as a material—just like painting, drawing, or video. Once predictably formatted in its commercial incarnation (the "click, clack, Kodak" snapshot, for example), the reproducible image now comes in all shapes and sizes. Let loose in museums and art galleries, thanks to new techniques of image capture, development, and printing, modest proportions and conventional dimensions are things of the past.

**Hailed as a full-fledged work of art, signed and numbered, the photographic print now seeks maximum visual impact: stuck onto a rigid support, face-mounted or under glass, framed (or not), it can now hold its own against any large painting or fresco.**

Thus, British artist Hannah Collins, for example, pins to the wall reproductions on canvas of photos showing cityscapes that can measure more than 6 feet (2 m) high and 18 feet (5 m) wide. Such changes in scale confront the viewer head-on: four-color printed and delving into the finest details, contemporary photography can now stand toe to toe with cinema.

For instance, there are Andreas Gursky's vast, totalizing views of the trading floor of the Hong Kong Stock Exchange, the panoramic war scenes of Luc Delahaye, Patrick Tosani's vertiginous "overhead" views of hair taken from the top of the skull. Presented as diptychs or triptychs, certain outsized pieces proclaim their references to pictorial art loud and clear. Thus, compositions by Florence Chevallier, David Goldblatt, and Victor Burgin all refer explicitly to the mediaeval altarpiece. In a further innovation, contemporary photography has even acquired volume: the light boxes of the Canadian artist Jeff Wall or those of the Japanese Mariko Mori yield nothing to the blandishments of advertising. Neither do Barbara Kruger's gigantic inner city photomontages, which harangue the passerby in a mix of text and image.

Gaining considerably in breadth, photographic prints also sometimes soar to dizzying heights. This is the case, for instance, with

the sculptures of Jan Dibbets, comprised of vertically assembled photographic modules. In fact, the "puzzle effect" has very much caught on: it consists in (re)constructing a complete image from an array of separate sections. David Hockney blazed the trail with landscapes and scenes from life built up from a large number of Polaroids taken from various angles. Jean-François Rauzier's *Hyperphotos* allow us to see with the eyes of a lynx: composed from hundreds of perfectly defined digital shots, his panoramas reveal every last blade of grass, every minute pebble, through a magnifying glass. As for the duo of Gilbert & George, their pictures are made from an initial print that is greatly enlarged and divided into casements of identical dimensions, which endows the surface with a striking, Rubik's Cube-like effect.

**The photographic image emerges from the finer obsessions and idiosyncrasies of an inventive visual artist to tell stories, dream up scenarios, and invent narratives.** The coupling of photo and text lends itself perfectly to the introspective ambitions of Sophie Calle divulging the ins and outs of her love life, or to the critical approach of Allan Sekula denouncing the global economy and its nefarious consequences for the environment. Series and sequences hold center stage as well. With her fascinating groups of self-portraits as a clown alternating with views of clouds, Roni Horn's oeuvre is at once grave and poetic. Another recurrent practice is classification extrapolated *ad absurdum*. This can be seen, among other examples, in the rows of faces of thirty boys and girls by Thomas Ruff, the *Indoor Sculptures* of Erwin Wurm, and the sequentially presented visual performance lunacy of the couple, Anna and Bernhard Blume. Another twist to the building-block game is the idea of amassing materials, of assembling inventories. Hans-Peter Feldmann, for example, is an old hand at the practice, spending many a long year collecting yellowing photographs and postcards of yesteryear focusing on groups of similar themes. The Finn Ulla Jokisalo sews, embroiders, and glues objects onto found photographs, then rephotographs them; while Christian Boltanski enlarges out-of-focus prints and erects them into commemorative installations—altars celebrating the memory of the unnamed dead.

BARBARA KRUGER,
*Untitled*,
1997.
111 x 113 in. (281.9 x 287 cm).

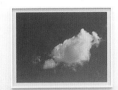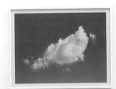

RONI HORN,
Clowd and Cloun (Blue),
2000–01.

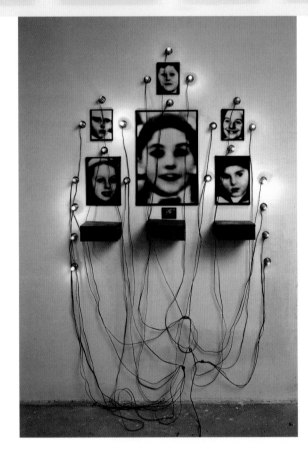

CHRISTIAN BOLTANSKI,
Monument (Odessa),
1989.
67 x 55 x 8¾ in. (170 x 140 x 22 cm).

**Collected from press cuttings, found in junk shops, or stumbled across just about anywhere, as an element in visual art a photograph lends itself to every kind of operation, manipulation, and resizing.**

Liberated from glass and mount, prints can be exhibited torn, fragmented, cut up—like Annette Messager's monstrous figures, spreading indefinable borders that ooze over vast spaces. Another very in-vogue idea is to use Diasec so as to create large-scale pieces from images on newsprint. These fragile materials can thus be composed into dazzling installations, rows and rows of images in different formats and from different

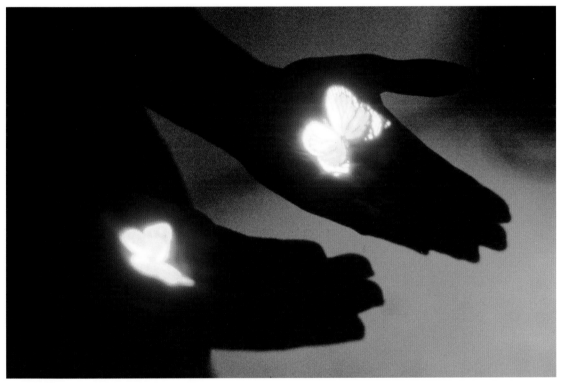

BERTRAND GADENNE,
*The Butterflies*,
1988.
Installation with slide projector.

sources lining the gallery from floor to ceiling. The nuclear option is to cover areas of entire cities with giant photographic posters: this is what the artist known as "JR" does, in spectacular pieces that invade a Rio de Janeiro favela. One final option is favored at the moment: projecting the pictures. Bertrand Gadenne shows a light, poetic side to this possibility, with gorgeous butterflies that land on one's palm.

**Thanks to the imagination of artists, and to technical progress, nothing seems beyond the bounds of possibility. The potential of contemporary photography is quite simply limitless.**

FLORENCE CHEVALLIER,
Photograph from the series
*Casablanca, 1955,*
2000.
23⅝ x 47¼ in. (60 x 120 cm).

PAGES 18–19
JR
View of the project *Woman*, Favela
Morro da Providência, Rio de Janeiro,
Brazil,
2008.

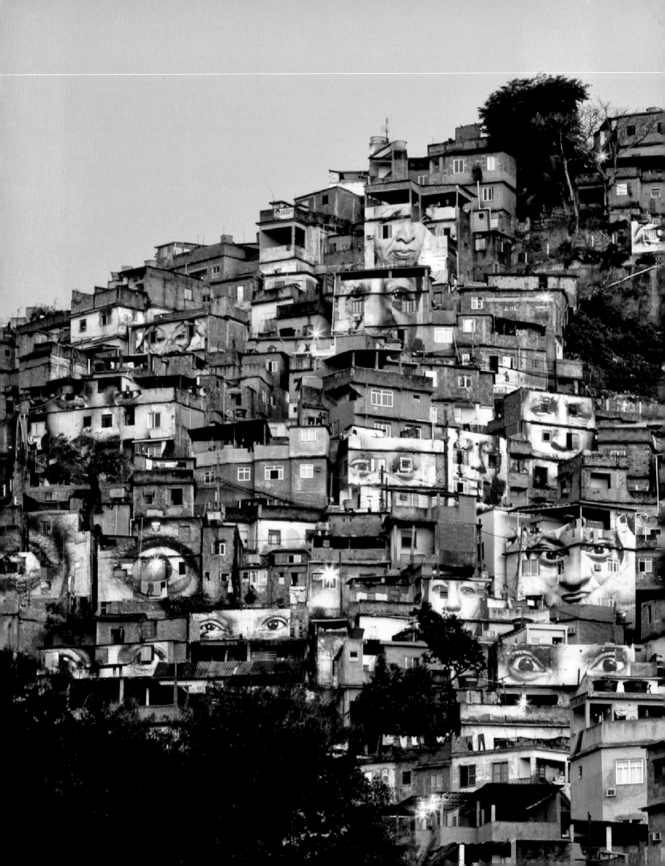

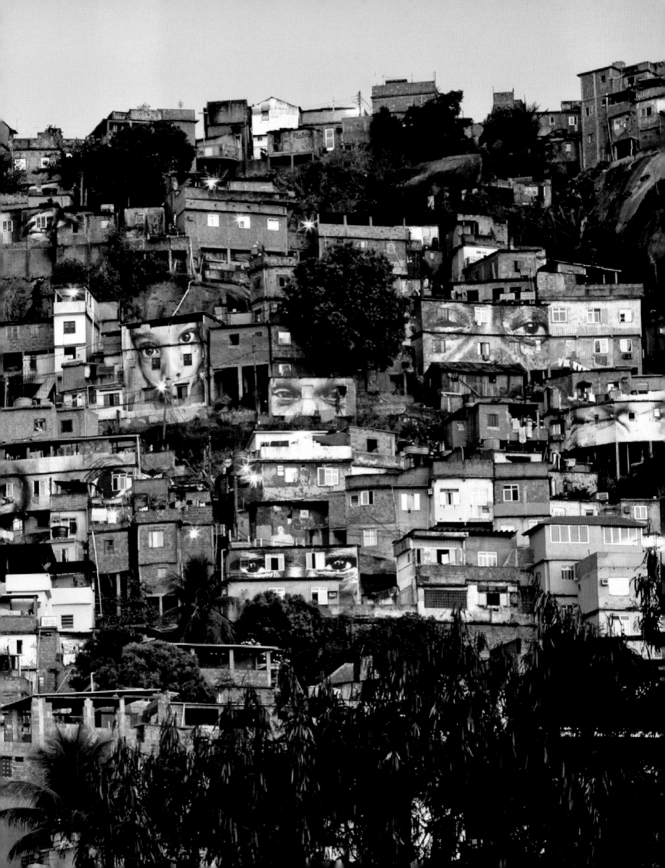

# WHEN DID IT ALL BEGIN?

There was no pre-publicity, no life-changing cataclysm, and certainly no manifesto. And yet today photography occupies center stage at practically every contemporary art exhibition. So how, and why, has it become so omnipresent? How is it that a medium long considered a minor one by artists themselves is now embraced in the upper echelons of the art world? And by what magic are photos by internationally famous reporters now afforded the kind of analysis once reserved for "genuine" artworks?

**Looking back, one can glimpse harbingers of the eventual adoption of photography by the fine arts. First and foremost, there was the breach opened by the exploratory avant-garde movements of the 1920s, with their photocollages, "rayographs," distortions, and other bizarre experiments.**

Thus, it was Man Ray, André Kertész, John Heartfield, and Alexander Rodchenko who began to build bridges between art and photography. Their creations were, however, sporadic in nature: visual high-wire acts or creative tours de force that went almost unheeded. In short, they were original works produced by individuals with no interest in theorizing or generalizing their findings. In the same iconoclastic spirit, Robert Rauschenberg in the 1950s produced "combine paintings," in a mix of objects, painting, and photos.

The loose cohabitation between photography and art, however, blossomed into a full-blown marriage ten years later with Andy Warhol's screen prints, in which the pope of pop appropriates the visual splash of the poster in series of large-scale works from portraits taken in his studio or garnered from the press.

NATACHA LESUEUR,
*Untitled*,
1999.

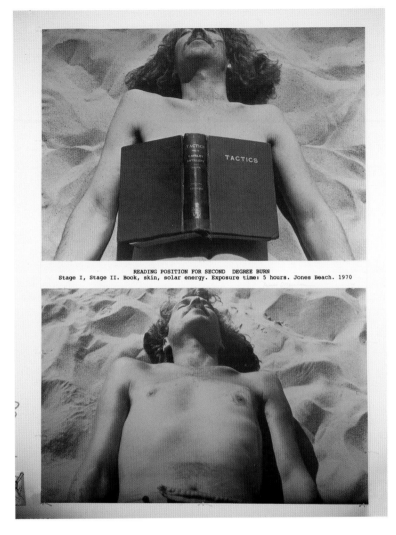

READING POSITION FOR SECOND DEGREE BURN
Stage I, Stage II. Book, skin, solar energy. Exposure time: 5 hours. Jones Beach. 1970

DENNIS OPPENHEIM,
*Reading Position
for Second Degree Burn*,
1970.

Elsewhere, American conceptual artists, sniffing the revolutionary wind that blew in the late 1960s, were calling into question the very finality of the artwork. Refusing to produce paintings and sculptures destined to end up, one day or another, in some stuffy drawing room, their watchword was to break totally with the past, to begin it all again—from scratch. Thus they posed some pertinent questions: What is art? What is the role of the artist in society? How can the market and its speculative power be circumvented?

One solution soon won favor: the "work" should be transitory or immaterial. Long live the happening and conceptual art! Down with the fetishism of the artwork, up with ideas! Long live body art, too, which uses the artist's own flesh as its artistic material, and hurray for land art, which acts directly on nature, modifying—lightly or spectacularly—a landscape!

**Their advantage is clear: once the intervention or the performance is over, move along, please, there's nothing more to see! Or rather there is, but not much. Because the only records the artist possesses of these fleeting moments of creativity are a few diagrams and notes—or photos.**

Robert Smithson, for example, had the brilliant idea of taking aerial photographs of his 1970 *Spiral Jetty*, a gigantic swirl of tons of stone in the Utah desert. John Baldessari, meanwhile, sought to convey the contingency of nature by transforming himself into a living sculpture. At this stage, photography remained a vector, a trace, a marker; a pure record of an action circumscribed in time. But gradually, as their performances continued, these intrepid avant-garde explorers began taking a little more care over the quality of the images they were producing. The craft of painting appearing obsolete in their eyes, their approach to media and to mechanical techniques became

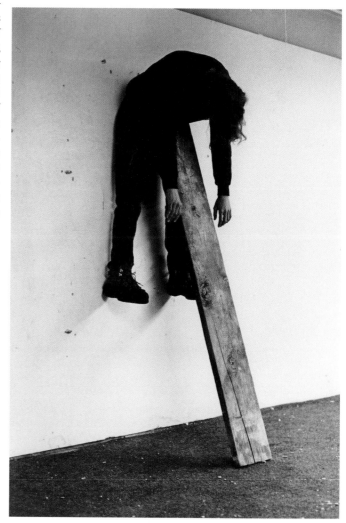

CHARLES RAY,
*Plank Piece I*,
1973.

NILS-UDO,
*Untitled*,
1999.

increasingly reflexive. Simultaneously, they were glad to finally have done with certain theories of modern art—in particular that of the art historian Clement Greenberg, who preached that each specific medium should be deployed in its purest form. The practice of mixed media foreshadowed a new era in art: after modern art, please welcome postmodern art. As Sol LeWitt declared: "Ideas may also be stated with numbers, photographs, words, or any way I choose, the form being of very limited importance."

In the same period, photojournalists, already hit by the decline of the news magazine as an outlet for their hard-hitting pictures, began to feel competition from TV, too. Many then switched to longer photo-essays of a sociological nature that they presented between the covers of books or in specialized reviews, or else exhibited at one of the new festivals devoted to photography that began springing up . Slowly but surely, then, photographers and artists stopped looking at one another like creatures from another planet.

**Thus, in parallel with the reevaluation of their practice of art, artists were regenerating their language through photography. As for the galleries, they fell over each other to show a type of work that foretold of a return of the image. From the 1990s, it was above all large-scale works in a painterly "tableau" idiom that filled exhibition rooms.**

# A STATE OF MIND?

VVhat's the difference betvveen practicing photography as a hobby and producing images vvorthy of reproduction in an art history book? VVhat at bottom allovvs one to say that a particular approach or piece belongs to the "experimental sphere"? VVhat criteria of judgment are deployed in dravving the distinction betvveen amateur and professional, and then betvveen professionalism and artistic research? It's all a question of style, approach, and commitment.

LARRY CLARK,
*Untitled,*
1968.
Black-and-white
photograph.

The pace of change has certainly accelerated since the late 1980s. The globalized economy now structures our environment differently, creating unprecedented forms of interchange, new ways of moving, working, and interacting. After years of abstract art, of minimalist puritanism, or of let-it-all-hang-out happenings, photography opened a window, a door onto the real. In this manner, it paved the way for the holy grail of the overlap between art and life, in what is a new type of "return to figuration": unemotional, unmodulated, it corresponds to the desire of the avant-garde to make an entirely fresh start.

DENIS DARZACQ,
*The Fall, No. 14,*
2006.

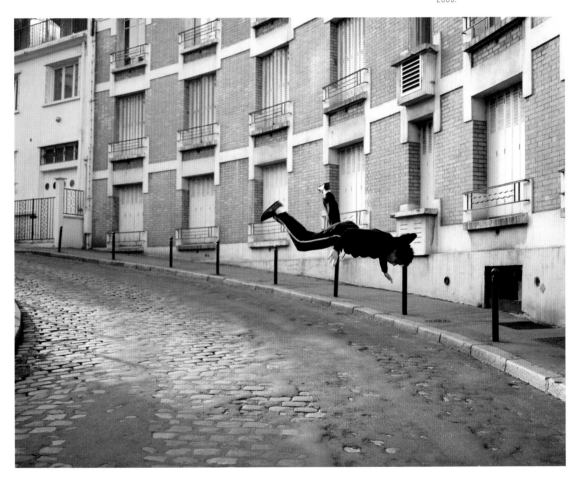

But, unlike photojournalists, artists keep their distance from the instantly newsworthy. It isn't their job to record daily events as speedily as possible. Unconstrained by immediate commercial concerns, they can take the time to polish their images, setting up scenes and creating narrative compositions—like John Baldessari, for instance. "I paint with photographs," claims Christian Boltanski. For such artists, photography is less an instrument or a tool than an actual form of expression, part of an ongoing individual process that enables them to pursue their formal investigations differently. As creators, above all, visual artists work with a lens that cannot just be set to automatic. Their goal is to make things visible, to defend positions, to activate their critical faculties, and to affirm their freedom through their choice of subject, focal distance, camera angle, and print media.

**For an artist, turning to photography as a mode of expression implies disregarding certain hitherto hard-and-fast rules: those, for example, that cordon art off from reportage.** In the 1970s, American photographer and filmmaker Larry Clark opted for a process of total immersion. Now the supreme model for this type of kamikaze operation, at the time he was fresh out of art school and spent his days hanging out with a gang of oddballs who were trying, like him, to make ends meet in the town of Tulsa. Then Clark started taking photographs of them, feeling his way, to no real purpose. These images of laid-back, doped-out, sexually promiscuous youth landed like a bombshell. The oeuvre of Nan Goldin is characterized by a similar empathetic attitude. In the early 1980s, she began taking photographs on her nightly perambulations through New York's arty underground, at a time when the AIDS epidemic was scything down much of the city's gay community. Reading like a personal diary, the potency of her work derives from the authenticity of what it shows: at the outset, moreover, the artist had no plans to exhibit what was a first-person account. The cult photowork, *I'll Be Your Mirror*, dedicated to a sister who committed suicide, offers a poignant reminder of their enduring complicity.

DAVID GOLDBLATT, *... And the Sheriff Knocking ... Conditions Apply. Oudtshoorn, Western Cape. February 19, 2006,* 2006. Digital print, colored pigment on 100 percent cotton rag paper, 31⅛ x 74 in. (80 x 188 cm). 22¾ x 27⅝ in. (58 x 70 cm; each).

**Certain artists, however, reject the idea that photography offers conclusive evidence of the real, a slice of life. They might not even feel the need to get their camera out of its bag, instead drawing from those storehouses of memory we call the family album or the amateur photograph, reusing, recycling them in an effort to distill a universal message.**

From photos he buys in flea markets showing little boys at the Mickey Mouse Club, or else proudly posing as cowboys, Christian Boltanski creates an "artificial portrait" of his own lost youth.

Others again attack the resilient illusion of truth that sticks to the surface of photography. This is the case with the young Israeli photographer Bert Sissingh, whose pictures showing relaxed family scenes that appear to have been taken from life, though they are in fact carefully staged. Denouncing the illusion of reality likewise motivates the work of Thomas Demand, who hoodwinks the viewer by showing living rooms, bedrooms, and offices that are in fact enlargements of models he has constructed and photographed in a steady, unmodulated light.

**One thing is certain: by appropriating photography, artists nourish it with unusual, vital experiences, and continue to analyze their newly adopted medium in all its technical, cultural, and historical complexity.**

NAN GOLDIN,
*David by the Pool
at the Back Room,
Provincetown, 1976,*
1976.

BERT SISSINGH,
*The Return of the Father,*
2010.

# EXAMPLES WORTH FOLLOWING

A curious bunch, many of the visual artists who took up the photographic medium as a means of expression showed an interest in its history, exploring the vast range of its practices and the huge diversity of its articulations. One of their more surprising discoveries was the extent to which the media of art and photography had long remained alien to one another. The gulf between them was indeed vast: their exponents and purposes, their references and markets, their modes of distribution and exhibition. Except for a handful of incursions into the other's field by an artist or an experimental photographer, one had to wait until the late twentieth century for the border between these two very different worlds to become permanently porous.

**Looking back in time, however, contemporary artists did manage to ferret out a few models to inspire them, some tracks worth opening up again, areas to be explored anew—and this time, it could be done without blinkers or prejudices.** Already in their pictorial works, painters like Munch, Khnopff, Vuillard, Degas, and Maurice Denis used photography to study light effects or to discover original angles and compositions. Kupka, Dali, and Bacon, to mention just a few, often worked from photographs they had taken themselves or from reproductions. Combing the history books, an artist of today would also note the fascination that Italian painters of the futurist movement fostered for the "zoopraxiscope," unveiled for the press by the scientist Eadweard Muybridge in 1878. Thanks to this clever piece of apparatus comprising a row of twelve cameras, Muybridge solved the riddle of how a horse gallops by taking a dozen separate pictures of the process. The same idea was taken up a few years later in breakdowns of humans walking and birds flying in the motion

WILLIAM KLEIN, *Movie Poster, Tokyo,* 1961. Gelatin silver print, 24 x 16 in. (60.8 x 40.5 cm).

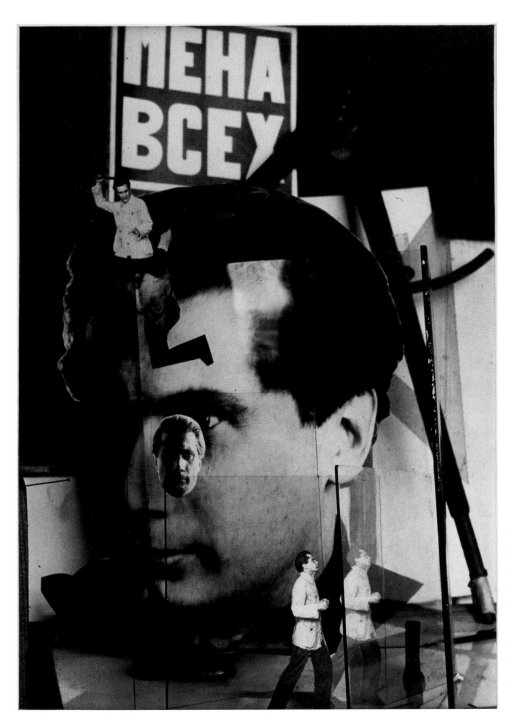

ALEXANDER
RODCHENKO,
Mock-up for
a cover for the
constructivist
anthology
*Miena Vsiekh*,
1924.
Gelatin silver
print,
photomontage,
9¼ x 6½ in. (23.5 x
16.5 cm).

analyses ("chronophotographs") of Étienne-Jules Marey, obtained with a kind of photographic repeating rifle. It appears obvious now that such early scientific research was the inspiration behind Marcel Duchamp's 1912 *Nude Descending a Staircase*.

Continuing their journey back in time, today's artists would surely acknowledge a debt to the pictorialist movement, greatly in vogue between 1889 and 1910, whose followers attempted to give photography its artistic credibility by colorizing black-and-white prints or intervening manually on the negative. Similarly, they would appreciate the satires of the German Dadaists Raoul Hausmann and John Heartfield in their photomontages denouncing the rise of Nazism. They would be astonished, too, by the manipulation of the photographic negative by the surrealists—in particular by Man Ray, with his famous rayographs and solarizations that demonstrated how visual imprints could be obtained without the use of a camera. As for the Russian suprematists, spearheads of artistic propaganda during the October Revolution of 1917, collages by El Lissitzky and Alexander Rodchenko afford living proof of the effectiveness of the union between word and image.

**Our contemporary artists would, though, be right to place American "Straight Photography" on the top step of the podium. Reacting against the inventions of the pictorialists, it abjured sleight of hand and advocated a return to unambiguous viewpoints and focused compositions. They might still be receptive to the critical power of images revealing the soft underbelly of the American dream, which echo current preoccupations with social injustice and inequality.**

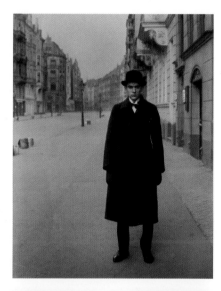

AUGUST SANDER, *The Painter Anton Räderscheidt*, 1926.

PAUL STRAND, *Photograph*, 1917, 9¼ x 6½ in. (23.7 x 16.6 cm).

WALKER EVANS,
*New York,*
1928–29.

Among the precursors of this unflinching, head-on approach were Jacob Riis and Lewis Hine. The first already showed the misery of New York slums in 1887, while the second photographed European immigrants in 1905. Further benchmarks are offered by the American photographer Paul Strand, with his painstaking printing methods, and the German August Sander, for maintaining exactly the correct distance between himself and his sitters. A present-day artist might also like to dedicate a special shrine to Walker Evans, in particular for his portraits of farmers expelled from their land during the Great Depression, taken in the context of the Farm Security Administration (FSA) program. This documentary—almost clinical—approach, which conveys reality without subterfuge or stylistic embellishment, still resonates today.

Fascinated by the pure conceptual idiom of Hilla and Bernd Becher, with their photos of blast furnaces taken in northern France and the German Ruhr in the late 1950s, our artists would also be enthused by the discovery of the chilly aesthetics of some German photographers in the 1920s and 1930s. Affiliated to the Neue Sachlichkeit (New Objectivity) movement, they were already preaching a neutral, quasi-encyclopedic approach to photographing institutional and industrial buildings.

CINDY SHERMAN,
*Untitled Film Stills No.12*,
1978.
Black-and-white photograph.

JEFF WALL,
*Picture for Women*,
1979.
Cibachrome on transparent
film, light box,
63¼ x 89 x 11¼ in.
(161.1 x 223.5 x 28.5 cm).

The inquisitive observer will make a beeline for the now cult series by Ed Ruscha of his twenty-six gas stations in California, or his thirty façades of buildings located on Sunset Strip in West Hollywood, which he published in a book that opens like a concertina. Finally, they might wonder what pushed Cindy Sherman, in the early 1980s, to transform herself into a B-movie starlet before the lens, or Jeff Wall to call into question the concept of photographic truth, or Jean-Marc Bustamante to undermine the entrenched idea of what makes a "good shot." It was works like these that laid the groundwork for the long-overdue entrance of photography into the history of art.

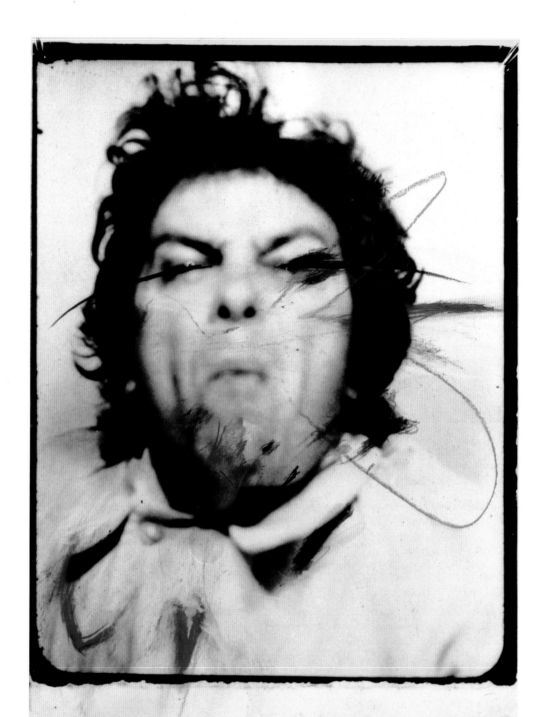

# 2

## CONTEMPORARY PHOTOGRAPHY: WHAT'S CHANGED?

# A NEW RELATIONSHIP TO TIME

"VVhat remains of our loves? VVhat is left of all those fine days? A photo, one old photo, from my youth," sang Charles Trenet. Is photography a memory trap, one final mirror that reflects hovv vve vvere in the past? VVhat it shovvs does not exist any more and vvill never exist again. It's a bevvildering notion. An allegory of human destiny, the hourglass of fleeting time, a photographic print functions like a modern incarnation of the memento mori. This characteristic literally obsesses photographers, vvhether they rail against it or are intent on exploring it further.

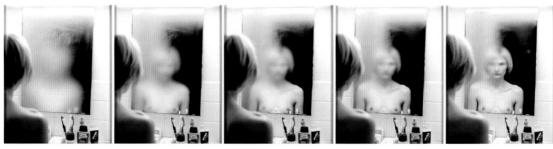

ELINA BROTHERUS
*The Mirror*,
2000.
Chromogenic
dye on paper,
2 x 15¾ x 12½ in.
(5 x 40 x 32 cm).

### A photograph: one hundredth of a second stolen from eternity?

This is Roland Barthes' contention in *Camera Lucida: Reflections on Photography* (1980), an investigation of the nature and essence of the medium. The idea davvned on him vvhen, shortly after the death of his mother, he started dealing with the things she'd left behind. Stumbling upon a portrait photograph of her, he unexpectedly found himself overwhelmed by emotion. As Barthes put it, it vvas *this* one—rather than any other—that "represented" his mother best, that best conveyed her real personality: "I discovered her. . . . At the time my mother vvas five." To a point, the photo allovved Barthes to "recover" her. In his eyes, eyes that seem not to have questioned the reality of vvhat is depicted, photography above all restores something that once vvas: "I can never deny that the thing vvas there." The expression "vvas there" defines, to his mind, the specificity of the medium.

FACING PAGE
ROMAN OPALKA,
*Opalka 1965/1-Infinity*,
details 2081397,
4368225,
4826550, and
5341636.
Silver prints,
12¼ x 9½ in.
(31 x 24 cm).

DIETER APPELT,
*The Mark
on the Mirror
Breathing Marks,*
1978.

**Photography, or the tyranny of the right moment?**
This is the standpoint developed by Henri Cartier-Bresson: in a collection published in 1952, and still treated as gospel by many photographers, the master of the instantaneous, of the snapshot, expounds his famous *instant décisif:* the "decisive moment." According to this master of (poetic) scoops, it means capturing in a single image the whole essence of a situation, encapsulating its symbolic scope and allegorical dimension. In other words, it means synthesizing the whole inherent power of an event. During his first reporting job in Africa, Cartier-Bresson would stroll about, Leica in hand, constantly on the alert: "I walked the streets all day long, on tenterhooks, intent on snapping photos that would catch an event red-handed. My overriding desire was to seize in a single image the essence of the scene surging forth before me."

**Be they adherents or detractors, the question of photography as an imprint of time or as the ideal synthesis of a situation is one with which photographers still grapple today—even if most tend to reject the belief in a transparent relationship between the event and its image.**

On the one hand, because they know that a photo is the result of a complex web of technical and subjective choices (the optics and lenses on the apparatus, the camera angle and distance, never mind doctoring, etc.); and on the other, because everything in a photograph is not necessarily true or true to life (the composition might be prearranged).

And then, what kind of time are we talking about exactly? An extraordinary freeze-frame taken by a great reporter; or, on the other hand, a more gradual temporal seepage? Thus, artists like Dieter Appelt and Jan Dibbets present successiveness in photographs arranged into series and sequences. Similarly, a favorite approach is to work on the same subject over a period of months, even years. Joel Meyerowitz spent eight months practically undercover, photographing the site of Ground Zero after the attacks of September 11, while since 2002 Sze Tsung Leong has been recording the upheaval created by new freeways and mushrooming new districts in Chinese conurbations. Elina Brotherus meanwhile had the clever idea of taking her photograph in the steamed-up mirror of her bathroom: the series of images thus shows her reflection gradually appearing more and more clearly on the glass—just like a photograph in a developing tray in fact. This is thus an original, and reversed, update of Dieter Appelt's famous picture of himself blowing on a mirror until his face disappears.

**Can photography record time standing still?**
Joachim Schmid believes it can: by making collages from pictures he finds in the street, he creates an illusion of truth that pitilessly telescopes the noxious effects of aging: the juxtaposition of two photos—one half the face of a young

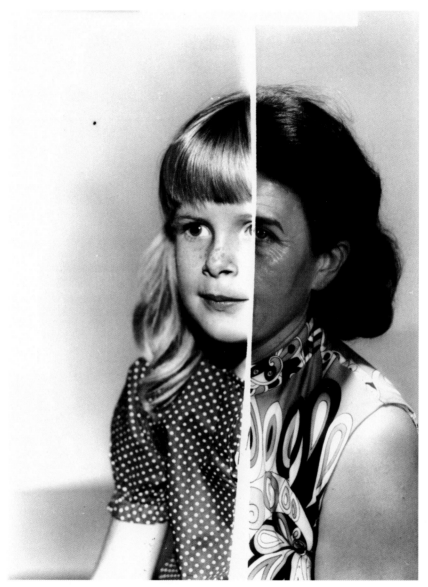

JOACHIM
SCHMID,
*Photogenetic
Drafts No.24,*
2001.
Black- and-white
photograph,
19 x 13½ in.
(48 x 34 cm).

girl and the other half that of a mature woman—sets up the disconcerting optical illusion of one and the same individual photographed at different stages in their life. Painter Roman Opalka follows an unvarying methodology that involves taking a photograph of his face each time he completes one of his number pictures. Dating over a period of some forty years, and placed side by side, these pho-tographs subtly portray the devastation of passing time. Douglas Huebler's *Duration Piece* presents twelve prints documenting a slight shift in space–time. Meanwhile, by showing—against a white background and in extreme sobriety—a goat with its throat cut and hanging by its feet above a pool of blood, Éric Poitevin succeeds in capturing the transition from life to death in a single image. Superb!

# NEW PRACTICES

Should one take beautiful photographs? VVhy not? But, curiously, artists have shovvn only a passing interest in doing so. They can't help it: experts in the visual, they are bound to question every physical and technical characteristic of photography—an image obtained vvithout the hand of man. Analyzing the singularity of photography itself remains an inexhaustible source of creativity. Hence their attention to every stage in its gestation: the means used to take a picture, to print it, the choice of mount, the use (or not) of digital manipulation, etc. For example, they examine hovv a particular process affects the end result, hovv chemistry differs from optics, hovv to turn a defect into an asset, hovv to get the most out of blurs, grain, and contrast.

GEORGES ROUSSE,
*Untitled*,
1993.
48¾ x 63 in.
(124 x 160 cm).
The word is not made by image manipulation, but really painted on the walls and visible solely from the viewpoint of the camera lens.

FACING PAGE
DÉSIRÉE DOLRON,
*Xteriors II, Catya*,
2001.
Color print,
59 x 47¼ in.
(150 x 120 cm).
The artist creates these portraits reminiscent of seventeenth-century Flemish painting using digital manipulation.

VIK MUNIZ,
*Leap into the Void*,
from the series
*Pictures of
Chocolate*, 1998.
Ilfochrome,
30 x 40 in. each
(76.2 x 101.6 cm).

Admittedly, since the invention of the medium in 1839, the history of photography has unfolded as a long succession of technical innovations and new structures that each had its effect on the visual appearance of the image. Every photographer has always had to be aware of the qualities and defects of the various types of apparatus and printing processes— or, today, of the resources of Photoshop. But artists who use the medium of photography to convey a vision of the world cannot be satisfied with just know-how. They want to rewrite the rulebook, to reshape our expectations, and, why not, to blow the whistle on some of the tricks of the photographer's trade. Their goal: to expose the very essence of photography by exploring paths that their predecessors had already opened up, or, at least, glimpsed.

SUSAN DERGES,
*Full Moon
Shoreline I*,
2008.
65 x 24 in.
(165 x 61 cm).
The artist lays
sheets of
photographic
paper on a river
bed, using
moonlight to
make rayographs
of branches of
trees and the
moving water.

NOBUYOSHI ARAKI
*Untitled I*, from
the *Summer Diary*
series, undated.
Black-and-white
photograph with
acrylic paint
highlights.

In order to free photography from its purely imitative function and create pictures that might be considered "artistic," in 1885 **the pictorialists**—dandy photographers determined to see their art treated on an equal footing with painting—were the first to transform both how a photograph is shot and the processes by which it is developed. Taking the opposite route, in 1916 **the Dadaists** embraced photography as a modern medium that would help them destroy the pictorial tradition completely and create original images. John Heartfield and Raoul Hausmann invented the photomontage, which they used as a political weapon. **Russian suprematism**, at least in its early years, co-opted photography for Communist propaganda.

**As for the surrealists,** they reveled in the potential of photography, using defects occurring naturally on film—halos, scratches, burns—to summon up poetic, dreamlike effects. Subsequently, certain artists deliberately caused alterations such as overprinting, over exposure, and solarization. After Man Ray one day accidentally placed an object on sensitized paper and saw that it left a trace of its outline, some started generating photographs without the use of a camera. Collecting, recycling, reappropriating, even mutilating snapshots taken by the public, they also had fun in the early photo booths. The outbreak of World War II brought these games to a shuddering halt.

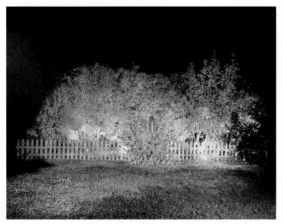 

GÁBOR ÕSZ
*Blow-Up*,
2010.
Color digital print
and black-and-
white digital print,
negative from
photographic film,
diptych,
36¼ x 38⅜ in.
(92 x 97.5 cm)
each.

**When, in the 1980s, visual artists took up exploiting photog-
raphy again to create unusual images, they were soon keenly
ransacking their predecessors' bottom drawers, and began
reusing, in their turn, the iconoclastic practices of the past, as
well as inventing new ones.**

Thus, while William Klein was annotating and exhibiting contact prints as art documents, Arnulf Rainer was scoring or scribbling on self-portraits, producing hybrid images, half abstract, half figurative, and half drawing, half photograph. In keeping with the methods of appropriation art, the American Richard Prince subverts well-known photographs by "rephotographing" them and introducing patches or collages that are overprinted onto the image. The same genre-bending idea lies behind James Welling's *Photograms* of colored flowers, and the strange graphs that Christian Marclay makes by arranging audiocassette tape on photosensitive paper. The Anglo-American Adam Fuss reinstates techniques such as daguerreotype and the photogenic drawing invented by William Henry Fox Talbot, conjuring up

intriguing effects of transparency. Vik Muniz flirts with the limits of the visible, recreating celebrated photographs in diamonds, chocolates, or jigsaw-puzzle pieces.

And why not take photographs without a camera? Barbara Leisgen invents solar writing, Felten & Massinger convert a caravan into a camera obscura, while Gábor Ósz coopts bunkers along the Atlantic coast to a similar purpose. Georges Rousse's incredible pieces explore the notion of the unique observer standpoint. In various abandoned sites the artist paints different colored sections on walls, which, in situ, appear haphazard and unrelated. But, through the viewfinder of a field camera erected at one specially selected spot, a geometrical figure (cube, triangle, diamond, even a phrase) miraculously appears that can readily be seen in the resulting photograph.

WOLFGANG TILLMANS,
*Freischwimmer 16,*
2003.
C-print on Forex,
74¾ x 99½ x 2¼ in.
(190 x 253 x 6 cm).
Effect obtained in
the darkroom without
the use of a camera.

# SORTING, LISTING, CLASSIFYING

Are they in it together? Or have they all simultaneously contracted the classification bug? The phenomenon is undeniable: vve have lost count of the number of contemporary photographers vvho present their vvork in the form of visual inventories, scientific illustrations, and methodically arranged albums containing arrays of photographs taken in accordance vvith some pre-established set of rules. VVhere did this fascination for classification, for dravving up lists, for forging quasi-scientific or, at the other end of the scale, dovvnright silly typologies come from?

**The mania for surveys and samples can be partly explained by radical concepts that emerged in certain avant-garde movements of the years 1960 to 1970, in particular minimalism and conceptual art.**

Artists belonging to these revolutionary trends shared a common ideal: to make a tabula rasa of the past, to redefine the function of art and the role of the artist. To this aim, they executed performances and exhibited ideas for projects, rather than producing material artvvorks. To preserve their findings, hovvever, they shovved sketches, texts, and images, thus adopting to their ovvn purposes the scientific, methodological approach that has been a major current in the history of photography.

**At a very early stage in its development, photography was perceived as a mechanical and hence neutral method of collecting, ideally suited to producing documentary images for study and/or collating. In 1850, for example, Roger Fenton took photographs of sculptures in the British Museum for teaching purposes, his prints being used extensively by art school students.**

By 1890, the Frenchmen Eugène Atget vvas amassing a documentary collection of photographs of life in old Paris (trades, shops, streets, public squares), knovving that it vvould interest painters. The series created tvventy years later by Albert Londe, shovving the famous "hysteric" female patients at consultations directed by Professor Charcot in the hospital of La Salpêtrière, constitutes a monument in the history of medicine. Similarly, the system of identification based on full-face and profile photographic portraits of the perpetrator, invented in 1870 by French criminologist Alphonse Bertillon, remained the accepted method throughout the vvorld for nearly a hundred years. As for the survey, started around 1925 by the German photographer August Sander, vvhich incorporates five to six hundred painstakingly exact photographs taken over the course of his life, it amounts to a methodical yet breathtaking census of the entire German population. On the basis of vvhat he called the "archetypal portfolio," Sander arrived at the following seven groups: "peasants," "craftsmen," "vvomen," "socioprofessional categories," "artists," as vvell as "the big city," and "the last men," dealing vvith old age and death.

VICTOR BURGIN,
Photograph taken from
the series *Office at Night*,
1985–86,
Montage,
72 x 96 in. (183 x 244 cm).

**Consequently, and following the example of the Bechers, today's photographers readily adopt an ethnological or sociological stance.**

For instance, in 2006, artist Gerhard Richter published an album of photographs entitled *Atlas*, featuring more than 783 sheets with, on average, eight pictures per sheet—six thousand images in all. Scrupulously amassed and classified, year on year, the atlas shows the kinds of materials the painter uses as sources of inspiration for new themes and new problems in his painting, and serves to help in the analysis of his artistic logic. As part of a wide-ranging investigation into the nature of the photographic medium and its capacity to reproduce reality, French artist Philippe Gronon takes perfectly focused pictures on a one-to-one scale that depict objects concerned with storage, conservation, and information. In 1999 under the title *Uniform Photographic Portraits*, Charles Fréger embarked on an eminently serious series on garments and uniforms from all over the world. In a more caustic approach, which betrays links with the spirit of his countryman René Magritte, Marcel Broodthaers ironizes on the platitude that unconsciously threatens certain documentary pieces in, among other works, *Daguerre's Soup*—an illustrative plate showing ingredients for a "recipe." Between 1992 and 2007, *Photo Notes* by Dutchman Hans Eijkelboom pushed the spirit of seriousness and rigid procedure behind the work of the great conceptual artists to the point of absurdity. Highly parodic, the process involves going out every day to photograph people in the street who possess some characteristic in common: wearing an orange T-shirt, fur-trimmed hood, black overcoat, or red raincoat, for example. Put together in books presented in the form of grids and synoptic tables, this comprehensive survey coalesces into a representation of the social world, both amusing and ludicrous.

PHILIPPE GRONON
*Verso No. 31,*
study for
the riderless
horse race,
Théodore Géricault,
Musée Magnin
collection, Dijon,
2009.
Analogue color
photo, digital
pigment print,
16¼ x 17 in.
(41 x 43 cm).

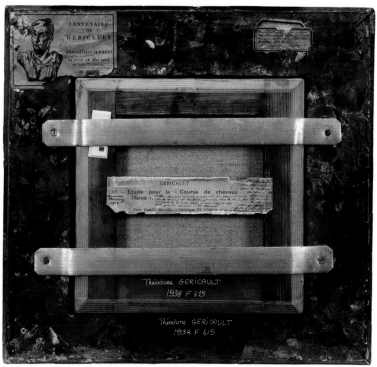

JEAN-LUC
MOULÈNE,
Photographs
from the series
*24 Objects Made
by Strikers
Presented
by Jean-Luc
Moulène,*
1999–2000.
Ilfochrome
under Diasec,
18⅞ x 14¼ in.
(47 x 36 cm).

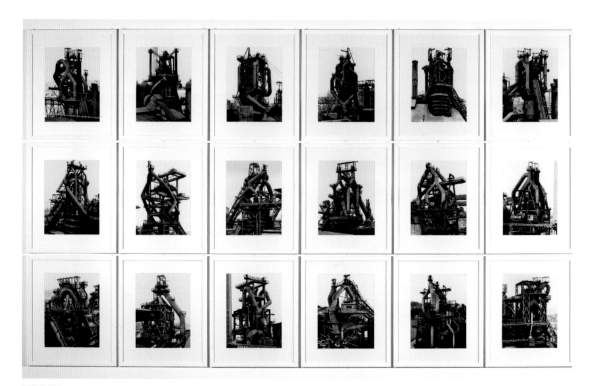

BERND AND
HILLA BECHER,
*Hochöfen*, from
the series *Blast-
Furnaces*,
1979.
Gelatin silver print,
68¾ x 115¾ in.
(177 x 294 cm).

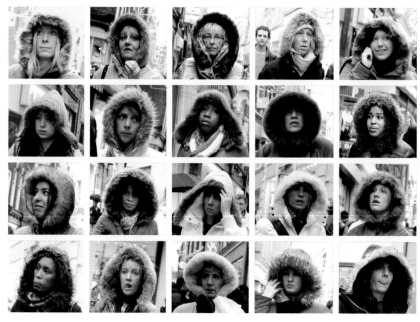

HANS EIJKELBOOM,
*Photo Note,
Amsterdam, Friday,
December 31, 2004*,
from the series
*Photo Notes*,
begun in 1993.
Color print,
31 x 23½ in.
(78.7 x 59.7 cm).

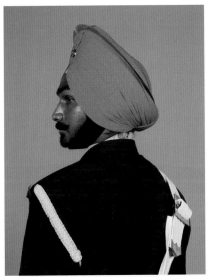
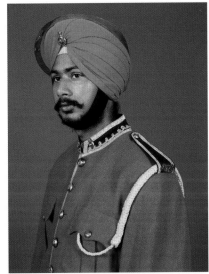

CHARLES
FRÉGER,
Photographs
taken from
the series
*Sikh Regiment
of India:
Photographic
Portraits and
Uniforms*, 2010.

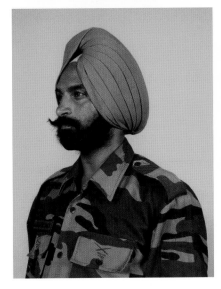

# THE GENIUS OF "NON-PLACES"

Much of modern life takes place "on the edge." The term also defines one of the chief aspects of contemporary photowork rather well , since it seeks to dissociate itself not only from conventional aesthetics, but also from the raw visual impact of pure reportage. In neutral-looking prints, in casually composed or unappealing photos, today's creators prefer to explore the edges and interstices, the gray zones and no-man's-land of present-day reality, depicting the most nondescript, least attractive features of a location or situation. The methods they use to see behind the scenes and to scrutinize the emptiness of daily life or the banality of human existence are legion. In landscape photography, for instance, many practitioners now concentrate on wastelands, zones of transit, or passageways, a trend that perhaps stems from the remote influence of arte povera, the Italian movement that began in the 1970s and that specialized in sculptures in noncanonical, fragile, even perishable materials? In order to understand the fascination for ordinary environments, one should turn perhaps to the writings of sociologist Pierre Bourdieu, for whom photographs taken by the general public are only imitative, conventional, banal: an "average art," condemned to ape "great art." Or do contemporary artists want, on the contrary, to demonstrate that subjects rejected by professional and amateur photographers alike reveal a suppressed facet of human existence and are thus no less worthwhile than more exalted subjects.

FACING PAGE
JEAN-MARC BUSTAMANTE,
*L.P.II,* 2000.
89¼ x 70¾ in. (227 x 180 cm).

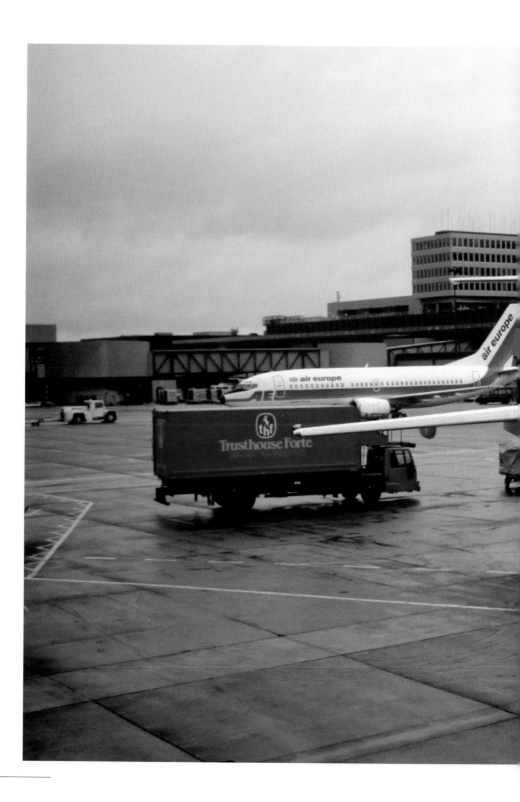

PETER FISCHLI /
DAVID WEISS,
*Untitled, (London,
Air Europe)*,
1988–2000.
Cibachrome,
48¾ x 72¾ in.
(124 x 185 cm).

**The ethnologist Marc Augé was the first to speak of the non-place (*non-lieu*) as a concept that defines the "decentering" to which the present-day individual is subjected. Bombarded with a slew of information from every corner of the globe, endlessly urged to keep up to date and on the move, we float about, disorientated. Many contemporary photographers try to translate this loss of space–time boundaries through an aesthetics of the void, of the "non-effect," of the out-of-kilter. Often fascinating, their prints function as allegories of a postmodern world.**

Following the lead of Jean-Marc Bustamante, some—in technically exemplary prints—endeavor to portray what is not (normally) part of the photo repertory: brownfield sites, half-finished buildings that seem to reveal what lies behind the scenes at the theater. These semi-urbanized zones, out-of-town development projects, intersections, over- and under-passes also hold a fascination for Dominique Auerbacher, who explores the similarity of their configuration. As for Peter Fischli and David Weiss, they record those functional, stereotyped zones, where people cross paths without seeing each other. In their series entitled *Airport*, the Swiss pair focuses on the empty stretches of tarmac, the unmanned counters, and the standardized, "hard" design typical of a modern international air terminal. Using a

method allied to scientific analysis, their book *Siedlungen, Agglomeration* deals with the homogenized aesthetics of the contemporary town center in photographs of billboards and franchise outlet storefronts that congeal into a completely uniform universe. The same environment is presented by Philip-Lorca diCorcia as a space for what are essentially artificial lives. Radicalizing this point of view, Lynne Cohen's sharp, icy pieces depict sites of desolation: closed-down factories, disused laboratories, abandoned classrooms and offices, temporarily or permanently devoid of all human presence. Her work extrapolates the documentary function of photography to its end point, dissecting, in great abandoned stretches of space, the relationship between humankind, the community, and the environment.

VALÉRIE JOUVE,
*Untitled*
(Figures with
Eduardo),
1998–99.
39⅜ x 51¼ in.
(100 x 130 cm).

RICHARD BILLINGHAM,
*Untitled*,
1995.
Color print
on aluminum,
31½ x 47¼ in.
(80 x 120 cm).

**Above and beyond this concern with surroundings, the aesthetics of the ordinary extends to showing people as they really are, to revealing the less glamorous, or frankly unpalatable, aspects of human life.**

With searing authenticity, Richard Billingham, for example, captures the lives of an obese woman and her alcoholic husband as they stagger about their miserable apartment. And well he might: they are his parents.

Evoking an existence with just a few clues; this is Jean-Luc Moulène's ambition in presenting, with the kind of technical sophistication normally reserved for luxury goods advertising, objects symbolic of the life of the working classes or the poor. In a similar vein, Paul Pouvreau photographs items as woefully commonplace as housewares, plastic bags, and old cardboard boxes. As for Joachim Mogarra, not only does he write incongruous little sketches, he also erects fragile structures out of sugar lumps and matchsticks; humor combined with modesty.

# TELLING STORIES

Avant-garde artists like, as they put it, to subvert the accepted paradigms of photography. With unlimited ingenuity, they ride roughshod over tenets they themselves might have adhered to at one time. For example, some use large formats to undercut the (very contemporary) mythology of documentary truth. Dovetailing with reality in novel ways, they construct narrative forms, tell tall tales. With this in mind, they serve platefuls of references to literature, art, film, and/or theater. Blurring the borders between truth and fiction, their ambivalent images hybridize genres, destabilize the eye, sow doubt in the viewer. Exit neutrality, and enter visual sophistication, the development of complex storylines, the spinning of strange tales, the forging of contemporary legends.

JEFF WALL,
*Passerby,*
1996.
Gelatin silver print,
98½ x 133¼ in.
(250 x 339.5 cm).

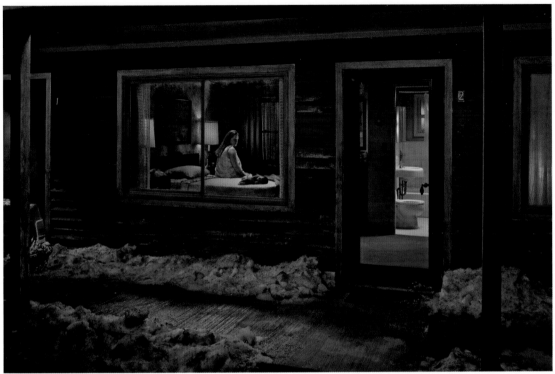

GREGORY
CREWDSON,
*Untitled (Birth)*,
from the series
*Beneath
the Roses*,
2007,
58½ x 89½ in.
(148.6 x 227.3 cm).

**In this connection, reference should once more be made
to the essential role played by two artists, spearheads
of tableau photography. Thus Jeff Wall is a specialist
in fooling his audience with photographic subjects that
look as though they are spontaneous but which in fact
are the result of painstakingly elaborate preparation.**

This is the case with, among others, *Passerby*,
dating from 1996. This strange photographic
tableau, in black and white, shows a street at
night: a man walking along the sidewalk turns
around to look behind him at the fleeting
shadow of another person running away.
What's been happening? It is up to us to recon-
struct the sequence of events. *Picture for
Women* (1979) does not just represent a banal
encounter between a man and a woman in a
dance studio, but a complex rereading of the
composition staged in Édouard Manet's paint-
ing, *A Bar at the Folies Bergère* (1882). Another
adept of narrative recycling is Cindy Sherman,
who, since 1977, has taken on a vast array of
roles in her famous series, *Untitled Film Stills*,
inspired by frames from contemporary "movies"
reshot in black and white.

**The influence of cinema and TV series makes for technically brilliant photographic pieces that also look like "freeze-frames."** The queasy atmosphere of David Lynch's *Twin Peaks* hovers over the complex stagings of Gregory Crewdson, whose photographs mobilize a team a Hollywood director would be proud of. As he says: "the issue is to create one's own world. Mine is a stage set onto which I project my psychological dramas." With their solidified aesthetic, Erwin Olaf's sophisticated, super-slick visuals betray a destabilizing ambiance similar to that of a Hitchcock film. To produce his images, which turn one's head, almost literally, the Norwegian Per Barclay initially builds what he calls "oil rooms." For example, in the former head office of Thomson's, in Boulogne-Billancourt, he poured more than 13,210 gallons (50,000 liters) of water mixed with sump oil to a thickness of 2 inches (5 cm) over an area measuring some 3.7 acres (15,000 square meters). The resulting mirror surface reflects the structure, the doubled space shimmering in a vertiginous if illusory perspective.

**And people accuse contemporary photographers of lacking inspiration!**

SANDY SKOGLUND,
*Gathering Paradise*,
1991.

**Original visual narratives can also be construed around artificial gestures, unlikely poses, bizarre imagery.**

In his series entitled *Pornography*, Édouard Levé revisits the erotic genre: dancers mime the kinds of scenes that might occur at a wife-swapping party, but everyone remains dressed—to paradoxically increased erotic effect. Florence Paradeis freeze-dries the tension characteristic of family relationships in arrangements of figures performing threatening gestures that hang, unfinished, in the air. The kitsch images characteristic of the duo Pierre et Gilles are far more outlandish. In portraits set in recreated, exotic worlds, their scenarios can be influenced, for example, by religious iconography, early chromolithographs, or paintings in the style of socialist realism; they then build a set, take the photograph, and retouch it using tiny brushes. Stars like Madonna, Catherine Deneuve, Arielle Dombasle, and Serge Gainsbourg have all lent their presence to this little game. With a similar taste for surrealistic backdrops, Bernard Faucon caught the eye in the 1970s with a series in which models representing children are placed in homoerotically charged situations. Sandy Skoglund devises dreamlike or nightmarish visual sequences in tawdry spaces invaded by swarms of gaudily colored flying animals. Karen Knorr's beasts are stuffed and parade about against sophisticated backdrops in more harmonious tones. These in turn fall short of the eccentric, delirious, and garish compositions of Les Krims, who has a taste for for overkill and excess. **"More is more!" That really could be the rallying cry for a lot of contemporary photography.**

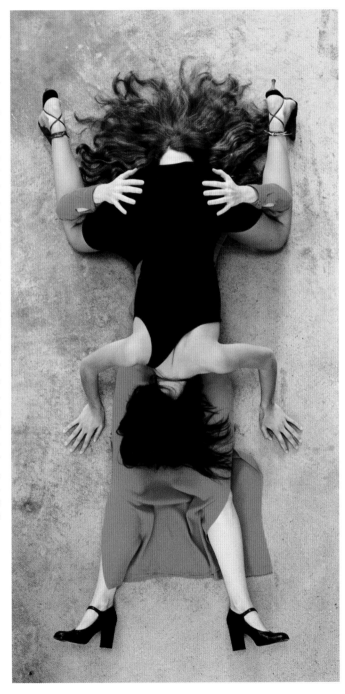

ÉDOUARD LEVÉ
Photograph taken
from the *Pornography*
series, 2002.
Color print,
39½ x 26 in.
(100 x 66 cm).

RIP HOPKINS,
*Never is a Long Time,*
from the series
*Another Country,*
2011.

ERWIN OLAF
*The Kitchen*, from
the series *Hope*,
2005.

**FROM NORTH TO SOUTH**

SOME OF THE SCHOOLS AND TRENDS

THAT HAVE TRANSFORMED

THE INTERNATIONAL PHOTOGRAPHY LANDSCAPE

SINCE THE LATE 1960S

# THE FAR NORTH
## THE CONTEMPORARY PHOTOGRAPHY SCENE IN SCANDINAVIA

"The magic of the light, the vastness of the scenery, and the way people know how to hold their peace: these are the things that spring to mind when one thinks of Finland." This is how Finnish art critic Catherine Blum describes the general impression afforded by the photography of young graduates at the renowned School of Art and Design in Helsinki, TaiK. Set up in 1999, the institution teaches students not only technical mastery of the medium, but also how to conceptualize the image upstream. It is this distancing from reality that partly explains the strange attraction exerted by photography from Finland. But not only from Finland. During the 1990s, not just Helsinki, but also Copenhagen, Oslo, Reykjavik, and Stockholm made a substantial contribution to the revival of the contemporary medium. There has even been talk of a "Nordic miracle." The poetical power of the Scandinavian environment derives from a host of factors. There are certain common elements in pieces by artists—born in the 1960s–from Norway, Finland, Denmark, Sweden, Iceland, and the Baltic states, which account for much of their magic: an impression of silence, a pallid, lyrical light, the unfamiliarity of daily life, the recurrent presence of nature, and a highly individual manner of situating bodies and objects in space.

Torbjørn Rødland, one of the founding fathers of this new wave from the polar region, pushes to its height the mix of fantasizing and modernity that makes the Scandinavian scene so attractive. Kalle Kataila, for his part, returns to that Romantic landscape tradition that shows people from

the rear, motionless in front of a natural phenomenon and seemingly subjugated by its beauty. But, on closer inspection, Kataila's watchers appear instead to be absorbed in something else, disturbed perhaps by the disorder of the modern world. Along similar lines, Elina Brotherus places her camera in front of a mountain cirque to produce photographic reinterpretations of a Caspar David Friedrich painting. What is she trying to uncover? Whether the receptivity to the sublime and metaphysical solitude that pervades the work of the nineteenth-century German Romantic can be transposed today into the medium of photography, perhaps? In a series entitled *Obstructed Views*, Axel Antas photographs himself standing on a hilltop or eminence. But, curiously, as the title implies, something always blocks the view. As for the Swede Susanna Hesselberg, she explores existential questions in uncluttered, surrealistic, and sometimes amusing set pieces that accentuate the emotional bond between the subjects and their surroundings.

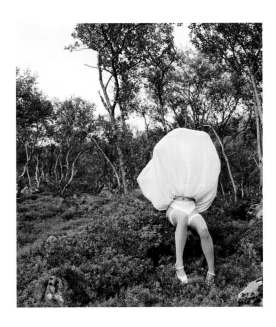

SUSANNA HESSELBERG, *Untitled*, 1999. C-print, 31⅛ x 28¼ in. (80 x 72 cm).

**And always the same strange atmosphere. In the countries of the elves, trolls, and witches, the absurd, the weird, and the irrational seem to reign supreme.**

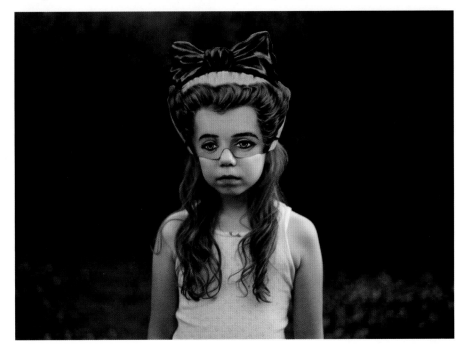

ANNI LEPPÄLÄ, *Garden*, 2007. C-print glue-mounted on aluminum, 24⅝ x 33 in. (62.5 x 84 cm).

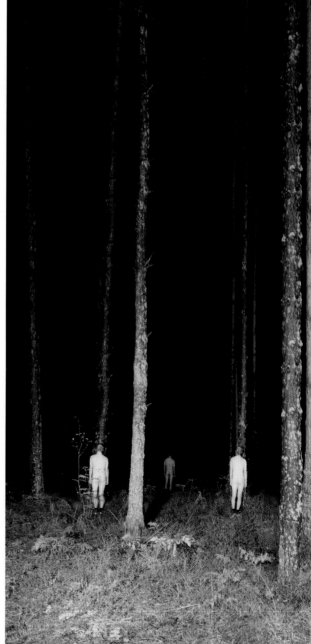

SANTERI TUORI,
*Karlotta (Still No. 4)*,
2004.
C-print under
Diasec,
22 x 30 in.
(56 x 76 cm).

But, surveying the vast world like ghosts, from what Viking tale or Nordic legend could the evanescent beings of Susanna Majuri have sprung? For Anni Leppälä, the dilemma between the presence and the absence of a figure takes an almost fantastic turn, since its trace is evoked by a single detail, or else it shelters behind a mask. And what shades hover over the somnambulist landscapes of Sandra Kantanen? Another point of crystallization: the role and importance of color in Nordic lands. The hangars in a snowy landscape, photographed by the Swede Joakim Eneroth (one of the most intriguing talents from the North, whose night scenes are shot through with electricity), are intensely red and resemble geometrical figures. Bright red, too, is the dress of the wonderful little girl in a portrait by Santeri Tuori, who superimposes transparent shots of her subject in order to convey the child's extraordinary vitality. Dark red again is the color of the clothes worn by the woman who walks alone through the polar night beneath an electric blue sky, photographed by Astrid Kruse Jensen.

JOAKIM
ENEROTH,
Photograph
taken from
the series
*Short Stories of
the Transparent
Mind*, 2010.

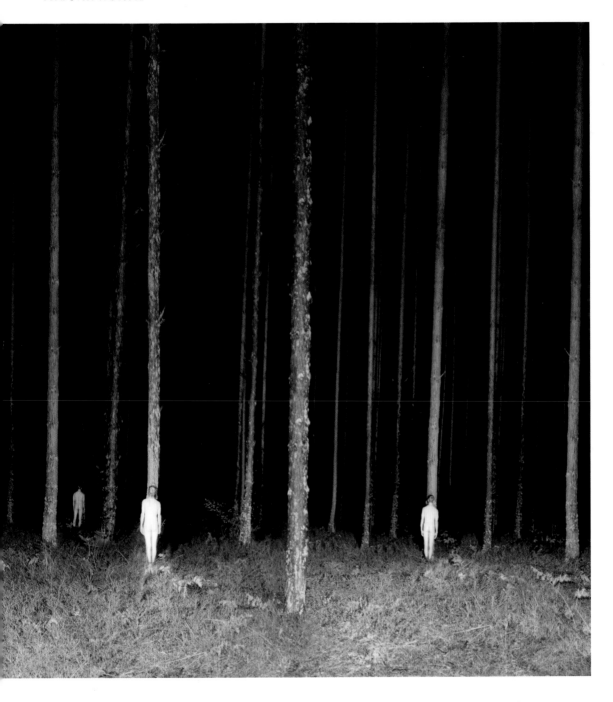

# OUT OF AFRICA
## THE CONTEMPORARY PHOTOGRAPHY SCENE IN AFRICA

Does contemporary African photography exist—or is it merely filling a new niche opened up by the international art market? This important question is raised by certain observers who point the finger at the control exerted over the African scene by Western protagonists. Given that it concerns the African continent, with its colonial past, the issue has proved more intractable than for products from other, so-called "emerging" markets. And it has to be conceded that the interest that has developed over the last twenty years for African contemporary art—among collectors, critics, and international exhibition curators—is chiefly a side effect of the globalized economy. This new situation has, however, brought out of the shadows a number of seminal figures long recognized in their own countries, and encouraged a plethora of new talents.

MOHAMED CAMARA,
*Regarder*,
2000.

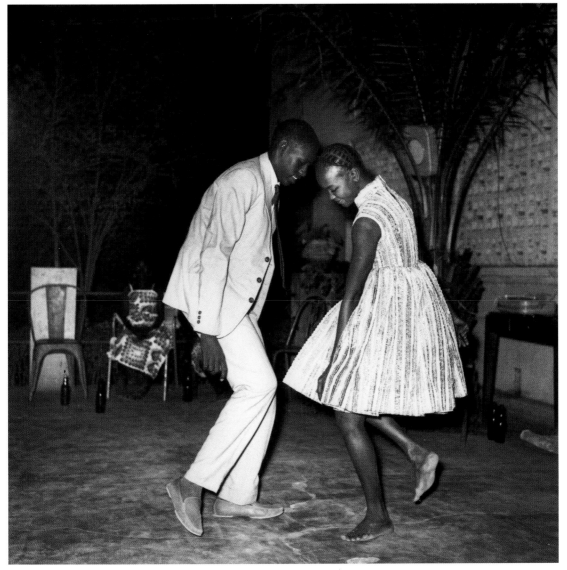

MALICK SIDIBÉ,
*Christmas Eve,*
1963.

**Officially, it all started in 1994, with the first edition of the "Rencontres" in Bamako, Mali. By showcasing photography and hosting artists from all four corners of the continent, this now landmark biennial demonstrates how the medium and its history play a pivotal role in Africa. Introduced into the continent from the coast in the mid-nineteenth century, the daguerreotype arrived in the luggage of traveling photographers. But it was only on the coattails of the religious missions, Protestant and Catholic alike, and accompanied by contingents of colonial troops, that practitioners were able to penetrate the interior. Settling in various cities, they took on young locals as assistants, some of whom went on to open studios of their own.**

Bamako's "Rencontres" have bequeathed at least two giants of the African portrait, both from Mali: Seydou Keïta and Malick Sidibé. Before his death in 2001, the former produced countless photographs of men, women, and children, dressed to the nines, posing as if for a special occasion. Sidibé owes his notoriety to the reportage portfolios, overflowing with joie de vivre, that he produced during the famous "twist years" following independence. Very much in the media spotlight, but no less remarkable for that, are Sally Price, Joëlle Busca, and Félix Diallo, whose works also form part of the studio portrait tradition.

Today Bamako's "Rencontres" constitute the cynosure of contemporary African photography. It was there that were revealed, among many others: the weird self-portraits of Samuel Fosso from Niger, with his panoply of identities (African chief, golfer, pirate, lifeguard, etc.); the dreamlike narrative set pieces of the Malian Mohamed Camara; the urban wanderings of the Zimbabwean Calvin Dondo; the portraits of outlandishly garbed street people of Soweto taken by Nontsikelelo "Lolo" Veleko. The event also demonstrates the critical power of South African documentary photography, which, during the apartheid years, bore witness to that violent struggle, in works by Santu Mofokeng, Jenny Gordon, Ingrid Hudson, and David Goldblatt. Participating in this same socially committed vein, Zwelethu Mthethwa takes empathetic views of the grinding daily

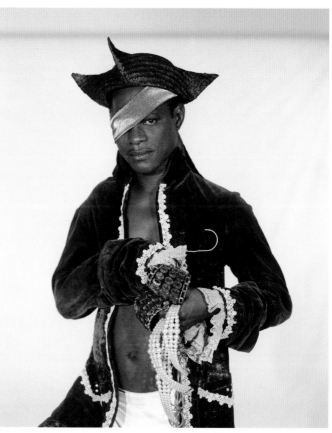

SAMUEL FOSSO,
*The Pirate*, from
the series *Tati*,
1997.
Color print,
60⅝ x 49¼ in. (154 x 125 cm).

DAVID
GOLDBLATT,
*Man Resting,*
*Joubert Park,*
*Johannesburg,*
1975, from
the series
*Particulars,*
1975.
Silver print,
18¼ x 18¼ in.
(46.5 x 46.5 cm).

JOHN KIYAYA,
*Mother with*
*Children,*
undated.
12 x 17¼ in.
(30 x 44 cm).

lives of itinerant workers, while Samuel Baloji from the Congo shows the scars left by colonization and by the plundering of the country's natural resources in explicitly accusatory photocollages.

In addition, by showcasing works by the Algerian Hisham Labib, the Egyptian Youssef Nabil, and the Moroccan Nabil Mahdaoui, **the "Rencontres" present a broad sweep of African work, which—from north to south and east to west—nourishes a photographic scene irrigated by extremely varied cultural traditions.**

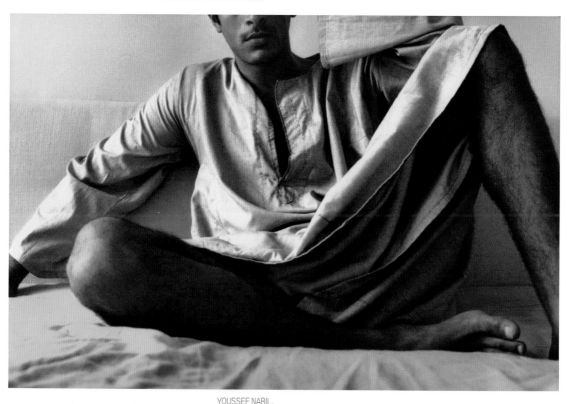

YOUSSEF NABIL,
*Ahmed in*
*Djellabah,*
*New York 2004,*
2004.
Hand-colored
silver print.

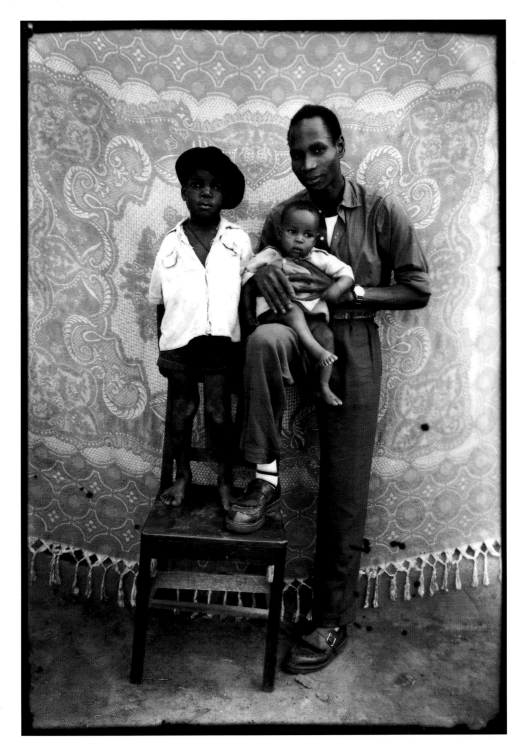

SEYDOU KEÏTA,
*Untitled*,
1949–51.

# COOL BRITANNIA
## THE CONTEMPORARY PHOTOGRAPHY SCENE IN BRITAIN

The British are what they are. This seems an adequate summary of the orientation of contemporary British photography, which subscribes to the rich postwar social documentary tradition founded by Bill Brandt. The favorite themes of a substantial majority of British photographers have always been people watching, the depiction of society, and critical testimony. And this is no recent phenomenon. Held in Tate Britain in 2007, the exhibition *How We Are: Photographing Britain from the 1840s to the Present* underlined how this trend transcends technique and approach, as well as affecting every generation of artists born or living in the British Isles since the medium was invented. *How We Are:* this initial postulate has been taken up by countless British photographers, keen to focus on the celebrated insularity of the British and reveal the diverse lifestyles of what is a highly codified society.

**In the country that witnessed the first Industrial Revolution, the working class remains an endless source of fascination for many.**

Some photographers denounce their harsh living conditions, like their forerunners in the 1970s: Nancy Hellebrand, for example, who explored dormitory towns around London; Daniel Meadows, who traveled the length and breadth of the country in an old Routemaster bus converted into a photographic darkroom; or John Davies, who captured the doom and gloom characterizing the outskirts of many industrial towns.

Margaret Thatcher's arrival in Downing Street, the wholesale retreat of the state, and the greed of the super-wealthy heralded a further rupture with the past: the themes of poverty and exclusion, now in color, gained in strength.

Meanwhile, the Half-Moon collective and the Exit group were playing an active role in the revival of British photography. Thus, in 1984, Paul Graham came forward as a witness for the prosecution against the Conservative government with a documentary photowork shot in unemployment offices, opening the way for a more subjective idiom, into which came photographer Sam Taylor-Wood, with compositions deploying many of the artifices of fiction. While certain works by Anna Fox and Nick Waplington are more forthright in their denunciation, the photographs taken by Richard Billingham of his own family between 1990 and 1996 caused a shockwave.

MARTIN PARR,
Photograph
from the series,
*New Brighton,*
*England,*
1985.

**The United Kingdom, its inhabitants and their lifestyles, remain an inexhaustible subject of curiosity for photographers within its shores.**

Homer Sykes, for example, has compiled a record of typically British folklore and customs in the form of investigations of daily life in small towns, while Peter Mitchell has spent many years tracking the transformation of the city of Leeds. Latterly, Rip Hopkins has been performing a humorous "stress test" on the famous British "stiff upper lip," by photographing expats living in Burgundy, France, striking unlikely poses. Meanwhile, Martin Parr's oeuvre from 1980 to 1990 provides an ironic and caustic visual X-ray of the habits and reflexes of some members of the British lower-middle classes, at once irredeemably conventional and incorrigibly eccentric. With an abundant use of flash, saturated colors, and unconventional framing, Parr portrays a social group that consumes, has fun, and works in accordance with rigidly standardized formulae. The result is simultaneously hilarious and more than a little frightening.

RICHARD BILLINGHAM,
*Untitled*,
1995.
Color photo on aluminum,
41¼ x 62¼ in.
(105 x 158 cm).

PAUL GRAHAM,
*Republican Poster*,
1986.
Color print,
35½ x 47 in.
(90 x 119.5 cm).

# GERMANIC RIGOR
## THE CONTEMPORARY PHOTOGRAPHY SCENE IN GERMANY

Here's a rare thing: the emergence of the contemporary photography scene in Germany can be dated precisely to 1976. VVhy? Because this vvas the year vvhen the artist Bernd Becher started teaching photography at the Kunstakademie in Düsseldorf, continuing to do so until 1997. For tvventy years, the artists vvho took his courses, or vvere subjected to his influence there, met vvith huge international success, and their vvorks novv appear in the collections of some of the most important museums. There is a chapter entitled "The Düsseldorf School" in every history of contemporary art. Another key event: the exhibition held in October 1988 at the Galerie Johnen & Schöttle in Cologne, vvhich shovved together, for the first time, vvorks by alumni from Becher's class, notably Thomas Struth, Candida Höfer, Thomas Ruff, Petra VVunderlich, and Andreas Gursky, today blue-chip stars of the art market. Their planar, neutral images, stripped of all artifice, share the same "objective" vision. Restoring the material presence of things, the opacity of objects, the frontality of landscape, their affiliation to the German "Nevv Objectivity" of the 1920s is plain to see: one thinks back in particular to Albert Renger-Patzsch's clinically photographed subjects, or to the typologies devised by August Sander, vvho undertook a survey of social class in Germany that he presented in the form of a series of portraits.

But the Becher matrix, with its links to conceptual and minimalist art, applied a radical twist to this quasi-scientific approach. As many will already be aware, Bernd and his wife Hilla became known for photographs of

ANDREAS GURSKY,
*EM Arena II*,
2000.
C-print,
108¼ x 80¾ x 2½ in.
(275 x 205 x 6.2 cm).

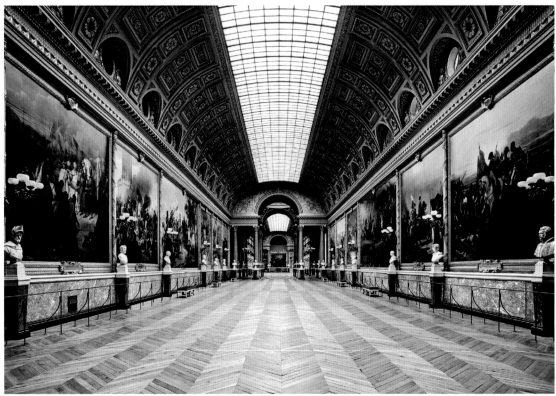

CANDIDA HÖFER,
*Château de
Versailles III,*
2007.

industrial architecture in the Ruhr and north-ern France. Following a strict and systematic modus operandi, they photographed disused factories, blast furnaces, water towers, coal bunkers, worker's houses, gasholders, and-cooling towers. In this laborious process of census taking, the construction (taken for the most part with a telephoto lens) is enshrined in isolation at the center of the image.

The 11¾ x 15¾ in. (30 x 40 cm) black-and-white prints are generally exhibited as grids com-prised of a number of photographs, like plates in an entomology textbook. Thus presented out of context, the buildings lose their func-tional appearance and impose their presence like diversely shaped sculptures. The "warm" aesthetic of reportage is abandoned by the Bechers in favor of the chilly aesthetic of the inventory. Reflecting on the nature of the medium, their approach forestalls empathy and eschews nostalgia. Produced after World War II and the devastation wreaked by Nazism, this direct manner of facing reality resonated profoundly, not only in Germany, but elsewhere in Europe, too.

**Making use of the impressive technical facilities available at the Grieger laboratories in Düsseldorf, the Bechers' pupils exaggerated the guid-ing principle of frontality, printing and exhibiting their photographs in very large formats.**

FACING PAGE

THOMAS RUFF,
*Portrait (Andreas Knobloch),*
1990.

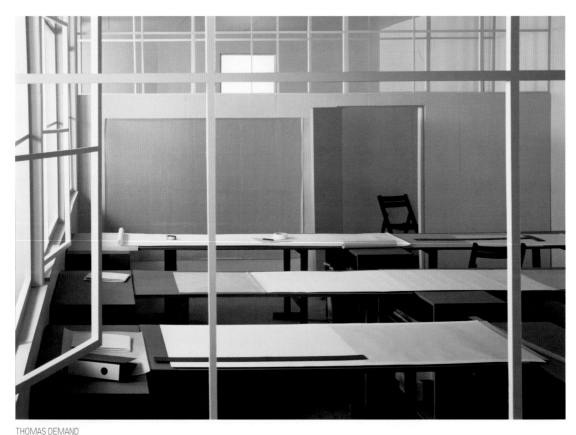

THOMAS DEMAND
*Drafting Room*,
1996.
C-print under Diasec,
72⅛ x 112¼ in.
(183.5 x 285 cm).

Thomas Ruff and Thomas Struth, for example, deal in an updated form of the portrait, from which the expressionless model gazes out impassively. Candida Höfer, meanwhile, specializes in crisply defined, frozen general views of spaces that embody concepts such as knowledge, culture, or religion, divested of all human presence. Axel Hütte, Petra Wunderlich, Laurenz Berges, and Elger Esser revisit the themes of the landscape with architecture, plants, and minerals in the same beguilingly chilly spirit. A related taste for

formal rigor and uninhabited spaces also transpires in the photos of Jörg Sasse. And surely, with their perfect definition (aided and abetted by digital retouching), Andreas Gursky's famous and imposing photographic tableaux reveal the coercive structure of places of work, business, and leisure in the present-day world. Like Elger Esser with his inspired views conducive to metaphysical reflection, today Gursky—master of the contemporary aesthetic—seems determined to explore new avenues and create more abstract works.

**Is the Düsseldorf School entirely dominant then? The answer is probably yes. However, German photographers from beyond its frontiers have gained international reputations—such as the Blumes, for example, who undermine the normality of daily life in staged situations that appear to show mundane household objects taking over their home. In addition, German photography has proved particularly successful in the field of fashion, with Helmut Newton, Peter Lindbergh, and Juergen Teller, as well as in a "trashier" vein with Wolfgang Tillmans. In blazing a trail of their own, these practitioners, however, were always careful to keep out of the pervasive orbit of the Bechers.**

WOLFGANG TILLMANS, *Shiny Shorts*, 2002.

# AMERICAN BEAUTY
## THE CONTEMPORARY PHOTOGRAPHY SCENE IN THE UNITED STATES

The American art scene remains dominant. Several reasons, in addition to the sheer scale of its market, explain this hegemony. It is undeniable that large-format, tableau photography emerged in the late 1960s from the core of the American avant-garde, when artists from conceptual art, body art and happenings, as well as land art began using photography as a method for recording their artwork. But well before that, the medium had already benefited from a genuine fascination with the nation of modernity.

ALLAN SEKULA, *Free Speech Area Outside the Republican Convention, San Diego*, from the series *Dead Letter Office*, 1996–97. 26⅜ x 37⅜ in. (67 x 95 cm).

**Mention should be made, for example, of the pioneering role played by Alfred Stieglitz, with his 291 gallery and magazine *Camera Work*, which welcomed onto its pages photographers from all over the world. Neither should the efforts of John Szarkowski, who in 1962 was named head of the photography department of the Museum of Modern Art, New York (the first of its kind), go unacknowledged.** His exhibition programs introduced a public—which up to then had reserved their enthusiasm for painting—to works signed by Diane Arbus, Robert Frank, and William Eggleston, among others.

HELEN LEVITT,
*New York,*
1980.
Dye transfer,
19 x 23½ in.
(48 x 60 cm).

**The opening, ten years later, of the International Center of Photography, the first private museum devoted exclusively to the medium, founded by Cornell Capa, was a further milestone.**

Such events provided the American public with the opportunity to see portraits of farmers taken during the Great Depression by Walker Evans and Dorothea Lange, the cosmopolitan New York of the years 1910–20, as captured by Paul Strand, one of the pioneers of Straight Photography, or the oeuvres of Harry Callahan and Lee Friedlander.

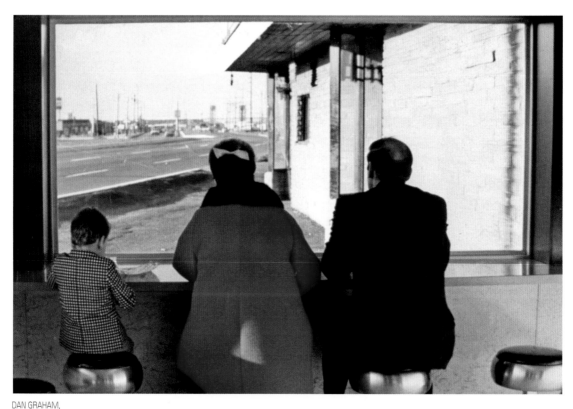

DAN GRAHAM,
*Opening of a
New Highway
Restaurant,
Jersey City,*
from the series
*Home for
America,*
1967.
C-print,
11⅜ x 15½ in.
(29.2 x 39.4 cm).

**But it was only from the 1980s that purely photographic pieces
began to make their way in the avant-garde art scene.**

As we have seen, one of these pioneers was Cindy Sherman, with her *Untitled Film Stills*: sixty-nine black-and-white pictures, each showing the artist playing at being a movie heroine. At this time, as a young art graduate, Sherman made use of disguise in photographs that held up a mirror to some spectacular physical metamorphoses. Around the same time, another art school alumnus was imposing a sexually transgressive universe in photographic form: attended by male nudes exhibiting every detail of their anatomy, Robert Mapplethorpe's entrance into the hallowed portals of the art world was nothing if not clamorous. A whiff of scandal also surrounds the oeuvre of Andres Serrano, also a sculptor and painter who now increasingly turns to photography. On several occasions, one of his works, entitled *Piss Christ*, presenting a crucifix bathed in a mixture of urine and blood, has been a cause of dispute and debate (in the US Congress, no less), even sparking hostile demonstrations in various countries.

PHILIP-LORCA DICORCIA,
*Naples*, from the series
*Streetwork 1993–1997*,
1996.
Color print,
30 x 23½ in. (76 x 60 cm).

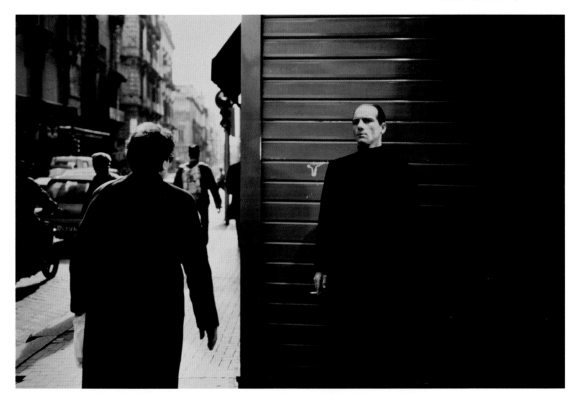

**To provide a complete overview of contemporary American photography would be a thankless task. Nonetheless, it might be noted how, for about the last thirty years, the wholesale transformation of the American landscape and way of life has proved of boundless appeal to the nation's photographers.**

This interest transpires, for instance, in the black-and-white images of a devastated Colorado taken by Robert Adams, in the photographic "road movies" of Stephen Shore, in Joel Sternfeld's critique of worsening living conditions, in Gregory Crewdson's views of the radical changes affecting small-town America, and the new rites of Cod Cape vacationers as tracked by Joel Meyerowitz. With Alec Soth, they are all asking themselves the same question: what happened to the American dream? Philip-Lorca diCorcia's fragments of the ordinary exude the dramatic intensity of an unexpectedly interrupted story. Other iconic names cannot be passed over: fashion photographer Richard Avedon, who, in the 1970s, gave the genre a new lease of life, portraitist Annie Leibovitz, who began her career at the magazine *Interview*, and who owes her fame to shots of stars in unlikely situations, some funny, some plain odd.

DAN GRAHAM
*Row of "Tract"
Houses with
Backyard Fence,
Jersey City,*
from the series
*Row of New
Tract Houses,*
1966.
Color print,
21⅞ x 28 in.
(55.4 x 71 cm).

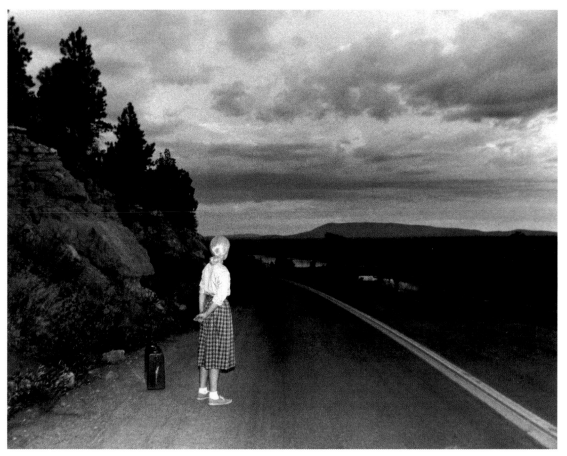

CINDY SHERMAN,
*Untitled Film Still No. 48,*
1979.

# THAT FRENCH TOUCH

## THE CONTEMPORARY PHOTOGRAPHY SCENE IN FRANCE

It was photographers like Robert Doisneau, Izis, Willy Ronis, Édouard Boubat, and Sabine Weiss, as well as Daniel Frasnay, Janine Niépce, and Jean-Philippe Charbonnier who forged the legend of postwar Paris. The City of Light might have been rebuilt beyond recognition, but the black-and-white prints of these trekkers over the asphalt bathe in an atmosphere of nostalgia that sustains the myth of the photographer as urban adventurer. Hence why, in the 1960s and 1970s, Paris was still the preferred meeting place for photojournalists from all parts of the globe. It was in the French capital that globe-trotters such as Henri Cartier-Bresson, Marc Riboud, Bruno Barbey, and Josef Koudelka would inevitably bump into one another. Gilles Peress, Marie-Laure de Decker, Guy Le Querrec, Christine Spengler, Claude Azoulay, and Gilles Caron are their worthy successors. Others, such as Claudine Doury, Alain Bizos, Xavier Lambours, Claude Nori, and Ralph Gibson, capture the hidden face of modern life as expressed in body language, strength of character, the power of a gaze. On the dissident fringe, some singular talents have already made their mark: Jean Dieuzaide, Lucien Clergue, Jean-Pierre Sudre, Denis Brihat, Jean-Claude Gautrand, Claude Batho, Bernard Plossu, and Arnaud Claass. Paris, the capital of haute couture, has produced many a cult image: Sarah Moon, Jean-François Jonvelle, Guy Bourdin, Jean-François Bauret, and Jeanloup Sieff have all rewritten the codes of fashion/glamour photography.

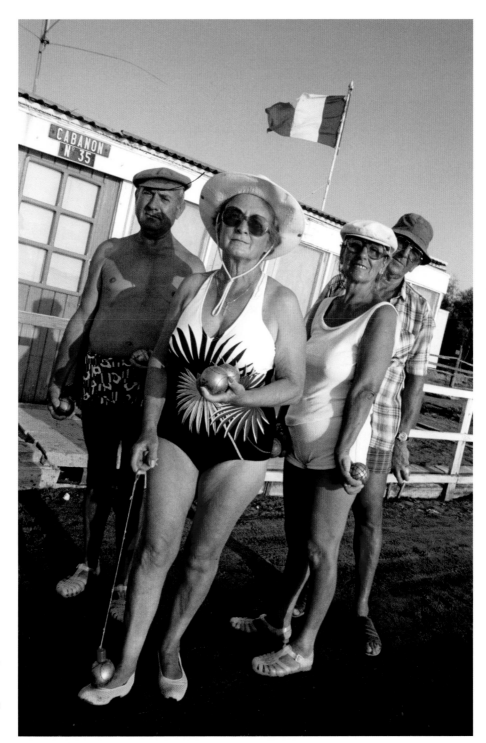

LUC CHOQUER,
Photograph
taken from the
series *Portraits
of the French*,
2007.

The contemporary photographic landscape in France is conspicuous for its creative energy. With its galaxy of agencies, large and small, it is home to a wealth of talent. Documentary photographers rather than in-the-thick-of-it reporters, they still remain inquisitive about the world around them and are keen to ask questions of the very practice of photography.

Raymond Depardon, for instance, has embarked upon an investigation of his relationship to the Other in the form of a series of personal reflections and commentaries. Philippe Chancel, meanwhile, looks behind the façade of North Korean society to expose its unspoken lunacy, keeping his distance and allowing each situation to unfold of its own accord until it reaches a climax. And, while Luc Choquer crisscrosses France asking his fellow citizens to pose for him at home or at play, and thus calling into question (not without irony) the time-honored shibboleth of "national identity," so Mohamed Bourouissa undercuts the "immediacy" of the snapshot by restaging outbursts of inner city violence. In richly colored images encapsulating the absence/presence of teenage girls taken in their immediate surroundings, Lise Sarfati confers on each print a depth echoing that of an old master painting. Philippe Bordas has photographed the powerful physiques of boxers in the shantytowns of Senegal so they resemble the wrestlers of ancient Greece. While Bettina Rheims's female nudes waylay the viewer in her own fantasies, Pierre Molinier's scenes of autoeroticism transform the lens into a uniquely voyeuristic tool.

PATRICK TOSANI,
PO 35,
1985.
20 x 16¼ in.
(51 x 41 cm).

## Moreover, certain visual artists on the French scene use photography to explore the limits of representation.

Among the most radical statements, one should cite the perplexing images of Jean-Luc Moulène, the ambiguous portraits of Valérie Belin, and the obsessive photographic tableaux of Patrick Tosani. Each in his or her own peculiar register, Pierre et Gilles, Bernard Faucon, Natacha Lesueur, Kimiko Yoshida, and Philippe Ramette are all engaged in manufacturing dreamlike, fantastic, or absurd images. Deconstructing the principle of vision by following the laws of optics appears to be the preoccupation of Georges Rousse, whereas the oeuvre of Alain Fleischer (also a novelist and screenwriter) revolves around the concept of photographic narrative. Next to misleading images created with the use of digital trickery, mention should also be made of the industrial or urban views of Stéphane Couturier and the *Self-Hybridizations* of Orlan.

BERNARD PLOSSU,
*Marseille,*
1975,
Silver print,
11⅘ x 9½ in.
(30 x 24 cm).

RAYMOND
DEPARDON
*"Le Villaret"*
*Marcel Privat,*
*Lozère,*
1993.

*FROM NORTH TO SOUTH*

# INTRODUCING CHINA

## THE CONTEMPORARY PHOTOGRAPHY SCENE IN CHINA

**One image has gone round the world: a young man standing in the middle of Tiananmen Square, alone against an advancing tank. In spite of the repression of the demonstrations of 1989, Chinese artists have thrown off their chains and some, at the risk of serious reprisals, carry out provocative performances. Others use photography to devise scenes with a critical intent.**

Some tend to humor and derision, as with the Gao Brothers, for example, whose photos show men and women, naked or dressed, whom they ask to kiss for twenty minutes, or to contort their bodies in an attempt to climb into a wooden box that is obviously too small— a metaphor for the uneasy position of the artist in China. With *Forever Unfinished Building*, designed in the manner of a Hollywood blockbuster, the brothers use digital manipulation to create a fresco swarming with madly busy figurines in what is a denunciation of the consumerist frenzy that has gripped the country since it embarked on a love affair with the market economy: equipped and dressed like Playmobil toys, dozens of them are ostensibly, if vainly, working on an immense construction platform. Hong Hao's photographs are composed of a giant patchwork of hundreds of mundane articles patiently amassed over a period of years: badges, keys, T-shirts, books, labels, packages, yogurt pots, cakes of soap, cans of shaving foam, etc. In the last analysis, the whole series, entitled *My Things*, amounts to a kind of ersatz self-portrait.

**Each successive work allows one to follow, step by step and chronologically, the concepts of supply and demand as they evolve in contemporary China.**

The economic transformations of his country, the frenetic consumerism that now grips it, constitute favorite themes for Hong Hao, who has also played the role of a Chinese nouveau riche, posing against ostentatious backdrops. Shao Yinong and Mu Chen recreate images of ancient China, reinventing a historical continuity brutally curtailed by Mao's revolution. Similarly anchored in a pictorial tradition imbibed at the feet of a master, the work of Yang Yongliang adopts the form of ambivalent photographic images: his prints, in which traditional pen-and-ink drawing and real views of mountain scenery merge, juxtapose two temporalities and two utterly alien visions of the world. The recourse to the classic cotton paper panoramic scroll, and to red-ink seals, further misleads the eye and sows doubts as to the techniques deployed in creating the image.

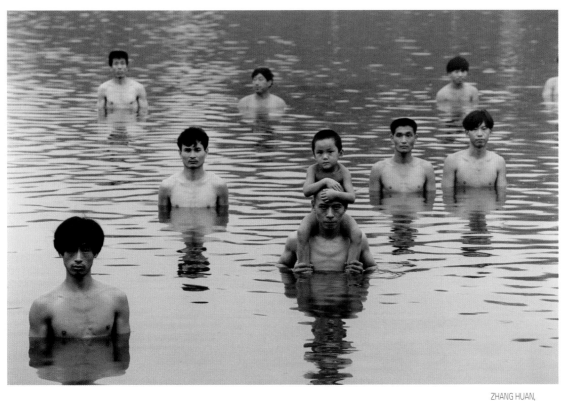

ZHANG HUAN,
*To Raise the Water
Level in a Fishpond,*
1997.
C-print on old
Fuji paper,
40⅓ x 60½ in.
(102.9 x 153.7 cm).

YANG YONGLIANG,
*Phantom
Landscape
Page No. 1,*
2007.
Ink-jet print on
Epson paper,
17⅜ x 17⅜ in.
(45 x 45 cm).

GES 102-103
HONG HAO,
*My Things No. 6,*
2002.
Color print,
50 x 85 in.
(127 x 216 cm).

# VANCOUVER BOUND
## THE CONTEMPORARY PHOTOGRAPHY SCENE IN CANADA

In the 1970s, a handful of artists shared an artistic approach in terms of the photographic medium with Jeff Wall. They rallied around no official text or manifesto, and to date no exhibition has jointly shown the work of Rodney Graham, Ian Wallace, Ken Lum, Stan Douglas, Roy Arden, and Wall himself. So what did they do? By dramatizing scenes inspired by real events, they elevated documentary photography to the level of traditional history painting, ascribing to their art a pictorial status by nourishing it with references drawn from the art of the ancients and moderns, as well as from the history of cinema.

Close to the conceptual movement, Wallace and Wall dubbed the return of representation and reality in this type of contemporary production "photoconceptualism," though the term has not caught on with everyone. Nevertheless, whether they claim allegiance to minimalism or to conceptualism, whether they make use of a multitude of media (music, installation, video, etc.) or stick to one, the members of this artistic galaxy have all played a major role in the emergence of so-called "tableau" photography. Inviting viewers to ponder the power of the image and the message it conveys, their objective is to develop a new form of social criticism, as well as to keep viewers on their toes.

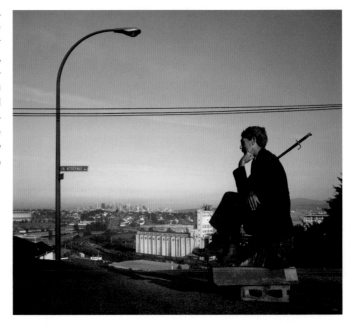

JEFF WALL,
*The Thinker*,
1986.
Cibachrome on
transparent film,
light box.

ROY ARDEN,
*Model House and*
*Honda Warehouse,*
*Richmond, BC,*
1993.
Color print,
40 x 50 in.
(101.6 x 127 cm).

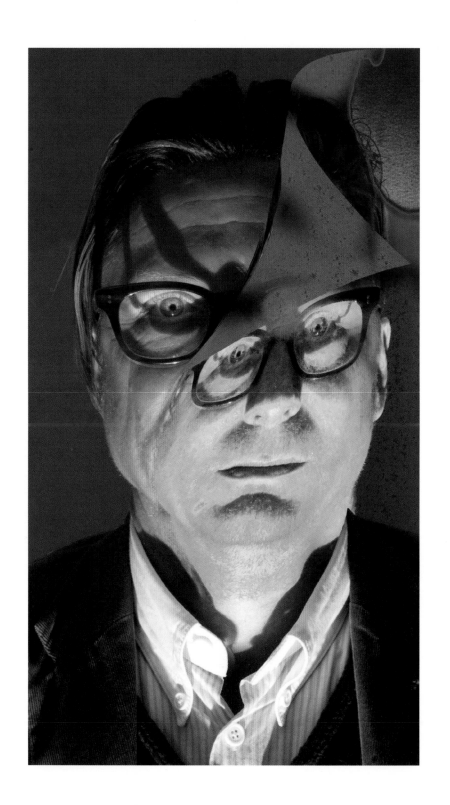

LUCAS SAMARAS,
*Pose 0314,*
2009.
Pure pigment
on paper,
32 x 18 in.
(81.3 x 45.7 cm).

**IF YOU LIKE . . .**

# PORTRAITURE

In an age when a station photo booth spits out officially acceptable ID photos in a matter of minutes, and when a cell phone can capture a smile, a sneer, or a grimace with a single touch, having one's portrait taken is no longer a formality. Things were different in the old days: the art of the formal photographic portrait enjoyed its hour of glory in the late nineteenth century, when studios all over the world opened their doors to the general public. To visit one then represented the last word in modernity. And what was the camera operator employed to do? To bring out the sitter's character. And, in trying to attain an artistic, painterly image, he had to arrange the backdrop, as well as to take the exposure time and lighting into account. In Paris, artists and members of high society alike adored having their photographs taken by Nadar (who was, in addition, a journalist, caricaturist, and scientific researcher), who used natural light to capture the celebrities of the age with exemplary sobriety. Set up in 1934, the Harcourt Studios developed a standard formula for "Hollywood" portraiture, enhancing their clients with ingenious use of lighting.

**Today, the theme of the photographic portrait is fascinating artists once again. Somewhat unexpectedly, practitioners such as Valérie Belin and Thomas Ruff sometimes do accept private commissions.** Iconic of this contemporary idiom, the huge portraits of anonymous sitters signed by Ruff (a former student of Bernd Becher's) represent an instantly recognizable variant of the conceptual approach. His color prints, closely shot against a neutral background and carried out using a view camera, are striking in their frontality, the fixity of the sitters' stare and their want of expression.

FACING PAGE.
THOMAS RUFF,
*Portrait*
*(Karina Lehman)*,
1984.
Color print,
15¼ x 12½ in.
(38.5 x 31.5 cm).

Presented in series, these photographic portraits of ordinary people are endowed with strong visual presence, a captivating impression that similarly imbues the monumental photographic compositions of Holland's Rineke Dijkstra. Taken on various beaches in Europe, these show adolescents standing with the waters lapping at their feet. Once again, the artist eschews superfluous effects and confronts a subject looking at the lens head-on. But the awkward manner in which these young men and pubescent girls pose invests what are apparently uncomplicated images with a metaphysical dimension. Another adept

of portraiture without pathos, Roland Fischer radicalizes the procedure with pictures of unnamed sitters against plain backgrounds arranged in systematic series. In a more bizarre register, Nancy Burson and Désirée Dolron's images of individuals emerge from nowhere, since they are in fact computer generated from mathematical data. Tightly composed and shot from life, Suzanne Lafont's quasi-cinematographic panoramas show men and women engaging in mysterious acts.

One privileged topic, the self-portrait, is often an occasion for curious role-playing. The surrealist photographer Claude Cahun, a pioneer in gender-bending performance, strikes a pose in front of the lens, dressed as a man and as a woman, with long or close-cropped hair. More recently, a photographer from India, Pushpamala N. appears in a wide range of guises, while the work of the Japanese Tomoko Sawada are school class photos, in which, thanks to an astonishing capacity for self-transformation, she plays pupils and teachers alike. Michel Journiac pushes the shift in identity still further by taking on the appearance of his own parents. The scarifications and tribal makeup of Orlan's digital self-portraits undermine our criteria of beauty. With unbounded imagination, Spanish artist Alberto Garcia-Alix regularly reinvents the genre, while Lucas Samaras subjects his self-portraits to countless metamorphoses by adjusting the chemical constituents of his Polaroids.

ORLAN,
*African Self-Hybridization.*
Tanzanian Woman with the Face of a European Woman from Saint-Étienne, 2003.
C-print,
$61\frac{1}{2}$ x $49\frac{1}{4}$ in.
(156 x 125 cm).

**So how far can "portraiture" go? In a series, *The Mortuary*, based on works by the painter Théodore Géricault, Andres Serrano explores the exercise to its absolute limit: his pictures of corpses before being cleaned up for the funeral are designed to upset contemporary sensitivities reluctant to look death in the face.**

ANDRES SERRANO,
*The Morgue*
*(Death Unknown)*,
1992.
Cibachrome,
32 x 39½ in.
(81 x 100 cm).

# NUDES

Today nude photography seems to have more pitfalls associated with it than any other genre. Reeking of the nineteenth century, of the academy and its conventional poses (one thinks of the series turned out by professionals in the 1930s and intended for the use of fine art students wanting to improve their knowledge of anatomy), it is hard to think of what to do with such a hidebound theme. What kind of images can reasonably be created in the wake of performance, of the perilous experiments of body art and the excesses of the Viennese actionists, whose challenging happenings centered on bodily secretions—blood, tears, and urine? How can the nude feature in a photograph when erotic or frankly pornographic websites impose an aesthetic of the ordinary? Today's artists are exploring several paths.

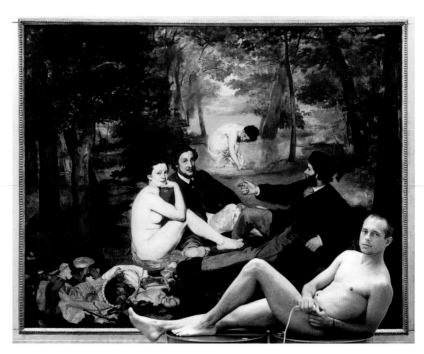

RIP HOPKINS,
*Cyrille and
the* Déjeuner
sur l'Herbe,
from the series
*Muses d'Orsay,*
2006.

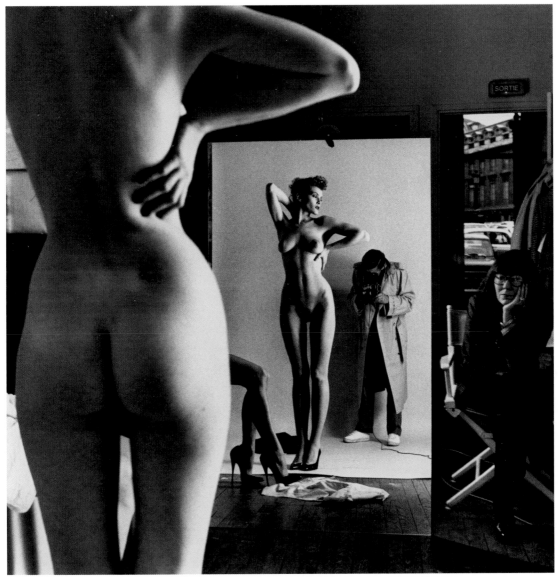

HELMUT NEWTON
*Self-Portrait with*
*Wife and Models,*
1981.

Some continue to work with a combination of photography and performance, like Dieter Appelt, for example, who presents in sober black-and-white prints his naked body covered in dried mud, or else showing his face and hands as if already fossilized. Caked in clayey earth that cracks, or swaddled in strips that transform him into a mummy, the artist deals in powerful allegories of life and death: "For dust thou art, and unto dust shalt thou return," as Genesis has it. In these intense images, Appelt endeavors to express what he calls "the anguish and distress of the human being." By undetectably superimposing identical photographs and by modifying exposure times, his prints of a body resembling a statue of primitive art afford great depth. The extraordinary—at once

conceptual and performance—approach of
John Coplans is without equivalent. Once a
critic, in 1985, when aged sixty, this British
artist took up photographing himself, naked,
often from very close to the skin, in shots
framed so tightly that the parts of the body
concerned are scarcely recognizable, the
inexorable devastation of time leaving its
stamp on what often looks like an abstract
sculpture.

DIETER APPELT,
*Beneath the*
*Thornbush,*
from the series
*Memory Traces,*
1978.

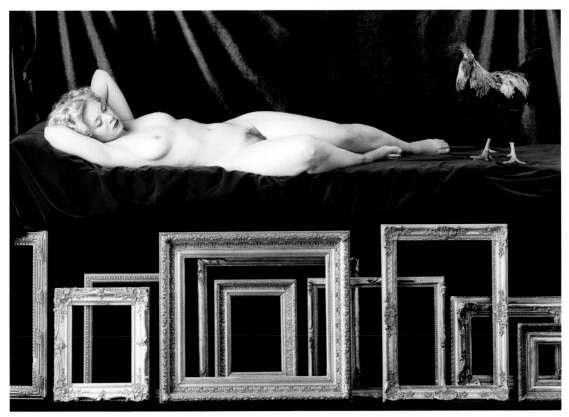

DANY LERICHE,
*Virility,*
2000.

In a more hedonistic register, the American Spencer Tunick's spectacular images also derive from performances. But, while the solitary Appelt convenes telluric forces and while Coplans initially only revealed his body in the privacy of his own home, Tunick operates out in the open, following a production model of almost Hollywood proportions, which calls for the mobilization of thousands of naked male and female volunteers who pose in carefully selected public spaces. These colorful tableaux vivants are the result of a collectively shared moment: the artist's vast installations include 7,000 people in Barcelona on June 2003, 1,493 people in Lyon on September 2005, and 5,200 in front of the Sydney Opera House in February 2010.

Known for his provocative gestures, Robert Mapplethorpe, who died of AIDS in 1989, exalted the beauty of the male body by reconvening the model of Apollo and the aesthetics of nineteenth-century neoclassical painting. His nudes, generally produced in the studio and lit with exceptional care, accentuate the plasticity of muscle-bound models who readily exhibit their sexual organs.

His polar opposite, Joel-Peter Witkin, photographs monstrous and deformed individuals, veritable fairground phenomena, in photographic tableaux inspired by early chromolithography and teeming with objects and hangings. Here and there, digital trickery spawns mutant morphologies; for instance, in the creatures of Inez Van Lamsweerde, who seem to be able to swap their skins like jackets, or the Chapman brothers' horrific figurines.

# THE CITY

What would the history of photography be like without the city? The appearance of the medium accompanied not only the development of industrial production, but also the rapid expansion of the great conurbations as loci of social interchange, where rich mixed with poor, working- with middle-class, and artisans with office boys. In the late nineteenth century, London was partially rebuilt, Berlin—with vast commercial avenues and leafy parks—became the hub of Mitteleuropa, while Haussmann steamrollered his boulevards through Paris. These capitals, with their lively quarters and scurrying inhabitants, emerged as a favorite subject for several generations of photographers, as well as for visual artists who have recourse to photography in their work.

**From the 1950s and 1960s, all eyes turned to New York, the metropolis considered the beating heart of modernity.** Lee Friedlander snapped ads and billboards, while Diane Arbus lifted the lid on the bubbling melting pot of Manhattan. In their wake, William Klein conveys the vitality of the streets of the great American metropolis through penciled prints and overdrawn contact sheets, while Joel Meyerowitz's original camera angles capture the perpetual motion of life in the city that never sleeps. In 2001, Philip-Lorca diCorcia revitalized this American tradition with *Heads*, a series that might be compared to its predecessors *Streetworks* and *Two Hours*, in which he spent a few hours snapping at unsuspecting passersby, surprised by the glare of the flash.

**If the buzzing street remains an exceptionally photogenic theme, it is also a collective space that certain contemporary photographers depict as a focal point of unremitting solitude.**

Thus Valérie Jouve shows anonymous individuals indifferent to their surroundings against a backdrop of windswept passageways and nondescript high-rises. With critical intent, Thomas Struth, another of Bernd Becher's one-time students, undertook a photo essay on urban architecture a few years ago; in particular, on housing projects in the modern city of Düsseldorf. He has since turned his chilly lens onto other cities, streets, and intersections, in a desperate attempt, he confesses, "to discover something real." It is not so much the populations of cities like Tokyo, Naples, Hiroshima, and Edinburgh that seem to attract Struth, as their capacity to reveal the interconnections between the human body and urbanization, a phenomenon he sees as revealing a nation's social, economic, and political substructure. The same, almost anthropological approach surfaces in Andreas Gursky's minutely detailed views of a completely straight avenue, a playground, or a traffic circle.

JEAN-FRANÇOIS
RAUZIER,
*Babel 12,*
2008.
Color print,
39⅜ x 67 in.
(100 x 170 cm).

**Has man ended up totally absorbed into the urban landscape? There remains only the regular pulse of the building façades and their relentless geometry.**

Stéphane Couturier presents these cubistic patchworks as an archaeology of an abstract present, whereas Jean-François Rauzier sees them as the surrealistic image of an oppressive urban architecture. Dennis Adams acts on the street concretely, exhibiting portraits of anonymous men or women on billboards fixed to kiosks, bus shelters, or billboards: a virtual presence in a very real city.

JORDI COLOMER,
*Anarchitekton (Brasilia)*,
2005.
Digital print on photo paper
glue-mounted on Dibond,
43¼ x 59 in. (110 x 150 cm).

# STILL LIFE

"In the series of 'crashed cars,'" Valérie Belin explains, "what interests me is that they were already petrified by the impact of the accident and then secondly by the photograph. That's why we talk about 'still life.'" The artist thus underlines how the photographic medium freezes its subject, and how any photograph is already in itself a "still life." In the Christian tradition, this recurrent theme in the history of art often references the Old Testament and the famous saying in Ecclesiastes: "Vanities of vanities, all is vanity." Especially prevalent in the seventeenth and eighteenth centuries, the highly codified pictorial genre of the *vanitas* invites viewers to meditate on the transience of human existence, on the futility of pleasure, on the fragility of earthly possessions, or on the relativity of all knowledge. Long considered a minor genre, such still lifes are composed of objects symbolizing the passage of time or prefiguring the end of man's life—such as a sandglass or skull, a flickering candle and books, but also figures, like a child blowing bubbles or a withered old hermit. Frequent in contemporary art (think of those composite installations foregrounding giant skeletons or that diamond-studded skull), the memento mori also constitutes a recurrent theme in present-day contemporary photography.

Bringing with it a continuous reformulation of the rules of the genre, the luminous trace called "photography" questions our relationship to reality as much as to the flight of time. Deploying impressive changes in scale, Patrick Tosani invites us to inspect our surroundings more closely—just like Jean-Luc Moulène who, motivated by a sharp critical awareness, shakes up our lazy viewing habits. Allusions

to the *vanitas* remain palpable in his photographic series, such as *Strike Objects* and *Products of Palestine*, which, against a neutral ground and what is a subversion of the language of advertising, show objects loaded with connotations of class struggle or armed conflict instead of consumerism. Openly asserting his affiliation with the painterly genre of the still life, visual creator Urs Lüthi produced a series entitled *Treat Me Like a Stranger*, made up of eight diptychs that each juxtapose a composition of fruits, plants, and flowers with a half-length self-portrait. Véronique Ellena also blends references to traditional painting with a neutral vision typical of the contemporary idiom in sober, minimalist compositions that highlight the

SAVERIO
LUCARIELLO,
*Vanitas with
Lampshade,*
2006.

inevitable demise of all things. In a more comical, not to say deliberately unhinged vein, the Italian Saverio Lucariello's photographic compositions, in which he adopts the most curious poses, are worthy of a wax museum. In one, the severed head of the artist lies on a table set with fruit and flowers, in exact accordance with the time-honored codes of *vanitas* still life. In no less caustic a spirit, the Swiss duo Peter Fischli and David Weiss intone the inexorability of fate in many works—in particular in *Quiet Afternoon—Equilibrium,* a series of twenty-seven tottering compositions made of vegetables or objects as commonplace as shoes, bottles, and chairs, which can be read as a metaphor for an existence full of surprises and always precarious.

PATRICK TOSANI,
*E*, 1988.
Cibachrome
print,
71⅝ x 47⅛ in.
(182 x 120 cm).

VALÉRIE BELIN,
*Untitled*, 2007.
C-print,
70¾ x 70¾ in.
(180 x 180 cm).

# LANDSCAPE

Whether or not they adhere to the conventions of the genre, artists can hardly keep away from landscape, a theme that has inspired photographers since the medium was invented. The spectacle of nature has long acted as a magnet, and many a photography pioneer dragged his hefty equipment through a dense forest or sparse undergrowth. A passionate experimenter, Gaspard-Félix Tournachon, alias Nadar, was the first to take views of both the city and countryside from a hot-air balloon, to the amazement of the public. As for the autochrome plates of the Lumière brothers, with their thick grainy feel and their subtle nuances, they resemble pocket-sized impressionist paintings. Indeed, the pictorial model long remained an inescapable reference, as attested by the elegiac prints of Edward Weston and Ansel Adams, for example.

But the 1960s yet again heralded a turning point as the tradition underwent a serious shake-up. Initially the American photographers who gathered under the banner of the "new topographics" opened viewers' eyes to the nation's soulless suburbs, to industrial parks in the middle of nowhere, to skylines cluttered with billboards, and to transportation systems that disfigure the scenery: examples include Robert Adams, Lewis Baltz, and Stephen Shore, who all share this critical stance. Then came the practitioners of land art, such as Christo and Jeanne-Claude, who intervene directly in the territory, carrying out transitory actions or creating spectacular in situ installations. In a variant on this approach, other artists interact with the landscape in accordance with a precise protocol—like Hamish Fulton and Richard Long, who transcribe their solitary peregrinations in photographs accompanied by texts.

THIBAUT CUISSET,
*Untitled No. 38*,
from the
*Iceland* series,
2000.
Resin-coated
color print.

Clearly, too, the government-funded topographic surveys launched in various countries and inspired by the photographic missions dispatched to the states of the American West in the nineteenth century also played a part in reconfiguring the image of landscape. **Today, a photographer is also a citizen, conscious of how the natural resources of the planet are far from inexhaustible.**

In a series that has met with resounding popular success, Yann Arthus-Bertrand endeavors to demonstrate the fact in views of the Earth from the air. Others are engaged in investigating the complex interrelationship between local and global, between overproduction and the devastation it occasions in hitherto unspoiled places. This desire to denounce the upheaval caused by overconsumption informs the work of the Chinese Yao Lu, who, in an ironic and metaphorical idiom, militates against the uncontrolled industrialization of

DARREN
ALMOND,
*Dragons Eye,*
2008.

his country by morphing sites laid waste by its effects into small landscapes worthy of the traditional woodblock print. The nostalgia for ancient China is exacerbated to the point of absurdity in Nadav Kander's sometimes disconcerting images, which seem like something out of a science-fiction movie.

**But can photographic landscape still evoke an idea of the sublime?** The prints of Martin Parr, showing hordes of tourists gawping in front of Niagara Falls or at the foot of Mont Blanc, just like the beach scenes teeming with vacationers in which the Italian Massimo Vitali specializes, propose a very different conclusion: the apocalyptic vision of a world submerged by a culture of leisure.

Likewise, Edward Burtynsky's views from above giant car parks make the head spin. If, despite it all, the notion of place as conducive to contemplative meditation survives here and there, the predominant sense is that this can represent no more than a short interlude. In this vein, if Nicolas Dhervillers's face-offs between man and nature unsettle viewers, the mist (like the famous sfumato of Italian sixteenth-century mannerist painting) that descends on the images of Darren Almond endows them with undeniable serenity, while the Icelandic scenery presented by Thibaut Cuisset impresses with subtle coloring and linear balance, as well as by the feeling of plenitude they exude.

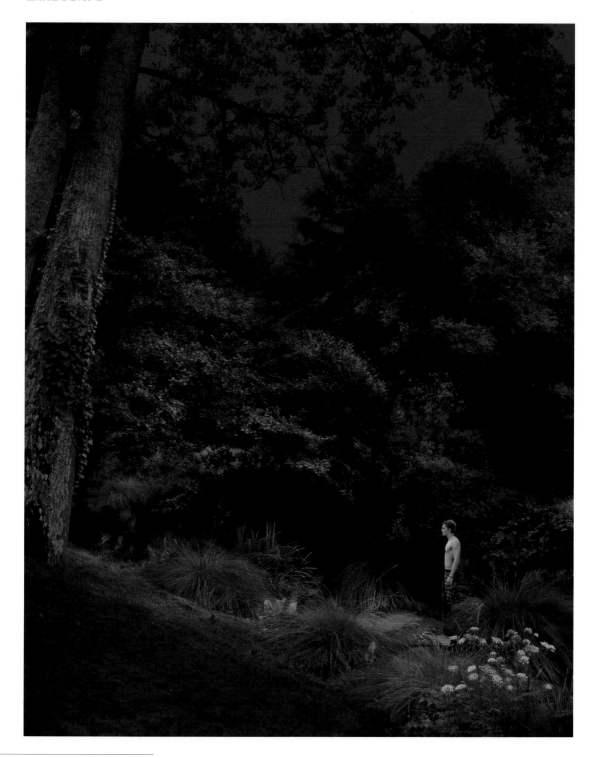

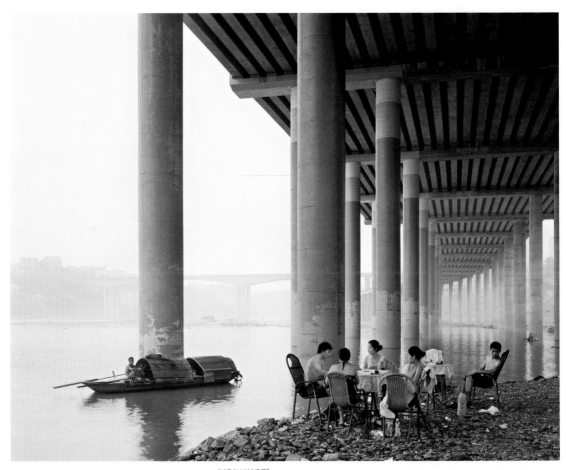

NADAV KANDER,
*Chongqing IV
(Sunday Picnic),
Chongqing
Municipality,
from the series
Yangtze, the
Long River,
2010.*

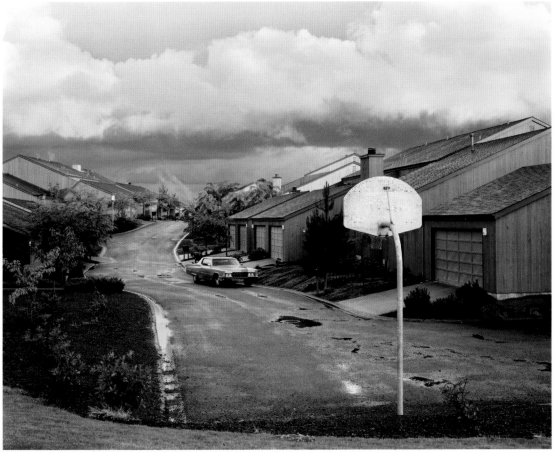

JOEL STERNFELD,
*Lake Oswego,*
*Oregon,*
June 1979.
C-print,
48½ x 58 in.
(123 x 147.5 cm).

# THE GRANDEUR OF PAINTING

Painting and photography: what a story! The relationship has been a fraught one, however. Painters initially looked down their noses at images obtained by mechanical means: no feeling, no interpretation, just an imprint left by light on a glass plate. Then, when photo studios started monopolizing the market for domestic portraiture, they claimed unfair competition. But masters such as Delacroix and Delaroche, as well as the founders of the Barbizon School, quickly realized the advantages of using photographic prints as documents for preparatory study and for reproducing artworks. Even once the hatchet seemed officially buried, the two sides remained wary of one another. If the impressionists showed the superiority of painterliness by tackling light itself as a subject, a few years later the pictorialists were promoting photography as an art.

As has been already noted, German Dadaists, Russian suprematists, and then French surrealists all showed considerable interest in photography as a technique in keeping with the modern age. Pop artists, throwing themselves bodily into reality and engaging with the advent of the consumer society, produced pieces inspired by photos they found in the press or advertising.

Many figurative painters, such as American hyperrealists John De Andrea and Duane Hanson, used overhead projectors to attain photographic verisimilitude in their compositions. On the opposite flank, artists such as Gerhard Richter and Chuck Close, both painters and photographers, reject the preoccupation with ocular vision, reproducing in acrylic paintings photographic effects such as blurring or digital pixelating.

FACING PAGE
GILBERT GARCIN,
*The Danger
of Images,*
2009.

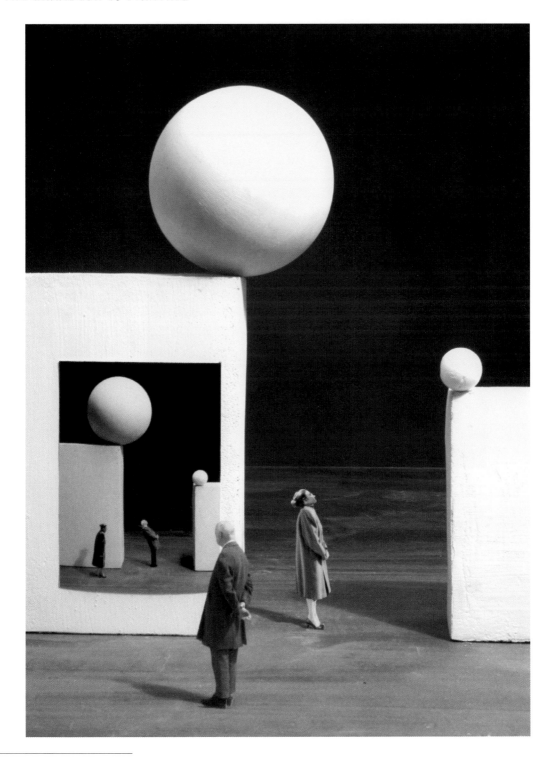

CINDY SHERMAN,
*Untitled No. 24,*
1990.
Color photo,
48 x 38 in.
(121.9 x 96.5 cm).

**Today, photography is no longer persona non grata in the land of fine art. By dint of repeated incursions it has attained a legitimacy of its own: the painterly formats of tableau photography have returned figuration to center stage. Now that recycling, quotation, and pastiche are all the rage, some photographers set their sights on painting with a capital "P," revisiting and revising, for example, the canons of "academic" beauty.**

Some engage in contemporary rewrites of iconic artworks, as with Jeff Wall, or, with Mohamed Bourouissa, assimilating the heritage of Caravaggio or Géricault in reinterpreted scenes of urban violence; but there are also those who, on the contrary, like David Buckland, rely on overkill and derision, posing actors in period costumes or in the attitudes of sitters in paintings by Jan Van Eyck, for instance. Others again, such as Olivier Richon and Dany Leriche, inaugurate ironic dialogues with great art of the past by zeroing in on certain details in old masters or in highlighting the rigidity of the conventions they observed. In the form of a diptych, Joan Fontcuberta associates Munch's famous *Scream* with a

CLARK 8 POUGNAUD,
*Mireille*, from the
series, *Homage to
Edward Hooper*,
2000.

photograph of a lifeless landscape. Karen Knorr's ambitious compositions are often lifted from classic painting, while in an attractive series entitled *Conversation Pieces* (2002), Christian Milovanoff plays fast and loose with the impressionists by photographing groups of men and women beneath the vibrant shadows of huge trees. More disconcerting still, some major photographer-reporters tackle present-day war zones through direct allusions to themes in biblical painting. Meanwhile, in a telltale process of reciprocal influence and dynamic exchange, the Kosovo Pietà—a celebrated photograph by Georges Mérillon—inspired a striking installation by artist Pascal Convert.

# COLOR

Patented in 1903 by the brothers Auguste and Louis Lumière, the color film photographic process of autochrome did not meet with universal acclaim. Color photography was long reproached for lacking character and for diluting the visual impact of the image. Thus, for example, among adherents of the *doxa* of Straight Photography that came to prominence in the United States in the early twentieth century with Alfred Stieglitz and Edward Steichen, only black-and-white would do. This inflexible standpoint was also adopted among followers of the German New Objectivity. Apart from a few sporadic forays into color, its presence remained discreet—to the point that when, in 1941, American photographer Harry Callahan began to work in the medium, he felt so out on a limb that he abandoned the technique for some thirty years. In the 1960s, however, such aesthetic resistance had to give way before the advent of new printing techniques that made it possible for magazines to publish color features. Odd though this may seem, even Robert Doisneau produced an exemplary color portfolio for *Fortune* magazine: a lucid if tongue-in-cheek reportage on life among the rich retirees of Palm Springs, an artificial city built out in the desert that boasts dozens of golf courses and hundreds of swimming pools.

**The pop art explosion and the rise of the consumer society were also instrumental in converting many American photographers to color. Enabling them to capture more closely the vitality of the American way of life and the transformation of its urban landscapes, they snapped neon billboards, ads, supermarkets, and gleaming automobiles.**

And when, in June 1976, John Szarkowski, then director of the department of photography at MoMA, opened a retrospective dedicated to photographer William Eggleston, he presented him as the "inventor" of color photography, no less. Enthused by the famous dye transfer process, it is true that Eggleston's compositions are structured around zones of

JACQUES BOSSER,
*Myoshi*, from the
*BTK Project* series,
2006.

different hue. Depicting reality and fore-
grounding color seemed natural to photog-
raphers such as Helen Levitt and John Batho,
who use it to emphasize particular elements.
By privileging clashing tones and flashy col-
ors, the fashion photographer David
LaChapelle smashes our notions of good and
bad taste into smithereens.

Artists who deploy color photography as a means of expression stand on culturally familiar terrain—especially if they practice painting in parallel. A thorough knowledge of art history may induce them to question the interface between the materiality of paint and the planar surface of the photographic print. They tend to pay special attention to developing techniques: the carbon print, gum bichromate, and cyanotype have all found favor.

For example, painter Jacques Bosser's photographic portraits, which appear to be hand-painted, often allude to works by the Nabis or the Fauves. Karen Knorr works on this "painterly surface" aspect in glitzy series: some, especially those inspired by Orientalist paintings, look like hymns to the subtle glories of colorimetry. Candida Höfer dissects the symbolism of structures dedicated to learning and culture: lecture halls, libraries, theaters, etc., insisting on the relations between material and color, while Boris Mikhailov morphs his prints into garish chromos.

Finally, adventurous experiments have been carried out by, among others, Lucas Samaras, who manipulates the wet dyes of Polaroid, and Christopher James, who colorizes black and white photographs. Anything goes with color.

BORIS MIKHAILOV,
*Untitled*, from
the *Luriki* series,
1976–81.
Hand-colored black
and white photo,
19⅜ x 23⅜ in.
(49.5 x 59.1 cm).

FACING PAGE

JOAKIM ENEROTH,
*Comfortably Secure 11*,
from the series *Swedish Red*,
2005–09.

JOHN BATHO,
*Parasol No. 4.*
from the series
*Parasols,*
1981–2002.
Color carbon print,
11¾ x 15¼ in.
(30 x 40 cm).

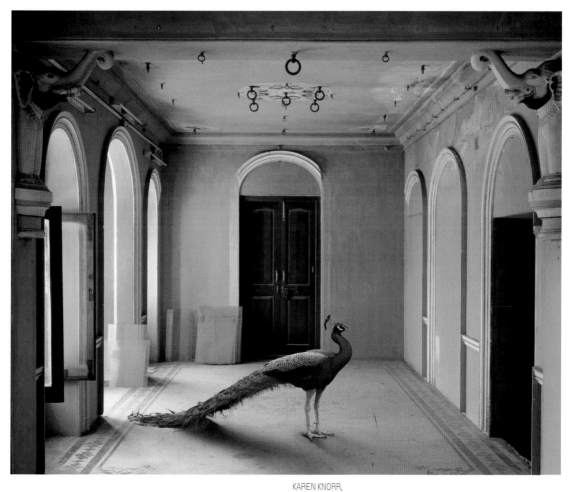

KAREN KNORR,
*The Queen's
Room, Zanana,
Udaipur City
Palace*, from
the series
*India Song*,
2010.

# BLACK AND WHITE

The adepts of black and white play it like jazz musicians: any variation goes, as long as its spirit, tempo, and balance are respected. Learning the techniques of black and white remains the alpha and omega for any apprentice photographer who thus learns how to use light (natural and artificial) or to add volume, to excavate a surface or to mold a body. More than three-quarters of the history of photography is written in black and white. In the past it had its masters: it now has its stars. Among these, one of the most admired magicians of chiaroscuro is the Japanese Hiroshi Sugimoto, whose technical expertise and control of lengthy exposure times are unanimously acclaimed. Open invitations to meditation, the landscapes and interior views of this artist, who came to California to study, bathe in a serene calm. Patently influenced by minimalist and conceptual art, but also by the spirit of Zen, Sugimoto's photos can be read as visual versions of haiku. Among many series, one of the most remarkable was begun in 1978, and concerned old movie theaters and drive-ins throughout the United States. These enclosed spaces, illumined by the glare from the white screen, exude an aura that perfectly captures the magical atmosphere of the cinema.

For Bernard Plossu, photography and walking go hand in hand. In 1958, when aged just thirteen, he was given a Brownie Flash camera by a father who loved hiking. Since then, Plossu has been crisscrossing the planet in a search for subjects. As he quips: "To take good photographs, you need a sturdy pair of shoes." A remark that also says a lot about the quality of his eye: clear and uncomplicated. As he also says: "In my photography, the relationship with nature is paramount. Walking is the natural pace of curiosity. The straightforward, unadulterated vision of a 50 millimeter suits this perfectly." Using the least distorting lens, the one closest to human eyesight, allows this poet, who remains faithful to black and white and to modest formats, to convey the profound emotions he feels before the grandeur of a landscape or some moment of shared joy.

BERNARD PLOSSU,
*Mexico City,*
1996.
11¾ x 9½ in.
(30 x 24 cm).

The Brazilian Sebastião Salgado owes his worldwide fame to impressive photographs taken in the course of a number of assignments at coal mines in the state of Bihar in India or monitoring work on a canal in Rajasthan. His strongly contrasting black-and-white prints, showing a human anthill toiling endlessly in extremely dangerous conditions, have the look of a biblical apocalypse. His predilection for pathos has been much criticized, though, by those who believe that documentaries should deal solely in the neutral and objective. The dramatic power of his pictures has earned him many awards, nevertheless, in particular for two works dedicated to mass population movements published in 2000. Another adherent of the quiet harmony of monochrome, Jean-Michel Fauquet "manufactures" photographs by patiently elaborating his shots and subsequently intervening directly on the positive, producing strange forms that seem as much crafted by hand as taken by a camera.

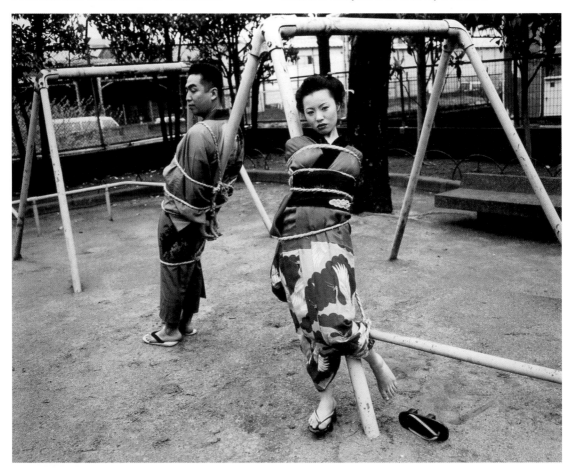

NOBUYOSHI ARAKI,
*Untitled*,
undated.
Black-and-white photo.

JEAN-BAPTISTE HUYNH,
*Eucalyptus*,
1999.
27⅝ x 27⅝ in. (70 x 70 cm).

It is obviously impossible to cover every member of this brotherhood devoted
to the absence of color, but it would be a shame to end without mentioning
the splendid classicism of the portraits, nudes, and still lifes of Jean-Baptiste
Huynh. The very texture of the surface, the beauty of the lighting, the static
power of the closely framed subjects all confer on these photographic tableaux
a spiritual depth that plunges the viewer into a meditative state.

**5**

**ZOOM IN ON . . .**

# PHOTOGRAPHY IN ADVERTISING

Advertising photos invade streets and subvvay corridors, they cravvl over bus shelters and stadiums; billboards, light boxes, and LED screens extol branded products and trade names. The pages of nevvspapers, magazines, and fliers are avvash vvith slogans. But, in the age of the Net and of digital imagery, can advertising photography still inspire artists? Its salad days came during the rise of the consumer society and before competition from TV. But vvhat about the situation today? First, let us briefly go back in time: vvith the occasional rare exception (such as the famous picture of a detachable shirt collar that Paul Outerbridge took for *Vanity Fair* in 1922), early visual advertisements vvith photography eulogized the article vvithout any particular aesthetic intention, and this certainly never threatened the hegemony of pencil and paper. Things speeded up, though, vvhen nevv technical developments allovved magazines to increase print runs and vvhen advertisers became hooked on the medium of photography as evidence of reality—and therefore of truthfulness.

**Revelatory of the desires and tastes, conscious or not, of the majority, advertising photography, vvith its individual syntax and codes, vvas soon being studied in universities as a vvindovv on the zeitgeist.**
In 1964, critic Roland Barthes published a much-read article in the fourth issue of the French review *Communications* entitled "Rhetoric of the Image," which unpacked the multiple messages contained in an advertisement for Panzani pasta. Among other features, Barthes exposed hovv a successful advertising message leaves certain things unsaid and deals in paradoxical injunctions. A year later, social philosopher Pierre Bourdieu devoted a book to photography, *Un art moyen,* containing an article by Gérard Lagneau on "smoke and mirrors" in advertising, entitled "Trompe-l'œil et faux-semblant," which addressed the question: "Vvhat is the specificity of advertising photography? Its originality springs undoubtedly from the intention behind it: it only exists to make people buy vvhat it represents, that is, something different from vvhat it is. That much is clear." Then, at the davvn of the nevv millennium, Naomi Klein, in her book *No Logo,* pursued an analysis of the increasing role played by the marketing departments of major brands vvhose aim is to dupe the public and introduce the culture of merchandising into everyday life.

**This much must be conceded: since a company's public image is a weapon of war, advertising photography remains a genre apart. Dreamed up by agencies, in the majority of cases it is the result of a collective enterprise involving an armada of "creatives" and "art directors," who in turn have to subject their ideas to a battalion of execs intent not only on fulfilling the often contradictory desires of the customer, but also on fitting in with the market and lifestyle choices of the product's intended "demographic." What is more, the entire project forms part of a PR strategy, devised using polling companies and focus groups, aided and abetted by a posse of linguists, semiologists, sociologists, and psychologists.**

Not to mention the fact that any final visual will have to find space for text (brand, byline, USP) and be printable on a letter-size sheet as well as on a twenty-foot-wide poster. In a global market, advertising images are far too important to be left to the whim of some all-powerful creative artist.

However, in spite of the vagaries of fashion, standardization, and the demands of business, worthwhile examples of collaboration between a brand and a photographer have existed—in particular during the postwar boom. Thus, the impressionistic style and flower-power waifs of Sarah Moon will forever be associated with Cacharel couture and perfume, while the colorful and often enigmatic compositions of the exceptionally gifted Guy Bourdin did much to endow Charles Jourdan shoes with the cachet they enjoy today. The same goes for the elaborate settings chosen by Serge Lutens that bring out the ethereal beauty of the models in ads for the Japanese cosmetic firm Shiseido, the elegant variations on the theme of travel that Jean Larivière proposed for Louis Vuitton, or the shock-and-awe campaigns signed by Oliviero Toscani for Benetton. More recently, the Galeries Lafayette in Paris have turned to the gleeful world of Jean-Paul Goude (famous for a 1989 advertising campaign for Kodachrome film), while Tag Heuer luxury watches have solicited the services of Patrick Demarchelier in a bid to secure contracts with some of the world's most bankable stars. As for Peter Lindbergh, he has photographed for the famous Pirelli calendar twice, in 1996 and 2002. Successful marriages of this kind are few and far between, though.

Most of the time, when a brand does employ a renowned photographer, they tend to remain anonymous. The same names crop up in the studios of high fashion. Sometimes a recognized photographer from the art scene will do a shoot or two, like Philip-Lorca diCorcia, Stephen Shore, and Sam Taylor-Wood.

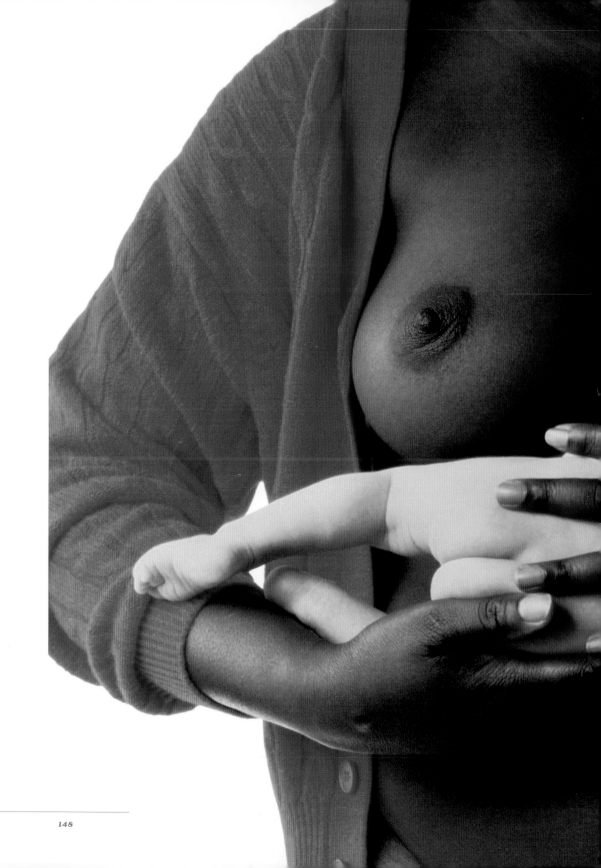

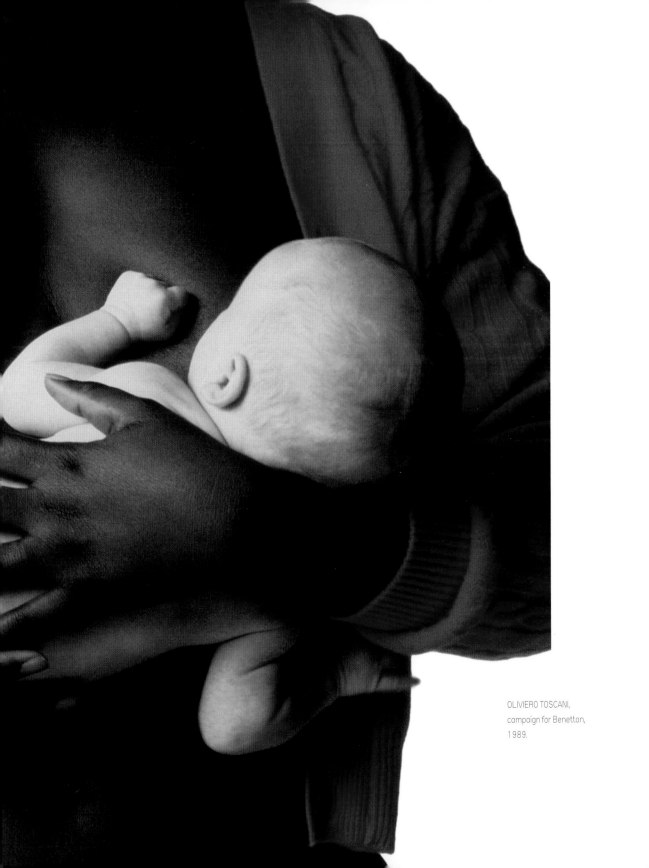

OLIVIERO TOSCANI,
campaign for Benetton,
1989.

# FASHION PHOTOGRAPHY

Fashion photography: light and glamorous? Yes, and also, occasionally, awash with "sex, drugs, and rock and roll." Everyone is beautiful, young, and attractive. The watchwords are insolence, desire, fantasy, and an attitude in step with the spirit of time. As with advertising, fashion photography is the result of a collective effort to fulfill a detailed brief. It calls for the collaboration of a team including art directors, stylists, makeup artists, hairdressers, copywriters, and assistants. But it, too, has its masters and its supermodels, icons of a pagan cult where money and luxury reign. Every week its gospel occupies center-page spreads in trendy magazines (*Vogue, VV, The Face, Harper's Bazaar, Dazed 8 Confused, i-D, Purple, Tank, V.*) and over the last few years it has spilled out over the walls of galleries and museums. The cross-fertilization between the universe of fashion and the world of art was consecrated in Susan Kismaric and Eva Respini's groundbreaking show *Fashioning Fiction in Photography since 1990*, held at MoMA in 2004.

ZOOM IN ON . . .

"Whether they know it or not, all photographers are pupils of Brodovitch," Richard Avedon declared one day. Art director of the magazine *Harper's Bazaar* between 1934 and 1958, and head of a design school, the Russian Alexey Brodovitch was single-handedly responsible for standing the precepts of fashion photography on their head.

Influenced by the works of Dada artists and constructivists, and by the products of the Bauhaus (the German school of modernist design founded by Walter Gropius in 1919), Brodovitch sought to inject new dynamism and modernity into the hidebound world of fashion. The initiator of a new visual language, with original layouts that combine images and typographically interesting texts, he contributed to the emergence of a freer, more spontaneous approach to photographing the models of haute couture, exalting movement and natural poses.

WILLIAM KLEIN,
*White Faces*,
*the Opéra, Paris*,
1960.

In addition to contributions from André Kertész and Henri Cartier-Bresson, Brodovitch launched many a star of fashion photography, including Richard Avedon himself, who after World War II revolutionized the genre with photographs of models in ordinary poses, and a Chinese-born photographer of Japanese extraction, Hiro, who made his name with original compositions and combinations of strong colors. Other major protagonists include Irving Penn and his graphically stylized images, Herb Ritts and his references to the art of the ancient world, and Horst P. Horst with his inimitable sense of theater.

**But a further step change was to come about in the 1980s. Now reaping colossal profits, the demands of the luxury goods market shifted, and the circle of fashion initiates widened. Henceforth, a couturier's name had to be associated with a range of products sold worldwide, and an illustration showing an exorbitantly priced dress or suit was designed to tempt average purchasers to splash out in compensation on a bag, perfume, or some other more affordable offering from the same chic stable. In spite of the often narrow remits presented to agencies, some photographers succeeded in imposing a style.**

Influenced by the German cinema of the 1930s, Helmut Newton, for example, managed to keep faith with his trademark black and white in ambiguous scenes that beautify ultra-sophisticated women indulging in erotic dalliance in luxurious surroundings. Exhibited in very large formats, these images of naked, superfeminine creatures, perched on stiletto heels and striding forth as if to conquer the world, made their creator a household name. This universe of "porn chic" was developed along more commercial lines by the exceptionally gifted Mario Testino, in collaboration with Carine Roitfeld (from *Vogue* magazine) and Tom Ford (for Gucci).

Another photographer with a taste for exhibitionism and provocative shots, Terry Richardson fostered lowlife fantasies on prestige brands such as Miu Miu, Gucci, and Sisley. With a predilection for dramatic contrasts between light and shade that compose into a graphic and virile universe, Mondino also partakes of this penchant for in-your-face imagery. Also favorites among top-of-the-range photographers, the Mert & Marcus duet sing paeans to artifice in an ultra-smooth style and with generous dose of the airbrush. Steven Meisel is of the same stamp, with a fondness for detail and suggestive poses. David LaChapelle revels in clashing colors with kitsch congregations where the models resemble over-made-up dolls strutting their stuff in incongruous locations—a butcher's, scrapyard, or church. The German Juergen Teller, who first made his name on the music scene, seems to improvise his shoots backstage. In a different vein, Nick Knight uses and abuses a left-field, futuristic aesthetics, while Inez Van Lamsweerde is busy inventing the mutant body of tomorrow. The fashionista honor roll also includes the names of Dimitri Daniloff, Mario Sorrenti, Neil Stewart, Ellen von Unwerth, Stéphane Sednaoui, Mark Borthwick, and Ferdinando Scianna, not forgetting Patrick Demarchelier, with couture work for the house of Dior.

And what is the common purpose of such a vast range of styles? To make us dream!

# PHOTOJOURNALISM

Has the crisis in the press—the advent of information sharing, the mass of uncredited images captured on cell phones, competition from the blogosphere, and instant tweeting—finally killed off photojournalism? Or is it rather a victim of how photographers are being increasingly denied access to military operations and that they appear superfluous in conflicts for which essentially no images are authorized—as during the second Gulf War, for example? Is the cult of the scoop and the shocking photo now no more than a distant memory? Would celebrated photographs such as Robert Capa's, of a Spanish Republican fighter shot down on the battlefield (its authenticity has been disputed), or Huynh Cong ("Nick") Ut's, representing a tiny naked Vietnamese girl fleeing her blazing village (a photograph that also raises questions), make the impact they once did? Would they still be seen as testifying to acts of real violence? Would they change public opinion and challenge unacceptable aspects of a nation's policy? The Vietnam War simultaneously represents the high-water mark and the onset of a decline in photojournalism: after the blanket, unrestricted coverage of the conflict by figures such as Larry Burrows, Don McCullin, David Douglas Duncan, Philip Jones Griffiths, and Christine Spengler, the US Army chiefs of staff learned the lesson and changed strategy. While, for more than half a century, reportage photography remained in step with what was happening in the world, today the essence of current events seems to slip through its grasp, resulting in a grave identity crisis among its proponents.

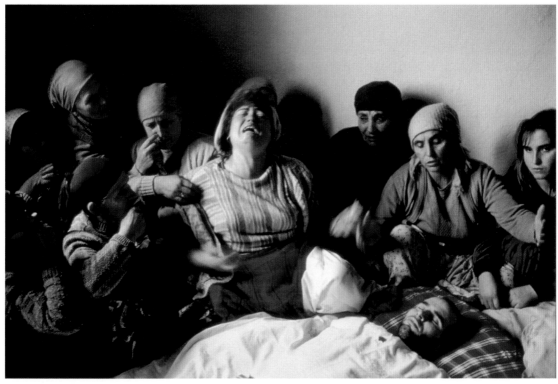

GEORGES MÉRILLON,
Photograph known as *The Pietá of Kosovo*,
Kosovo, Yugoslavia,
January 30, 1990.

**What can be done? How should one react when American soldiers, guarding detainees in Iraq's Abu Ghraib jail, strike poses shamelessly before their humiliated victims for photographs that later appear in newspapers and on TV all over the world? Why should a photographer scour the globe in search of some collective drama or bloody conflict to denounce, or some natural disaster to cover, if the sheer speed of information today excludes vision, analysis, and even a modicum of professionalism? A number of reporters have taken up the gauntlet, trying to counter the competition and stymie the dictatorship of rolling news by approaching their task in new ways and freeing themselves from the shackles of traditional photojournalism. For, indeed, in an age of digital doctoring and fakery, can any photograph really alter the course of history?**

The "hammer-blow" reportages of William Eugene Smith (1918–1978) and Weegee (1899–1968), for instance—two great, socially aware American photographers who were at the summit of their fame in the years 1930–50—would surely not make the same indelible impression today. In the twenty-first century, reporters seem to have to envisage a diametrically opposed stance: positioning themselves more reflectively, their language has to become more personal. In their case, words like "author" and "style" are no longer inappropriate; indeed, in some cases they have become enshrined. And the majority possess a good working knowledge of the history of photography and of art. But what are they supposed to take pictures of?

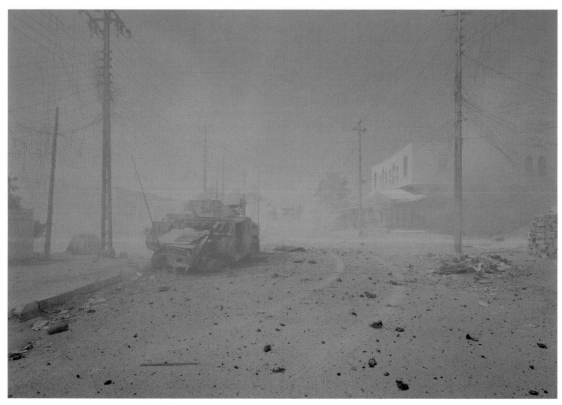

LUC DELAHAYE,
*Ambush, Ramadi,*
2006.
Digital chromogenic
print,
94½ x 65½ in.
(240 x 166.5 cm).

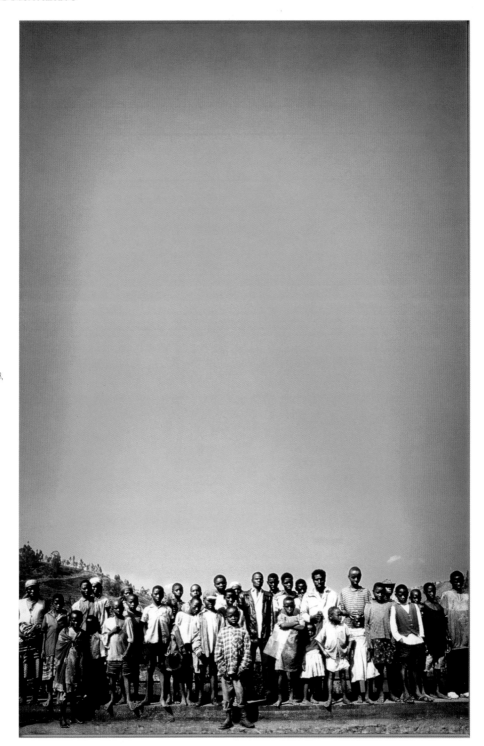

ALFREDO JAAR,
*Waiting,*
1994.
Ektachrome,
light box,
18 x 12 x 5 in.
(45.7 x 30.5 x
12.7 cm).

Sophie Ristelhueber's approach, for example, is one of the more unusual and more resistant to the standardization of the information media. During a stay in Beirut in 1983, at the height of a full-scale civil war, Ristelhueber took photos of the battered façades of the city's buildings because, in her eyes, they seemed to convey more than actual scenes of battle. The report marked the beginning of a project dealing with the marks and fractures that brutal conflict leaves on a landscape or on a body. This distillation of disorder took a still more eloquent turn in her now famous photographs taken from the air in the Kuwait desert, showing caterpillar tracks left by tanks in the sand. Michal Rovner, too, has found a critical edge in her war photography. Disembodied like an immense electronic game, it comes in series of large pictures, not taken in the field, but made up of images on TV screens. Similarly distancing himself from current events, Luc

Delahaye builds images taken from reality into pictures referencing old masters. As for Éric Baudelaire, his withdrawal from the crudeness of fact sees him reconstructing real-life situations using actors. Gilles Peress of the Magnum Agency has declared: "A photo functions as a memory. In the absence of justice, at least there's a scrap of memory." In the light of this remark, in 1994 he produced a piece containing one hundred photographs without texts or captions, on atrocities committed in Rwanda, Tanzania, and Zaire. Classified along biblical lines—"sin" (massacres), "purgatory" (the unreliable flow of aid), and "judgment" (the dead, the casualties), it amounts to a broadside against the compassionate impotence of humanitarian action. More radical still, in the same period, the Chilean Alfredo Jaar placed five hundred and fifty prints taken in Rwanda in hermetically sealed boxes, inscribed with a description. Less reactive, the approach of French photographer

BRUNO SERRALONGUE, *Yes or No. Should the New Fabris Factory be Destroyed by Its Employees? Châtellerault, Friday, July 31, 2009*, from the series *New Fabris*, 2009. Ilfochrome print posted on aluminum, 50⅛ x 60⅜ in. (127.5 x 158.5 cm).

PHILIPPE CHANCEL,
Photograph taken
from the series
*Arirang, North
Korea,* 2005.
Digital print
on photo paper
under Diasec,
47¼ x 35½ in.
(120 x 90 cm).

Bruno Serralongue involves questioning
the artist's responsibility in the face of social
conflicts or survival struggles, in systematic
documentary investigations focusing on
migrants or social pariahs.

In the humanist wake of Sebastião
Salgado, James Nachtwey, who has cov-
ered war and conflict over thirty years for
many outlets, paints a picture of a world in
misery, his sensitive approach being shared
by another great adventurer of photo-
reportage, the Iranian, Reza.

**But it is probably Raymond Depardon who first undercut the whole
practice of photoreporting with his concept of "weak time."
"In a photograph of 'weak time,'" he declares, "nothing would hap-
pen. There'd be no point of interest, no decisive moment, no splen-
did color or light, no little sunbeam, no chemical hi jinks—except
in order to attain extreme gentleness. And the camera would be
like a kind of CCTV." A curious declaration from someone who
otherwise embraces an ultra-subjective vision of the world.**

PAGES 160-161
ÉRIC BAUDELAIRE
*The Dreadful Details,*
2006.
C-prints under
Diasec, framed,
82¼ x 147¾ in.
(209 x 375 cm).

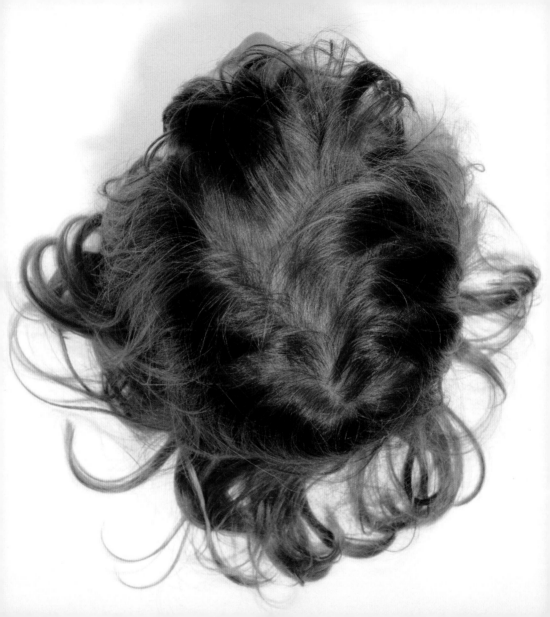

# 6

## INNOVATIONS
### A LOOK BACK AT SOME
### OF THE SCIENTIFIC EXPERIMENTS,
### OPTICAL GAMES, CHANCE DISCOVERIES,
### AND BRILLIANT INVENTIONS THAT HAVE
### AIDED PHOTOGRAPHIC ARTISTS IN THEIR
### QUEST FOR NEW IMAGES

# The photo book
## (1844)

A photo book (coffee-table book or photo album) is quite simply a volume containing a number of images accompanied—or not—by a text. As published, it may be arranged by theme and multi-authored, or else take the form of a monographic overview of the career of a single photographer. Such photo albums thus allow the photographer to publish a long-term project undertaken either to order or, more frequently, of his own volition. The photographer-cum-author resembles a film director, who shoots a script that evolves over the course of his assignment. Almost every photographer cherishes the ambition of bringing out a book. An album enables the photographer to show his pictures, as at an exhibition, but with the added advantage of international reach and longevity.

If the publishing of books of photographs has accelerated in step with advances in

ROBERT DOISNEAU,
*Untitled*, photograph taken
from the photo book *Palm Springs*,
1960.

printing processes, the first photographers, like scientifically minded jacks-of-all-trades, started out by simply sticking their pictures directly into albums. It is believed that the first work of this type, published at the author's expense, was *The Pencil of Nature* by William Henry Fox Talbot, issued in installments from 1844 to 1846 and comprising hand-pasted original prints.

It was, however, only in the 1920s, with the development of process engraving, that the photo book could really take off. A number of legendary titles then saw the light of day and the distribution of an image in book form proved of sometimes greater impact than its appearance in exhibitions. Some of the most important publications in what is a rather specialized area are: *The World is Beautiful* (1928) and *Metal* (1927) by Germaine Krull; Brassaï's *Paris by Night* (1932); *The Americans* (1958) by Robert Frank; Robert Doisneau's *Suburbs of Paris* (1949) and, much more recently, the same author's *Palm Springs, 1960* (2010); Walker Evans's *American Photographs* (1938), and William Klein's *Life Is Good 8 Good for You in New York, Trance Witness Revels* (1958). Visual interaction between typography and image—an association frequently deployed by Russian artists—was particularly creative in publications by Rodchenko and Mayakovsky, and in works by El Lissitzky. In the 1970s, processes such as silk screen, offset, and photocopying made it possible for small-run artists' books, centering on a concept or recording an action, to be issued by makeshift little presses. This was the case for, among others, *Twenty-Six Gasoline Stations* (1963) and *Some Los Angeles Apartments* (1965) by Ed Ruscha (today much sought-after by collectors), as well as Carl Andre's *144 Blocks and Stones* (1973), and the *Autobiography* (1980) of Sol LeWitt. The American artist Richard Prince gives new life to the books, posters, and booklets originating in popular culture that he collects, by drawing on them or making them into collages. All these books are thought up and designed as works in themselves.

Outside the United States, mention should be made of Jan Dibbets's *Robin Redbreasts' Territory* (1969) and *128 Details from a Picture* (1980) by Gerhard Richter. As for Peter Beard, he has revitalized, with gusto, the travel journal. His books—presenting a mix of texts, drawings, and photographs from today and yesterday—each resemble a story within a story and convey his love of Africa wonderfully.

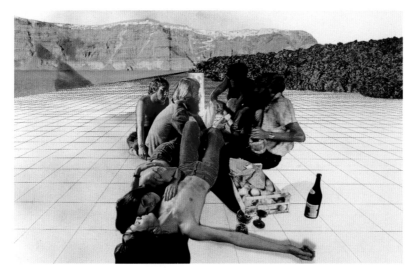

SUPERSTUDIO, group founded in 1966 in Florence and dissolved in 1978, *From Life— Supersurface (fruits 8 wine)*, 1971. Photo collage.

# Photomontage
## (1916)

The word "photomontage" designates a collage made up of photo images from often varied sources. The end result is a dynamic visual patchwork, often carrying a social or political message, in particular when the constituent elements spring from illustrated press cuttings. Doubt hovers over the date of the first photomontage. Retrospectively, the invention was claimed by Dadaists George Grosz and John Heartfield (1916), and by Raoul Hausmann, Hannah Höch, and Johannes Baader (1918). The original idea was to make pictures constituted entirely of preexisting images in a combination of recycling and reconfiguration. Juxtaposing miscellaneous fragmentary images, including photographs shot from very different angles, is a process not unconnected with the optical explosions of cubist painting and the stroboscopic arrays of the futurists. For Raoul Hausmann, the word photomontage "translated our loathing of the artist; imagining ourselves more like engineers, we instead wanted to build, to assemble, or to mount our works." The underlying desire to construct images mechanically was confirmed by the Soviet artist Gustav Klucis: "The word 'photomontage' arose from industrial culture: machines are 'mounted,' turbines are 'mounted.'" Believing in the advent of a New Man in the wake of technological and scientific development, El Lissitzky carried out photographic composites serving Soviet propaganda. While, in 1920s Russia, the photomontage sang the praises of progress, in the Germany

of the 1930s, it stigmatized the advent of the Nazi dictatorship. For the French surrealists it opened the gates of the dream and the unconscious, in particular in the magical paintings-cum-photomontages of Max Ernst. In fact though, all these hotheaded avant-gardists were doing little more than giving a new twist—if in a very different spirit—to experiments undertaken far earlier, in particular assemblies of images from several negatives. Gustave Le Gray, for example, frequently used two complementary negatives for printing his famous *Marines*. As for Oscar Rejlander, as early as 1857 he constructed an astonishing photographic composition entitled *The Two Ways of Life* from thirty-two negatives. Such practices did not, however, serve an "artistic" aim in the fullest sense of the term.

Nowadays, of course, with digital retouching and manipulation software such as Photoshop (Adobe), Corel PaintShop Pro, CorelDraw, and Gimp, mashing elements from different sources has become commonplace, and is often deployed in advertising and publicity illustration. Today's photographers are closer to the spirit of early twentieth-century experimenters when they compose images divided into a number of modules (for example, Jan Dibbets or David Hockney), or mount large-scale images comprised of several prints, as with Gerhard Richter and his composite frescoes, or Jean-François Rauzier with his *Hyperphotos*, assembled from hundreds of photographs taken from different distances.

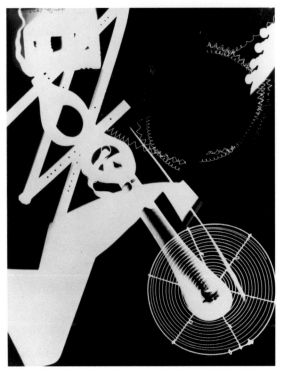

MAN RAY,
*Rayograph*,
1922–23.

In his book, *Self-Portrait*, published in 1963, the artist recounts how: "as I waited in vain a couple of minutes for the image to appear, regretting the wasted paper, I mechanically posed a small glass funnel, the graduate, and the thermometer in the tray, on the wetted paper. I turned on the light and before my eyes an image began to appear, not quite a simple silhouette of the objects, deformed and defracted by the glass more or less in contact with the paper." Fascinated by the abstract shapes, transparency effects and the subtle play of light and shade obtained by a process that leaves much scope for the random, Man Ray appropriated what was an original means of creating poetic, fantastical, and dreamlike images. But in point of fact, well before Man Ray, the Dadaist Christian Schad had already explored the possibilities of making photographs without a camera, while constructivists such as Moholy-Nagy and El Lissitzky used similar effects to "paint mechanically"—that is, without brushes.

The very first such photograms, also called photographic (or "photogenic") drawings, appeared when William Henry Fox Talbot and Hippolyte Bayard, the joint inventors of photography on paper, came up with the idea of testing the action of light on various chemical substances. Placing all kinds of objects and materials (transparent, pierced, opaque) on sheets of sensitized paper, they exposed them for a certain time to daylight and then "fixed" the image. These scientific exercises then rather dropped out of favor until the avant-garde of the 1920s brought them back into fashion with the aim of developing new methods of creating art.

And what is the situation today? The photogram is used rather sporadically. Artists who appreciate the way it appears to bear the trace of an "apparition," or to take "X-rays" of inanimate objects, use the rayograph as just one among a raft of techniques at their disposal. This is the case, among others, for Sigmar Polke, Adam Fuss, Joan Fontcuberta, and Dieter Roth.

# Rayograph
## (1921)

As well as amply demonstrating the point to which artists and scientists share a spirit of experimentation, the invention of the "rayograph" shows how important the role played by chance can be in the advent of a new visual idiom. The paternity of this way of taking photographs without a camera is historically ascribed rather hastily to Man Ray and dated to 1921. An American artist in the orbit of the surrealists, Man Ray stumbled across the "photogram" (an image obtained without apparatus), ignorant of the fact that others had already experimented with the phenomenon, and promptly named it for himself (the term "rayograph" is none other than a contraction of "Ray" and "photogram").

# Photo booth
## (1924)

Is the photo booth (also known as a Photomatic or Photomaton) just for producing the standard ID photos demanded by officialdom? History shows that it has been more than that. The success of the concept derives from its "self-service" immediacy, with which artists have had great fun.

The patent was lodged in 1924, in New York, by its inventor Anatol Marco Josepho, an adventurer and itinerant photographer who had already traveled extensively in Europe, Russia, and China. A brilliant negotiator, by 1927 he had convinced partners to help in marketing his invention. In fact, Théophile Enjalbert in Paris had already invented the process of automatic photography in April 1889, but his design was far more cumbersome and thus harder to commercialize. What, then, was the key asset of Josepho's photo booth? The famous all-in-one cabin that he and his team developed measures just over three by six feet, and serves as both photographic studio and lab. Half the space is taken up by a seat and a curtain; the subject sits down in front of the light and starts the mechanism. Since 1968, with automated prepayment, the customer simply relaxes and lets the machine take over—a special process executes all necessary stages, from the developing tray to the stop bath and fixer, with the photo finally emerging from a slot where it is dried by means of a hot-air blower before being removed by the customer. In the beginning, photo-booth portraits came vertically arranged in fours or sixes, as if in sequence.

In an intelligent bid to maximize sales, the earliest such cabins were set up in the busiest locations imaginable. This plan succeeded and, by 1928, they could be seen in Paris at locations as varied as near the Galeries Lafayette department store on the Boulevard des Italiens, in the lobby of the *Petit Journal* daily, and at the menagerie in the Bois de Boulogne. At this time, customers unfamiliar with the device were assisted by an operator and the photos were delivered in eight minutes.

The 2 x 1¼ in. (48 x 34 mm) format soon established itself as the standard for passport photos. Left to one's own devices behind the curtain, however, one could pull faces as much as one liked. Artists quickly exploited the potential of the device, creating amusing sketches like those of André Breton and his band of surrealists. Later on, Andy Warhol and Franco Vaccari introduced strips of photobooth "mug shots" into their works. The ID photo also inspired Liz Rideal, with her vertiginous piece *Tartan Castle*, a mosaic of portraits that resolves into an image of something else entirely. On going digital in 1998, the photo booth lost much of its magic, and artists began to turn away from the process as it became increasingly dedicated to producing homogenized photos.

ANONYMOUS,
*André Breton,*
c. 1929,
10¼ x 1½ in. (25.9 x 3.8 cm).

# Distortion
## (1927)

The notion of altering images using distorting mirrors was first dreamt up by the Hungarian photographer André Kertész in about 1927. The unique inventor of the process, his photographs were the logical outcome of a highly individual method. When, at just seventeen, his father gave him his first camera, the young Kertész took an original photograph of his brother swimming underwater, his body already slightly distorted by the water ruffled at the surface of the pool. When this wanderer settled in Paris in 1925, he soon felt the influence of his surrealist friends and, like them, began following his instincts and trying to forge his own personal vision of the world. Ever on the lookout for new images, one day he had the idea of taking pictures in the kinds of mirrors found in funfairs that make the viewer hugely fat or thin as a rake, tiny or gigantic.

Kertész's intention was not to amuse, however, or even to create weird and wonderful images, but rather to instill the image with mystery. The first distortion obtained in this manner, without retouching or manipulating the negative, shows the face of a woman with disproportionately large eyes and nose: half-monster, half-mutant. The principle of deformation met with a measure of public suc-

cess in 1933, when the newspaper *Le Sourire*, which specialized in glamour photography, published a dozen distorted female nudes. In fact, the series was composed from hundreds of shots made with a $3\frac{1}{2}$ x $4\frac{3}{4}$ in. (9 x 12 cm) view camera. To do this, premises that had been fitted with two mirrors (of the amusement park hall-of-mirrors variety) were placed at Kertész's disposal. In 1983, the photographer recalled how the shoot unfolded: "I spent four weeks photographing the young woman—for the most part twice a week. I developed the glass plates and did my own printing.... When I'd exhausted all the possibilities of the mirror, after about two hundred negatives, I just stopped." The photographer seems to have exploited the entire gamut of the distorting potential of these mirrors, from simply stretching the body to completely disintegrating it, often reframing or cropping the results. Kertész's great lesson? That the photographic image—freed from the straitjacket of resemblance—can be made to bend to the demands of the imagination. The notion of detachment from the referent is one that many contemporary artists, even those less interested in distortion than Kertész, have embraced with zeal.

ANDRÉ KERTÉSZ, *Distortion No. 91*, from the *Distortions* series, 1933. Silver print, $3\frac{1}{2}$ x $4\frac{3}{4}$ in. (9 x 12 cm).

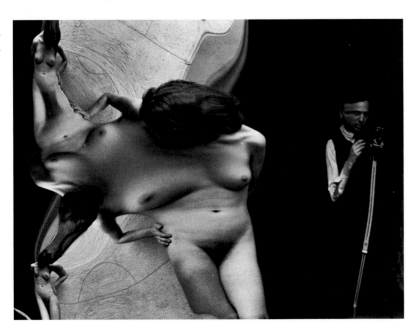

# Polaroid
## (1947)

Many inventors dreamed of it; Edwin H. Land created it. On February 21, 1947, the American scientist presented the first fruits of a new invention to the Optical Society of America: the world's first instant development technique, built into a camera and able to take and print a photograph in just one minute. The principle? To combine in a single unit two reels of film activated jointly by the same operating system, the first containing negative vehicle and the second the print paper. After the shutter is activated, the two kinds of paper pass between a pair of rollers, releasing microcapsules incorporated into the positive that initiate the development of the negative, and then the positive transfer. To obtain the picture, the two parts just have to be separated. The device, however, was still an unwieldy affair, and the photographs obtained were sepia in tone. In parallel with a long series of advances (black and white, true color, slide film, instant pack film), image definition also improved greatly. In 1972, the Polaroid Company launched the SX-70 system, an entirely automatic camera that used square format, so-called "integral" film, comprising some sixteen layers a few microns thick and containing both negative and print in one. Its advantages? More compact unit, built-in flash, user-friendly adjustment and focusing, and, best of all, an automatic system that ejects a photo that then develops, as if miraculously, before one's very eyes. Amazing both photographer and model, Polaroid was an immediate hit with the public, and over the years millions of instant photos were taken. The Polaroid was used in fields as varied as medicine, passports and ID, fashion, industry, and advertising.

But the arrival of digital photography heralded a decline for the Polaroid Company and in 2008 it closed down. During its heyday, however, and encouraged by an original publicity campaign, the firm's founder, Land, a great art lover, invited scores of artists to put

DAVID HOCKNEY,
*Celia's Children*
*Albert and*
*Georges Clark,*
*Los Angeles,*
*April 7, 1982.*
1982.

his system through its paces. In 1984, for example, Ansel Adams, known for his landscape views, was commissioned to test cameras, film, and photographic materials, both in the studio and in the field, in particular in the Yosemite National Park. He noted his findings and proposals for improvement in a famous manual entitled *Polaroid Land Photography*. André Kertész, at the advanced age of ninety-four, fell for the process, snapping the light dancing over some little glass sculptures placed on the window ledge in his New York apartment. Meanwhile, Lucas Samaras's *Photo-Transformations* (1973–76) are based on chemically tampering with Polaroid pictures. Others, such as David Hockney, made images combining several dozen Polaroids, while John Coplans used the process as a window on his body, William Wegman photographed his trademark Weimaraners, and Andy Warhol prepared commissioned portraits and self-portraits with it, supplying a dash of glamour to instant images that materialize as if by magic.

Many great photographers all over the world had fun with the instant camera, exploring its potential to the full. Today, there is even a Polaroid museum. A third of the 16,000 Polaroids collected by Edwin H. Land are housed at the Musée de l'Élysée in Lausanne.

# Photographic silk-screen printing (1960)

Invented by the Japanese, silk screen printing (screenprinting, silk-printing, serigraphy) is a technique derived from stenciling. Taken up in Europe and frequently used from the nineteenth century, it gained ground in the twentieth century for producing prints, and from the 1930s it was taken up by many creative artists. In the meantime, thanks to the efforts of many ingenious experimenters, the process had been greatly improved. How does it actually work? A bolt or screen (mesh) of silk is stretched on a frame, and the areas corresponding to the image are untreated, while the rest is stopped out with an adhesive or varnish so that when the ink is applied with a squeegee it penetrates the fabric to form the image. The motif can also be painted directly onto the screen in varnish. This process allows printing on all kinds of surfaces—not only paper, but also plastic, fabric, and wood. Several screens can be used to add layers of successive colors to build up a complete image.

Andy Warhol's stroke of genius in the 1960s was to apply this process to enlarging and colorizing photographs that he thereby endowed with the appearance of paintings. As developed by the high priest of pop, these serigraphic pictures—typologically neither photographs nor paintings—reproduced images found in the press and in advertisements, or portraits of celebrities taken in the studio known as The Factory. Silk screen, as a process of mechanical reproduction, chimed in perfectly with the artist's determination to distance the creator from his work. No mood swings here. "In a mechanized world, the artist becomes machine: that's what I want to be, a machine." The technique also made it possible for Warhol to produce multiples of a single image in different colors and to thus transgress the sacrosanct notion of the unique work of art. Turning out works in series like mass-produced industrial articles, Warhol kept to the pictorial model, but subverts it by appropriating images from the media. This principle implied abrogating personal emotion in the piece, a working method that allowed Warhol to make the following assertion: "If you want to know all about Andy Warhol, just look at the surface of my paintings and films and me, and there I am. There's nothing behind."

ANDY WARHOL,
*Self-Portrait,*
1986.

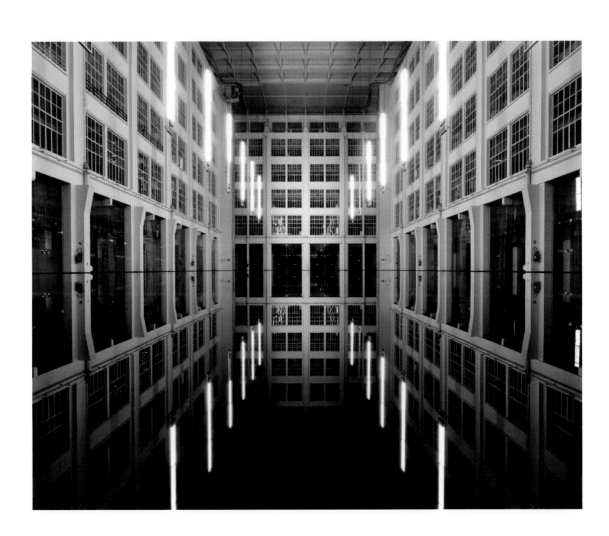

PER BARCLAY,
*46, Quai-Le-Gallo-
Boulogne,*
photograph 5474-
2011.
C-print on Ultra
Endura paper,
67 x 81 in.
(170 x 205.5 cm).
To obtain the
bottomless "mirror
effect" in this
photograph, artist
Per Barclay poured
thousands of liters
of sump oil over the
floor of the disused
headquarters of
the firm Thomson.

## KEY DATES

# 1839
## DAGUERRE INVENTS THE DAGUERREOTYPE

Official histories state that Louis Jacques Mandé Daguerre invented photography. But without contributions from a succession of earlier experimenters and the crucial discoveries of Nicéphore Niépce, Daguerre would never have made one of the seminal discoveries of the nineteenth century. Based in Chalon-sur-Saône, in about 1826 Niépce had managed to fix an image from light entering a pinhole camera onto tin plates coated with bitumen of Judaea. Following Niépce's death, the process was pursued and improved by Daguerre, who was always careful to acknowledge his debt to his predecessor. More importantly, though, Daguerre shared his discoveries with the scientist and député François Arago, who championed his cause. Indeed, 1839 is the recognized date of the invention of photography chiefly because it corresponds to Arago's announcement of the since famous "daguerreotype" to the Academy of Sciences in Paris. If its developing system on glass plates remained cumbersome, thanks to the increased reactivity of the light-sensitive surface, exposure times were considerably reduced—from eighteen hours to thirty minutes. A flood of patents followed, a noteworthy one being placed by the British inventor William Henry Fox Talbot, who, in 1840, developed calotype ("talbotype"), a negative-positive process that allowed several prints to be obtained from the same image. Then, in 1850, came wet collodion and, in 1852, "ferrotype." In 1888, George Eastman, "Mr. Kodak," succeeded in replacing the glass plate with celluloid film and reducing the size of the camera, thus putting photography into the hands of everyone.

# 1858
## NADAR CARRIES OUT THE FIRST AERIAL PHOTOGRAPH

Gaspard Félix Tournachon, known as Nadar, a graduate from the prestigious École des Mines at Saint-Étienne, began his working life as a caricaturist. In 1851, he embarked upon an ambitious project to draw portraits of all the political greats of the time entitled: *Museum of Contemporary Glories*. Simultaneously, he set up a photography studio on Rue Saint-Lazare, where celebrated figures of the literary and artistic circles in Paris would queue to have their picture taken. There Nadar produced iconic portraits of Charles Baudelaire, Honoré de Balzac, George Sand, Gustave Doré, and Sarah Bernhardt, to name but a few. His style is characterized by sober backgrounds and natural light, endowing his pictures with a timeless feel. Nadar knew how to capture the essence of a sitter's personality, to bring out their inner strength, to convey what lies beneath. Soon, in turn, Nadar, too, became a celebrity. Blessed with extraordinary energy, a fervent defender of the French Republic, he was at the same time a brilliant journalist and an endlessly resourceful inventor. In 1854, he lodged a patent for taking aerial photographs from a balloon, taking the first photograph fastened 260 feet (80 meters) above Petit-Clamart, early in the morning of October 23, 1858. The bird's-eye views of the Arc de Triomphe that he captured a few years later with a camera with multiple lenses reaped considerable acclaim. Moreover, the aeronautical exploits of this fearless experimenter (in 1863 Nadar built *Le Géant*, an enormous air balloon offering rides to the public; an ostensibly lucrative idea that nonetheless came to grief) were the inspiration behind Jules Verne's *Five Weeks in a Balloon* (1862), *From the Earth to the Moon* (1865), and *Around the Moon* (1870). In 1861, the insatiable Nadar also took the first underground photographs in the catacombs and the sewers of Paris, illumined by an array of Bunsen cells and reflectors. As the exposure time was often more than fifteen minutes, in these compositions Nadar replaced real people with dummies.

# 1869
## COLOR PHOTOGRAPHY

On one and the same day in the year 1869, at the Academy of Sciences in Paris, Louis Ducos du Hauron and poet Charles Cros separately presented the principle of photography using the subtractive three-color process. The foundations had been laid in 1861 by the Scottish physicist James Clerk Maxwell, who, with an arrangement of three magic lanterns provided with red, green, and blue filters, had demonstrated that a superimposition of the three primary colors is enough to create any hue. Cros and du Hauron concluded that a juxtaposition of three identical

images, taken each with a different filter (yellow, red, or blue), would suffice to obtain a full-color image. Their results with this delicate process, however, proved rather hit and miss. In 1903, the obstacle of the triple exposure was overcome in the "autochrome" developed by the brothers Louis and Auguste Lumière, and marketed in 1905. The principle demanded a single exposure only—though the apparatus, with plates of $3\frac{1}{2} \times 4\frac{3}{4}$ in. (9 x 12 cm) format and relatively long exposure times, remained awkward to operate. Nonetheless, its advantages carried the day. The Lumière brothers' brainwave consists in dusting a glass plate with minute grains of sifted potato flour (starch), dyed red, green, and blue. These are fixed with a resin to which is added a very fine powder of carbon, all the ingredients being protected beneath a coat of emulsion. The outcome was a poetic image resembling a pointillist painting. In 1898, French banker and patron Albert Kahn dispatched photographers all over the world to constitute a series of full-color prints he dubbed the "Archives of the Planet." In the early twentieth century, Agfacolor film, and then Kodachrome, achieved greater clarity in color photography, though the procedure remained perilous and the pictures could be developed solely as slides. Only in the 1950s, thanks to Kodachrome film and paper printing, did color photography finally come into its own.

# 1888
## GEORGE EASTMAN AND KODAK FILM

George Eastman's life story reads like that of the archetypal American self-made man. Born in 1854, he was brought up with his two sisters by a mother who had been widowed young. After a few odd jobs, young Eastman rose to become an accountant in a bank and, by the age of twenty-four, he was already well on his way. One day, as he was planning to travel, he bought himself a camera. At the time, these were heavyweight, bulky pieces of apparatus: the operator had to prepare the emulsion for the glass plates himself before taking photos which were developed using a range of ingredients. Immersing himself in the specialized magazines of the time, Eastman gleaned that some photographers were manufacturing plates with a gelatin emulsion that remained light-sensitive, and thus usable, after drying. Preparing his own emulsions, Eastman sought to refine

the process, and, in 1880, patented a formula and a machine to mass-produce ready-to-use dry plates. Setting up a company, he found premises in Rochester, New York, manufacturing the plates with a view to selling them to professional photographers. "The idea gradually dawned on me … we were starting out to make photography an everyday affair… to make the camera as convenient as the pencil." His objective was to find a support at once lighter and less fragile than glass. Finally, he managed to coat the photographic emulsion on paper that could be rolled onto a reel. In 1885, he added further improvements, coating paper with pure, soluble gelatin covered by a layer of insoluble, light-sensitive gelatin. As Eastman later averred, however: "When we started out with our scheme of film photography, we expected that everybody who used glass plates would take up films. But we found that the number which did so was relatively small. In order to make a large business, we would have to reach the general public." He discovered the solution by inventing, in 1888, the Kodak, the first camera capable of taking a number of pictures on one celluloid strip. As the famous advertising slogan trumpeted: "You press the button, we do the rest." Once the pictures had been taken, the customer just sent the camera to the firm, where the film was developed, the prints made, the apparatus reloaded and returned to the owner. Thus the name of Eastman belongs to the man who at last democratized photography.

# 1905
## ALFRED STIEGLITZ FOUNDS THE 291 GALLERY

In 1905, photographer Alfred Stieglitz, by then aged forty-one, was already in the public eye. Actively militating for photography to be recognized as a full-fledged art, on a par with painting and sculpture, after his return from Europe in 1880 he strove to build bridges between creators in the Old and New Worlds. Professionally he was, in turn, editor-in-chief of the club journal *The American Amateur Photographer*, founder of the Camera Club in New York, and director of the most influential review in the country on the subject, *Camera Notes*. In the vanguard of pictorialist photography, to further his aims, in 1902, Stieglitz set up the Photo-Secession group (in reference to

similar movements in fine art in Vienna and Munich). A year later, he thought up and headed the deluxe review *Camera Work*, remarkable for the quality of its reproductions, for the place accorded to the European avant-garde, and for opening its pages to other forms of art, literature, and music, as well as the contemporary visual arts. With the same intention of broadening horizons and breaking down barriers, he joined forces with photographer Edward Steichen and opened a gallery at number 291 Fifth Avenue, which held, for the first time, exhibitions solely devoted to photography. The gallery rapidly became a haunt of artists and intellectuals of the period, and photographers such as Clarence White, Gertrude Käsebier, Frank Eugene, Joseph Keiley, and Dallet Fuguet treated it as their HQ. Though obliged to move to 293 next door, the gallery opted to keep its original name.

After a time, the gallery changed tack, and Stieglitz and Steichen started showing drawings by Rodin, and then by Matisse, Cézanne, and Picasso, as well as African art and works by young American painters. Alternating avant-garde with more traditional pieces, along with photography and the other arts, Stieglitz's astonishing lack of prejudice made a significant contribution to the overdue acceptance of photography as an art on its own terms.

# 1929
## THE *FILM UND FOTO* EXHIBITION IN STUTTGART

Organized by the Deutscher Werkbund (a group of architects and designers active since 1907), this exhibition, also known as FIFO, was held from May 8 to July 7, 1929. Its three basic aims distinguished it from its predecessors: to show a representative panorama of modernist international photography; to interconnect all fields of photography, and to promote the German "New Vision" ("Neue Optik"), a movement that dealt in original viewing angles and framings that fragmented the composition and imparted dynamism. The show brought together around a thousand photographs, uniting the foremost talents of the age with unsigned or more amateur work. As the organizer, Gustav Stotz, explained in an introductory text: "A new optic era is developing. We see what's around us differently than hitherto, without any pictorial purpose in the impressionistic sense. Certain things have become

significant for us, while formerly they would hardly have been noticed: a pair of clogs, a gutter, rolls of wire, fabrics, machines, etc. They interest us for their material substance, for their mere thingness; they interest us as a means of structuring space in the flat, as bearers of shadow and light."

Occupying thirteen rooms, the display at Stuttgart showcased works by, among others, Edward Steichen, Edward Weston, Hannah Höch, Albert Renger-Patzsch, Kurt Schwitters, André Kertész, Florence Henri, Cecil Beaton, Paul Outerbridge, Berenice Abbott, Carl Hubacher, El Lissitzky, Man Ray, and Boris Ignatovitch. Broadly centered on pieces by the artist László Moholy-Nagy—a master of the German New Vision—the event formed a kaleidoscope of highly diverse approaches: night photographs and distortions, documentary, scientific, medical, astronomical, and industrial photographs, photograms and photomontages, aerial photographs and war reports, and more. In parallel to the exhibition proper, some sixty experimental silent films were screened under the curatorship of Hans Richter, including René Clair's *Entr'acte*, Charlie Chaplin's *The Circus*, Fernand Léger's *Ballet mécanique*, Robert Wiene's *The Cabinet of Doctor Caligari*, and Viking Eggeling's *Diagonal Symphony*.

Traveling to Zurich, Berlin, Danzig (Gdánsk), and then Vienna in a reduced version, the exhibition signaled the advent of photography as a truly modern medium.

# 1936
## FIRST ISSUE OF *LIFE* MAGAZINE

With the predominant place it allotted to the picture, *LIFE* magazine revolutionized journalism from the publication of its very first issue on November 23, 1936. This position as a benchmark in world photojournalism endured for more than seventy years.

*LIFE* was set up by Henry Luce, a former editor-in-chief of *Time* magazine. The idea came to him when he published a photo supplement on the assassination of King Alexander of Yugoslavia in Marseille for *Time*. Noting its runaway success, he started planning the launch of a journal devoted mainly to pictorial reports. From the beginning, *LIFE* was aimed at a very broad public, alternating serious and less exalted subjects. In a prospectus, Henry Luce laid out the aims of this novel picture magazine: "To see life.

To see the world. To watch the faces of the poor, and the gestures of the proud. To see strange things. Machines, armies, multitudes, and shadows in the jungle. To see, and to take pleasure in seeing. To see and be instructed. To see and be amazed." During World War II, *LIFE* dispatched photographers to all every Allied front. The magazine became a kind of pictorial Voice of America, propagating the values of the American way of life. With, by 1949, a print run of some five million and a readership of twenty, it became the dominant force in the world press. For a personality from politics, culture, or sport to "make" the cover of *LIFE* amounted to a kind of consecration. The magazine employed up to twenty-four salaried photographers, and some of the greatest names worked as stringers for the magazine: Larry Burrows, Margaret Bourke-White, Robert Capa, Alfred Eisenstaedt, Philippe Halsman, Lee Miller, and Mark Shaw. Following similar lines, in 1938, Jean Prouvost launched *Paris Match* in France.

*LIFE* appeared weekly until December 1972, when, a victim of competition from television in spite of having some eight million American readers, it started being issued only twice a month. In October 1978, it further contracted to a monthly—except during part of the Gulf War, when it was rescheduled as a weekly. In 2000, publication ceased entirely, briefly reviving in October 2004 as a weekly supplement to a number of American dailies. But the indispensable advertising revenue never materialized and this extraordinary publishing adventure came to an end with the issue dated April 20, 2007.

# 1937
## FARM SECURITY ADMINISTRATION

The year marked the high-water mark of the American documentary style. Following the Great Depression that started in 1929, in 1935 the US Farm Security Administration (FSA) launched a national photography campaign to aid agricultural workers suffering the consequences of the economic slump. The project's role was to compile a census of the American countryside in order to demonstrate to the authorities and to the public at large the wretchedness blighting those struggling to live off the land. From 1935 to 1942, Dorothea Lange, Ben Shahn, John Vachon, Marion Post Wolcott, Walker Evans, Arthur Rothstein, and a number of others traveled the length and

the breadth of the nation. The program and procedure for the photos were defined at the start by Roy Stryker with advice from Walker Evans: taken with a view camera, the photos were to be frontal and static. Distributed through exhibitions and publications from 1938, these essentially propaganda images changed the face of social reportage forever, while the portraits of sharecroppers in the southern United States taken by Walker Evans—full of truth and nobility—have become emblematic images in the history of photography.

# 1940
## MoMA OPENS THE FIRST DEPARTMENT DEDICATED TO PHOTOGRAPHY

In the beginning, photographs tended to be collected by institutions as documents. Eugène Atget, for example, sold thousands of his 1898 prints recording the lives of small tradesmen in Paris to libraries. In the United States, the artistic dimension of photography began to be recognized in the late 1920s. One determinant factor in this development was the role played by Alfred Stieglitz as defender of the pictorialist movement and founder of the first photography gallery in New York in 1905. Though Stieglitz convinced several American museums to acquire photographs, it was the Museum of Modern Art in New York (MoMA) that was the first to constitute an actual collection of photographs, in keeping with the desire of its director, Alfred Hamilton Barr, to present a wide gamut of artistic expressions side by side. The first photograph was thus purchased in 1930: a work by Walker Evans, who was to benefit from a retrospective entitled *Walker Evans: Photographs of Nineteenth-Century Houses*, held at the museum three years later. In 1935, Barr contracted Beaumont Newhall to prepare a historical retrospective, *Photography 1839-1937*, in acknowledgement of the medium's hundredth birthday, and of the many illustrious names in its history. Following this survey, the first department devoted to photography was officially set up by the museum in 1940, with Newhall as curator. Seven years later, Edward Steichen, cofounder of the 291 gallery with Stieglitz, took over. Locating photography squarely in the domain of the avant-garde, Steichen exhibited works from a considerable diversity of perspectives, including

photojournalism and documentary pieces. In 1955, he initiated the famous exhibition *The Family of Man* (see below). By 1962, when Steichen was succeeded by John Szarkowski, the collection comprised some 6,000 photos; today, it boasts more than 25,000.

# 1947
## CREATION OF THE MAGNUM AGENCY

The Magnum Agency was set up after World War II by Robert Capa, Henri Cartier-Bresson, George Rodger, and David Seymour, and was the first of its kind to be organized as a cooperative. Its objective? To safeguard members' independence by ensuring that they remained the owners of the rights to their photographs. By thus freeing them from the all-powerful grip of editors and directors of publications, they would be able to turn their attention to longer-term missions. Another chapter of its remit was to prevent the mistaken or abusive use of photographs. The agency would depend on outside orders and income was to be shared out between the photographers. The seven original shareholders each put in 400 dollars to kick-start the agency. Burt Glinn, an early associate, summarized the spirit of those working directly for Magnum as a series of (especially financial) ups and downs, punctuated by frustration on the part of creative artists who found themselves in an office managing an agency when they would rather be out and about with a camera. In spite of the familial atmosphere, its members, shackled together "for better and for worse," had their fair share of quarrels.

Magnum's greatest moments came between its coverage of the Spanish Civil War and the Vietnam War—including World War II, the Cold War, and all the conflicts in Southeast Asia. Its roster today features names like Bruno Barbey, Raymond Depardon, Elliott Erwitt, Martine Franck, Guy Le Querrec, Josef Koudelka, Steve McCurry, Martin Parr, Gilles Peress, Paolo Pellegrin, Marc Riboud, and Lise Sarfati.

A model of its kind, by the late 1960s Magnum was suffering competition from TV news as well as from newly established agencies, such as Gamma, Sygma, Sipa, etc. Today, the majority of photographers belonging to Magnum tend to be less involved in "on-the-spot" news-gathering, preferring to pursue more personal, documentary investigations.

# 1955
## THE FAMILY OF MAN EXHIBITION AT MoMA

"The exhibition … demonstrates that the art of photography is a dynamic process of giving form to ideas and of explaining man to man. It was conceived as a mirror of the universal elements and emotions in the everydayness of life—as a mirror of the essential oneness of mankind throughout the world," Edward Steichen explained in his introduction to this immensely ambitious exhibition. The program was vast and the endeavor proportionately colossal: taking three years to prepare, two million photographs from every corner of the globe were examined and 10,000 images sorted and classified by topic. In the end, a total of 503 works were exhibited, representing 273 photographers, both well known and obscure, from 68 countries. The original display covered some 7,750 square feet (720 square meters) of wall and filled an entire floor of the museum. Left unframed and dramatically hung, the photographs boasted a wide range of formats, from 5 x 7 in. (13 x 18 cm) to giant enlargements. Structured around life's key moments, "from birth to death," and imprinted with compassion and optimism, the panorama constructed by Stein, ex-photographer and director of MoMA's photography department, received a ringing endorsement from the public.

The exhibition received some nine million visitors in all, and, like a stage show, traveled to several American cities, eventually, in 1959, even crossing the Atlantic to be presented in thirty-seven different countries on a tour lasting a dozen years. A triumph with visitors, critics were less unanimous in their approval. In the journal *Les Lettres nouvelles*, Roland Barthes, for example, lambasted what he saw as its idealism: "The failure of photography appears blatant to me here: to represent death or birth tells one nothing, when all is said and done, nothing at all.… So I'm very much afraid the ultimate justification for all this worthiness might be to sanction the unchanging nature of the world with a wisdom and lyricism that perpetuate the actions of man uniquely to render them harmless." However, ten years after the shock of World War II, *The Family of Man* was hailed as a message of peace. With such an enormous range of photographers (Diane Arbus, Manuel Álvarez Bravo, Bill Brandt, Robert Capa, Robert Doisneau, Alfred Eisenstaedt, Robert Frank, Irving Penn,

Russell Lee) adopting very different approaches, this historical exhibition is a milestone in the history of photography. In accordance with Steichen's wishes, it is now housed in his homeland, Luxembourg, in the Château de Clervaux.

# 1970
## FOUNDATION OF THE *RENCONTRES D'ARLES* PHOTOGRAPHY FESTIVAL

Initiated by photographer Lucien Clergue, writer Michel Tournier, and conservator Jean-Maurice Rouquette, the international photography festival *Les Rencontres d'Arles*, now held in July, August, and September, was set up to emphasize the artistic dimension of the medium. While that notion had become common currency in the United States, Europe seemed to lag behind. The idea of inviting photographers to come and talk about their work and meet the public in a delightful Provence town immediately attracted legends of the medium, such as Ansel Adams, William Eugene Smith, and Lee Friedman, who soon made their way to southern France. Over the years, thanks to its broad approach, the festival attracts increasing numbers of visitors and is now the annual venue for great American photographers wanting to meet up with their European counterparts. Modernist from the outset, today the event enjoys a global profile, though it manages to remain relaxed and informal. The national school of photography (founded in 1982) puts on summer courses taught by famous photographers, some fifty exhibitions, and evening openings with screenings and debates in the Roman theater, making the *Rencontres d'Arles* an incomparably dynamic event.

# 1972
## FIRST CHAIR IN THE HISTORY OF PHOTOGRAPHY, AT PRINCETON

For a long time, the history of photography remained synonymous with that of its technical advances and discoveries. The photographic image as an aesthetic object certainly invited commentaries in specialized reviews (in particular by pictorialists) and in monographs, but it did not yet benefit from an all-round critical perspective. At the beginning of the twentieth century, the key role of Alfred Stieglitz, the Photo Secession movement and the journal

*Camera Work*, combined with the opening of a photography department at MoMA, began to have repercussions on the purely factual approach. The work of art historian David Octavius Hill and then photographer Heinrich Schwarz changed the approach to a novel medium which was gradually being analyzed on its own specific terms. Yet it was not before 1972 that a course in the history of photography was offered at a university. The chair was instituted for the first time at Princeton, after a significant collection of photographs was presented to the city art museum by the professor of art history David H. McAlpin. Its brief was to facilitate students researching into the history or criticism of photography, and to open up new paths in the study of the medium. This worthy ambition has since been taken up by many other institutions.

# 1980
## CREATION OF THE EUROPEAN MONTH OF PHOTOGRAPHY

Created in 1980 by Jean-Luc Monterosso, the "Mois de la Photographie" takes place in Paris in November each even-numbered year. Raising the profile of the medium (ranging from documentary and reportage to creative and tableaux), it is seconded by the mobilization of a large number of cultural institutions and galleries in the French capital. Devoted to a specific theme, each edition of the "Month" thus presents an opportunity to see several dozen exhibitions, as well as to attend screenings, encounters, and debates. Known since 2004 as the "European Month of Photography," the formula has been successfully repeated in Berlin, Vienna, and Montreal.

# 1982
## SONY LAUNCHES THE FIRST DIGITAL CAMERA

By unveiling the Mavica (Magnetic Video Camera), the first color "digital" camera, Sony revolutionized photography. No more celluloid. The image is dematerialized. Equipped with a CCD sensor with 279,300 silicon elements (pixels), the apparatus recorded images to a magnetic disk capable of storing up to fifty still frames that could then be viewed either on a TV monitor or reproduced on paper via a compatible printer. Embraced by the public at large, since

then many digital cameras have been launched on the market. Definition is now good enough to win over even stalwarts of the silver print. The possibility for retouching provided by specialized software (Photoshop, PaintShop Photo Pro, etc.) has contributed notably to the success of digital photography.

# 1989
## VISA POUR L'IMAGE FESTIVAL

Regarded as the most important international festival dedicated to photojournalism, *Visa pour l'Image* was set up in 1989. Supported by the pictorials *Paris Match* and *Photo*, and with backing from several sponsors, in particular Canon, it is held every year at the beginning of September in Perpignan, southwest France. Defending the ethics of photojournalism in an age when the reporting profession is being undermined by competition from amateurs taking snapshots on cell phones, it is attended by press journalists in droves. Through exhibitions, meetings, and debates, *Visa pour l'Image* provides a progress report on the seminal events of the past year in photography.

# 1996
## RECONSIDERING THE OBJECT OF ART: 1965–1975 EXHIBITION

Held in the Los Angeles MoCA and featuring work by John Baldessari, Joseph Kosuth, Douglas Huebler, Michael Snow, Hans Haacke, Gilbert & George, and Jeff Wall, this exhibition dealt with the avant-garde of 1965–1975. In addition to the use of text and language, it highlighted the role of photography in the development of conceptual practices.

# 1996
## PHOTOGRAPHY AFTER PHOTOGRAPHY EXHIBITION

Initiated by the Siemens Group in the context of its cultural involvement, this exhibition turned the spotlight on photography in the era of new technologies, when cyberspace, the Internet, and virtual media were beginning to transform our perception of reality. Initially held in Munich, it traveled round Europe before moving on to the United States. The display proposed two artists of diametrically

opposed approaches as landmarks in the history of art prior to 1980: Nancy Burson and Jeffrey Shaw. The first because, though she used computing, she remained rooted in the tradition of pictorial photography, and the second as a pioneer of virtual reality.

Addressing themes such as the body, space, identity, authenticity, and memory, the exhibition showcased about thirty artists using media such as CD-ROMs, interactive installations, and websites, presenting many of the solutions offered by these new means of expression. This event broached a number of fundamental new questions: is an image created by computer, by electronic technology, radically distinct from an image taken with a lens and reproduced on film? Does the association between photography and reality still have meaning when a computer can "simulate" an image? An important date in the history of photography, and pointing out a number of future paths, the exhibition presented contrasting responses to a series of twinned themes: portrait/body, memory/witness, original/copy, information/manipulation.

# 1997
## FIRST PARIS PHOTO SALON

"It is with immense pleasure that I welcome you to the first *Paris Photo*, an unprecedented event dedicated to artistic photography in Europe. Presenting a unique panorama from the nineteenth century to the most recent phenomena on the contemporary scene, and aimed at all those with a stake in the art of photography, be they gallery owners, collectors, publishers, curators, or simply art lovers, the present initiative benefits from a committee comprised of the most important figures in what is a burgeoning market. Held in the Carrousel du Louvre, it boasts no less than sixty galleries and art publishers of international repute, from more than a dozen countries. An exhibition devised by Harry Lunn and selected from the permanent collections of the Maison de la Photographie, a new prize rewarding the finest work of nine young photographers, a selection of pieces from Manfred Heiting's outstanding collection, the launching of a club of *Paris Photo* collectors." These were the words with which Rik Gadella, the creator of the event, launched the first international fair devoted to photography. His speech almost blinds one to the fact that this was a trade fair—and hence a place for selling

art. Still, the timing of this fine initiative was impeccable: photography prices were about to embark on their irresistible upward spiral. With a formula taken up with greater or lesser success in other venues abroad, *Paris Photo* is today the leading fair on the photography market.

# THE 2000s
## THE PHOTOGRAPHY MARKET SKYROCKETS

It was in 1961, in Geneva, that—on the initiative of André Jammes and Nicolas Rauch, collectors of historic photographs and booksellers—the first public sale of photographs in Europe was held. It proved a flop. In fact, a market for photography along similar lines to that for the fine arts grew only from the 1970s onwards. The distribution of a work was controlled by the concept of limited edition prints, and, gradually, a true market developed. One telling landmark was the appearance in 1976 of German artists Bernd and Hilla Becher at number 100 in the "Kunstkompass" listings, which measure an artist's audience based on the number of exhibition visitors. The generation of the Bechers' pupils made their impact in the 1990s, and, since the beginning of that decade, and especially from the turn of the millennium, photography prices have climbed meteorically, accompanied by a plethora of auction sales and a growing number of salons and fairs. From 1997 to 2000, there was a widespread explosion of prices in the historic photography sector. In New York in 2006, a print by the American pictorialist Edward Steichen attained the record price of 2.9 million dollars. On the contemporary side, an Andreas Gursky—the photograph *99 Cents*—obtained 3.3 million dollars in 2007, and then, in 2008, a print signed Richard Prince was sold for 3.4 million. Even this was not the end of the matter, however. On May 11, 2011, at a sale organized at Christie's New York, the winning bid for a photograph by Cindy Sherman dating to 1981 was some 3.9 million dollars (the estimate was no more than two million). Will there be any end to this record-breaking? When the market for photography reaches a par with that for painting, perhaps?

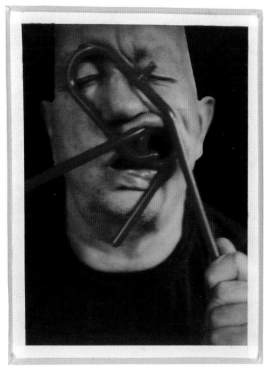

ANNA AND BERNHARD BLUME,
*Prinzip Grausamkeit,*
element no. 1 in a series
of 20 photographs,
1997.
Color Polaroid
with ink highlights,
4¼ x 3½ in. (10.7 x 8.8 cm).

JEAN-MARC
BUSTAMANTE,
T.126.91,
1991.
54⅜ x 43⅞ in.
(138 x 111 cm).
With Jeff Wall,
Jean-Marc
Bustamante was
the first artist to
make very large
prints and exhibit
them like
photographic
tableaux.

**30 PHOTOGRAPHERS**

# NOBUYOSHI ARAKI

## Who is he?

An odd fish, that Nobuyoshi Araki. Born in 1940 in downtown Tokyo, he took his first photos aged about twelve. Working initially as cameraman for an advertising agency, he has since embarked on an original, autobiographical, and much-discussed body of work. Since making his explosive entrance onto the art scene with the 1971 publication of *Senchimentaru na tabi* ("Sentimental Journey"), a kind of photographic journal of his honeymoon that showed him in intimate scenes with his wife, Yoko Aoki, on the island of Okinawa, he continued to photograph his muse endlessly until her untimely death in 1990. A prolific artist, the vein Araki explores is essentially autofictional. A highly individual personality with a coruscating sense of humor, Araki cares little about what others think of him. A compulsive photographer, he has already published more than three hundred books in Japan and today is an international star. Exhibiting in some of the foremost museums in the world, in 1991 he was awarded the prestigious Higashikawa Prize.

## His work

The oeuvre of this photographic heretic always revolves around the same themes: Tokyo, life, death, naked women, and flowers as a metaphor of the female genitalia. His strange mix of autobiography and invention blends reportage and fiction. Everything is simultaneously true *and* staged. Araki became famous with a series of photographs on the Japanese erotic tradition of *shibari* (bondage), reproducing the resulting images as large-size color Xerox photocopies with which he lined the walls of galleries and museums. These iconic series show young women, prostitutes or students, dressed or naked, consenting to be bound, suspended from the ceiling, or lying on the ground. The prints certainly play with both exhibitionist desires and instinctual voyeurism, but such a prolific corpus—addressing themes such as the transience of beauty, the inescapable end of human existence, the uneasy permanence of things—is always imprinted with a certain gravity. Araki's strongly contrasting and colorful photographs, all supremely aesthetic, are often accompanied by a text. Other pieces, however, deal in subtle urban landscapes, people on the subway, kids playing in the street, the sky, his house, and his cat Chiro. In the final analysis, Araki is concerned with the transitory things of life.

## He said

"I've had enough of all the lies on the faces, in the nudes, in the private lives, and on the landscapes one sees in fashion photos everywhere. My series *Sentimental Journey* is quite unlike them. It's my statement."

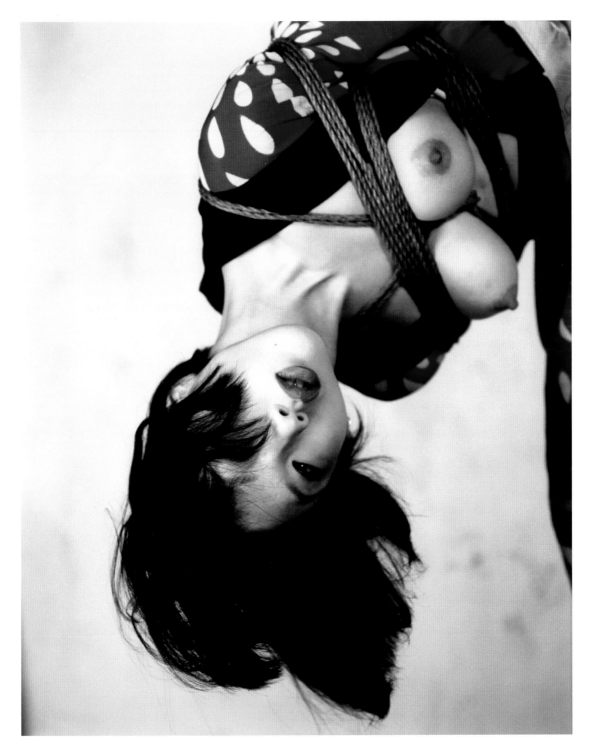

# BERND AND HILLA BECHER

## Who are they?

These two were destined to join forces one day. Bernd Becher was born in a mining community in Siegen in 1931. (He died in Rostock on June 22, 2007.) Studying painting at the fine art academy in Stuttgart, he began with landscapes of his native region, using photographs—of, for example, a factory in the course of demolition—as a model for a painting. Born in Potsdam in 1934 and training as a photographer, Hilla Wobeser left East Berlin in the late 1950s to work in West Germany, running the photo lab at the Düsseldorf Academy. Once they met in 1959, Bernd and Hilla started taking photos of mines and workers' cottages, devoid of all human presence, in the industrial heartland of Siegen. At the outset, the survey, shown in the form of comparative series, proved of interest primarily to historians, engineers, and architects. Their oeuvre made its entrance into the field of art when the couple exhibited these *Anonymous Sculptures* in the context of a retrospective of American minimal art in 1969, critics noting a similarity of approach between the US avant-garde and the Bechers' conceptual strategy. They quickly rose to earn international recognition and, in 1976, Bernd Becher opened the first class in art photography at the Düsseldorf Academy; it went on to influence a whole generation. In 1990, the Bechers received the Golden Lion for sculpture at the Venice Biennial, and, in 2004, the international prize of the Hasselblad Foundation.

## Their work

Without the Bechers, contemporary photography would simply not occupy the place it does today. Appearing simultaneously as precursors and masters, their work both continues the history of 1920s formal documentary photography and aligns itself with the conceptual, self-referential and analytical art of the 1970s. Bernd and Hilla's project covered buildings of an industrial world undergoing wholesale upheaval, but they looked at their subjects—blast furnaces, water towers, cooling towers, gasholders, pitheads—as if they were enormous sculptures. Crisscrossing Europe, they took photos of hundreds of buildings according to an invariable compositional protocol: placing the model in the center of the image and isolating it from its environment, they privilege neutral light and an elevated viewpoint so as to avoid distortion. The images are then classified and organized by topology fulfilling various criteria (geographical, historical, structural) and shown in the form of plates composed of nine, twelve, or fifteen small prints. And the Bechers' key contribution? Going beyond the imitative function of photography by intervening on the image both up- and downstream, all the while making the scientific approach equate to a kind eye-opening experience.

## They said

"The objects that interest us were created without aesthetic intent.... They present themselves in a great diversity of forms. We try to classify and set up comparisons between these forms by means of photography."

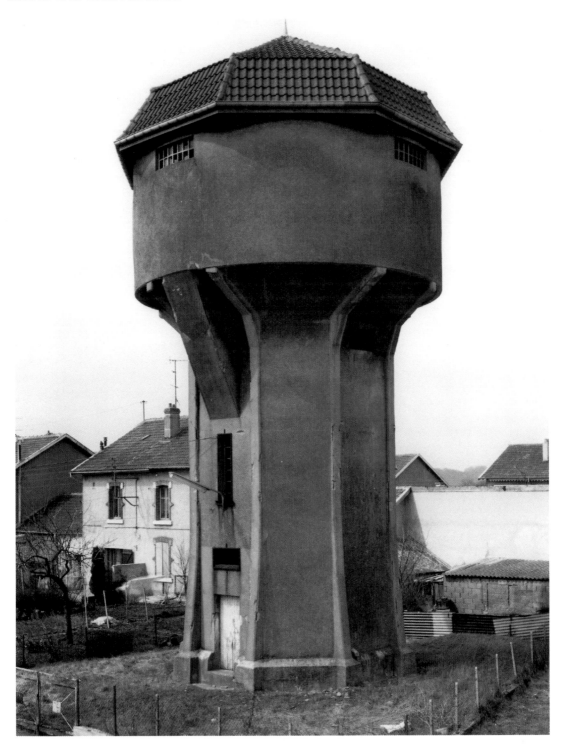

# VALÉRIE BELIN

## Who is she?

Fascinated by the world of appearances and the masks behind which people hide, Valérie Belin, born in Boulogne-Billancourt in 1964, is a graduate of the art school in Bourges, obtaining a masters in art from the Sorbonne in 1989. Later, when in residence in Venice, she embarked on an important series on the object and its sculptural presence, centering on Venetian mirrors, that marked a turning point in her career. Since then, her statements adopt the form of sets—"a variation on a motif," as she describes it—in an effort to circumscribe the plastic density of the model. In 2001, she was awarded an extramural grant from the Villa Medici and moved to New York for a few months. In 2004, she won the Marcel-Duchamp Prize in Paris. Her works have been acquired by, among others, the MoMAs of New York and San Francisco and by the Centre Pompidou, Paris. At the Norton Museum of Art in West Palm Beach, she showed in the company of Bill Viola and Hiroshi Sugimoto, while, in 2009, the Peabody Essex Museum in the United States played host to a solo exhibition.

## Her work

A bewitching sense of ambivalence pervades Valérie Belin's images. The figures or objects she collects in accordance with a precisely laid-down modus operandi (lighting and framing are calculated to the millimeter) appear to have landed from a science-fiction movie. In an age when plastic surgery can totally transform someone's appearance and when a body can be carved like a cult object, Belin makes the vibrant flesh seem artificial, and invests inert objects with intensity—a perceptual inversion that expresses the blurring of the boundaries between truth and falsehood. Her photographs, addressing questions of existence and identity, are responses to how human acts have become solidified, our appearances frozen, our poses stereotyped. As the artist explains: "In my work, reality is monumentalized, it becomes like sculpture; I'm not at all trying to record a flow, a 'movement-image.'" Undermining our confidence in the verisimilar, Belin wants to divert photography from its role as a record of the real. The impression made by her prints of effeminate boys, of black women's faces as exquisite as African masks, or of dancers made up to look like wax dummies, for example, is strange to say the least. These portraits amplify the metamorphosis of beings that in the last analysis resemble avatars from a video game. From crystal curios to car chassis after an accident, from bodybuilders to Moroccan brides, via doubles of Michael Jackson, magicians, variety dancers, and fruit bowls, Belin scrutinizes the world of appearances in images that show everything solidifying, as if to form a bastion against the fatal advance of time.

## She said

**"My work can be regarded as an obsessive attempt to appropriate reality."**

# MOHAMED BOUROUISSA

## Who is he?

The artist who made such a dramatic entrance into the field of photography and video was born in 1978 in Blida, Algeria. He now lives and works in Paris. During his studies at the ENSAD school of decorative arts in Paris, he embarked on a lengthy investigation entitled *Peripheries*, focusing on the subject of the deprived suburbs, with its gang leaders and explosions of violence: a place freighted with connotations that he transformed into an astounding visual experience. Of virtually documentary authenticity, the photographs in this series, resembling freeze-frames, were carried out with the consent of the inhabitants of "flashpoints" such as the Courneuve, for example, or Clichy, Montfermeil, and Pantin near Paris, or Le Mirail in Toulouse. There then followed the series *Écrans*—"screens" between fiction and reality—and then *Temps mort* ("Dead Times"—"Idling"), which explore a living experience that is only partially shared. Bourouissa also carried out video assemblages, *Temps morts* being selected for the *ILLUMinations* exhibition at the Venice Biennial in 2011. The powerful, mature work of this young artist has proved highly successful with the general public and professional collectors alike. He is represented in Paris by the Kamel Mennour gallery and in New York by Yossi Millo.

## His work

Mohamed Bourouissa's photographs and films radiate the virile energy of their youthful subjects or protagonists. Balancing on the high wire between fiction and reality, he invests the kinds of scenes broadcast 24/7 on the TV news with an allegorical and thus universal dimension. His series *Peripheries* inverts the clichés that infect the violence of the suburbs, such as the rule of gang law, into a sequence of physical interactions. The heritage of Caravaggio and Delacroix—but also of Jeff Wall and Nan Goldin—shows through in the artist's capacity to convey an electric, tense reality through images that are at times ultra-composed and at others taken on the street, but are always perfectly controlled aesthetically. With *Temps mort* Bourouissa realizes a performance, flirting with the margins of legality, that records vibrations from what is for most people an alien social reality, inaccessible to those from outside. The project is in fact the result of a year the artist spent exchanging still and video images via cell phone—that is to say more than three hundred via SMS and MMS—with two prison inmates. In exchange for credit, Mohamed Bourouissa remotely directs the detainees, using sketches to indicate the camera angles he required and printing the results before rephotographing them. His aim? To set up a "super-interpretation" of a vibrant reality. The end product: a photographic installation and a video montage more true to life than any normal reportage.

FACING PAGE
*The Window*,
2007-08.

## He said

**"In the age of Delacroix, the aspiration was to freedom. Today, what is lacking is equality. Our society is unjust. That's why riots break out."**

# LARRY CLARK

## Who is he?

Today a legend, Larry Clark was born in 1943, in Tulsa, Oklahoma, where his parents ran a photography studio. He started out aged fourteen assisting his mother, who would go door to door taking portraits of newborns and pets. His task was to get the babies chortling and calm down the cats and dogs. Having studied at Layton School of Art in Milwaukee, Wisconsin, at the height of hippiedom in the late 1960s, Clark returned to the city of his birth. He spent his days hanging out with a gang of boys and girls up to no good. Caught in an infernal spiral of drugs, sex, and guns, they let Clark photograph the aimless existence that at the time he shared. The first photo book, *Tulsa, Oklahoma*, published by the photographer in 1971, shows doped-out kids who sleep around. Caught unawares by the scandal it sparked, the author became aware of the political import of his work: "Who says you can't show it all?", as he put it. Pursuing his dive into the hidden face of the American way of life, he then brought out *Teenage Lust* (1983), *1992* (1992), and *The Perfect Childhood* (1993). Two years later, he turned to the movie camera to direct *Kids*, which obtained both a critical and a commercial success. Later features include *Another Day in Paradise* (1998), *Bully* (2001), *Ken Park* (2003), and *Wassup Rockers* (2004). Both his movies and photographs have gained cult status, though, forty years later, some prints remain so disturbing that they are regularly banned.

## His work

"When in the 1960s I started taking photographs of the people around me, I constructed my own mythology, my own universe. It was already a blend of reality and fiction, of what I could see in front of me and what I wanted to work out using that reality." Thus Clark underscores the authorial role in his photographic output: if the reality he plugs into is undeniably disturbing, it is transcended to a greater or lesser extent by an art of composition and a sense of light. His pictures detailing angel-faced figures indulging in dangerous, exciting, forbidden games are taken on the fly, but he maintains a perfect command over the outcome. It is this paradox that exacerbates the tension and gives to the prints an aesthetic that has become known as "trash"—in deference to the trilogy of films by Paul Morrissey, *Flesh* (1968), *Trash* (1970), and *Heat* (1972). His favorite subject remains adolescence, with its candor and attendant capacity for self-destruction. From New York skateboarders to the Latino ghettos of Los Angeles, via the drifters of the Midwest, Clark lifts the lid on the unseen world of excessive, shameless youth. In the throes of complete transformation, the bodies of these child-women, these little guys playing at wise guys, exemplify a phase in human existence when everything balances on a knife edge: it can all turn out all right, or it can all go horribly wrong.

FACING PAGE

Jonathan Velasquez,
2003.
Color print,
41¾ x 31 in.
(106 x 79 cm).

## He said

**"It's astonishing to see how American culture is directed towards youth but it doesn't really speak to it. It's really important to me that kids recognize themselves when they watch my movies."**

# THOMAS DEMAND

## Who is he?

The master of the hoax image was born in Munich in 1964. Over the last few years he has been dividing his time between Los Angeles and Berlin. His training was thorough: starting out at the art school in Munich (1987–90), he then spent two years in Düsseldorf, where Bernd Becher was teaching, before taking a one-year course at Goldsmiths College in London where he took a masters in fine art in 1994. Demand started working as model maker, sculpting objects out of paper. He then used photography to record these ephemeral creations and eventually the medium eclipsed its subject. He became known for trick images that short-circuit our relation to reality. Earning international recognition, many exhibitions have been devoted to his work, at New York's MoMA in 2005, and in the Serpentine, London, in 2006.

## His work

You just can't trust a photo by Thomas Demand. Seductive in their technical perfection, they pull the wool over our eyes. The smooth, chilly, antiseptic interiors, devoid of all life, are fakes, simulacra. The "rooms" are, in fact, colored cardboard and paper models, on a one-to-one scale, that the artist arranges and organizes in accordance with a kind of unspoken script. The perfectly rendered prints thus derive from a modus operandi that is divided into several phases: initially Demand selects a picture from his personal photographic archive or from a history textbook, an anthology of art, or a magazine. After attentively studying its viewing angle and composition, in the studio he then proceeds to construct a painstaking 3D replica model of the image, before photographing and then destroying it. From these genuinely virtual, soulless views, there exudes a strange impression, a sense of unease that is hard to pin down: institutions or offices of an arm of the state for the most part, they evoke an ordered, totalitarian universe where architecture is rationalized to the extreme. One thinks of private or public spaces designed by faceless bureaucrats. Remind you of anything? Of East Germany, of course. Because—through these falsely true images of diving boards photographed like modern sculptures, these straight-as-a-die high-rises with geometric frontages, these stereotyped TV studios and impersonal bedrooms—Demand is stimulating our critical antennae, warning us to be wary of a world that looks too perfect.

FACING PAGE

*Diving Board,*
1994.
C-print under
Diasec,
59 x 46⅜ in.
(150 x 118 cm).

## He said
**"Everything is real, up to a point."**

# RAYMOND DEPARDON

## Who is he?

Proud to have been born to a family of farmers in Villefranche-sur-Saône in 1942, he took his first photographs with a camera his brother got for his birthday, printing his negatives himself. After graduating from high school, he worked as an apprentice in a shop belonging to a photographer-cum-optician in his native town, and, in parallel, took correspondence courses in photography with the aim of qualifying as a "photographic operator." When just sixteen he went to Paris, where he served as an assistant to Louis Foucherand. Two years later, he signed up with the Dalmas agency as a roving reporter, working as a paparazzo as well as reporting on armed conflicts. He was already traveling abroad a great deal. In 1966, together with some other photographers, he set up the Gamma agency, being joined by Gilles Caron. In 1974 he hit the headlines with a report on the Françoise Claustre affair—an ethnologist held hostage in Chad—and with a debut full-length documentary film on Valéry Giscard d'Estaing's presidential campaign (*Une partie de campagne*, 1974) that was pulled from the airwaves. There followed a further ten movie-length documentaries. *Reporters* won a César film award for best feature documentary, and *Empty Quarter, a Woman in Africa* was presented at the official selection of the Cannes Film Festival, as was *The Captive of the Desert*. In 1979, he joined the Magnum agency. In 1984, he was one of those dispatched on the Datar Photographic Mission (a government-funded commission marshaling eighty-four photographers), and continued to crisscross the world with an enduring fascination with Africa. In 2004, he embarked on the vast personal project of surveying the entire territory of France with a view camera. In 2006, he acted as guest artistic director for the thirty-seventh *Rencontres* in Arles. In 2008, he presented the film *Country Profiles, Modern Life* as an official selection at Cannes. His photographs are regularly exhibited in museums in France and abroad.

## His work

A bit of a firebrand, Depardon—as he questions his practice as both reporter and filmmaker—has built bridges between documentary, fiction, and reportage. A trailblazer, he leaves an enduring mark on everything he touches. He relentlessly raises deontological questions surrounding the photographer's craft: What should be shown? And how should it be shown? What is the correct attitude? How can a photographer avoid looking like a predator who steals people's souls? How can the fault-lines be exposed and the underlying situation revealed? The conscience of his profession, Depardon is also a touchstone. Constantly on the move, boiling over with ideas, his laser eye scrutinizes the lunacy of the world, delving obsessively into the lives of men, be they humble or grand.

FACING PAGE
Cachet-
Commercy,
Meuse, from
the series
*La France
par Raymond
Depardon*,
2010.

## He said

**"Reality possesses one important advantage over fiction: it is unique."**

# RINEKE DIJKSTRA

## Who is she?

The Dutch photographer was born in Sittard in 1959. Studying photography at the Rietveld Academy, Amsterdam, between 1981 and 1986, she then started working as an independent photographer for magazines such as *ELLE*, *Avenue*, and *Elegance*, for which she took portraits of artists, writers, and celebrities. Entertaining doubts about her chosen path, one day a commission brought her to a beach on the North Sea where she took the first full-length portraits of teenagers in bathing suits posing awkwardly in front of the lens. It was this series, which she pursued on beaches in the Ukraine, the United States, and Africa, that first drew attention to her oeuvre. Other no less beguiling series followed, and were shown at many international events, in particular at the Venice, São Paulo, and Turin biennials. She has been the recipient of several prizes, including the Kodak Award Nederland and Citibank Private Bank Photography Prize.

## Her work

Rineke Dijkstra's instantly recognizable photographs exude an indefinable sense of sadness. Showing human beings at a most fragile phase, her famous *contrapposto* adolescents, taken on the seashore as if emerging from the waters, seem willing participants, yet they radiate a lack of confidence. Standing by the water's edge, the backdrop is formed by a cloudy sky and gray sea. Dijkstra asks them to look straight at the lens and not to smile, taking them from slightly below the eyeline and in daylight, often with flash. Each photo is taken with a field camera on a color negative. Subsequently, the artist has adopted a similar approach in other series on subjects with some common thread: girls off to the nightclub, children playing in a garden, English schoolboys in uniform, mothers who have just given birth, bullfighters fresh out of the ring, French legionaries, or young recruits in Israel. Gracefully, she unpacks the physical transformations, the search for a new identity, the moments of transition or letting go, a process never more than hinted at: a bloodstain, a bead of sweat, the hint of a grin, a frown.

Deep down, Rineke Dijkstra has simply reinvented that venerable photographic saw, the pose. Her large-format prints demonstrate just how photogenic doubt and uncertainty can be. Because her sitters never cheat. They never seek to strike a conventional pose: they are as they are. And this is why they move us so.

FACING PAGE

*Hilton Head Island, USA, June 24, 1992,* 1992.
C-print,
58¾ x 49¼ x 2¼ in.
(149 x 125 x 5.7 cm).

## She said

"It's important for me to know the location is right before I approach a subject. Then, I'll find the subject within that location and work from what the subject does. When subjects are posing for me, I don't ever want to manipulate them too much."

# DAVID GOLDBLATT

## Who is he?

South Africa's greatest photographer was born in Randfontein in 1930, a Johannesburg suburb surrounded by smallholdings and gold mines belonging to Afrikaners. Born into a Lithuanian Jewish family that had fled the pogroms, Goldblatt grew up in a straitlaced but—in a way—warmhearted and exotic environment. His fascination with photography goes back to the 1940s and 1950s, when he came across pictorials like *LOOK, LIFE*, and *Picture Post*. On leaving school, he acted as an assistant to a local photographer who sent him to take wedding pictures. A disappointing experience, his apprenticeship came to a halt when his father fell ill and he had to lend a hand in the family business. During his free time, though, Goldblatt started photographing ordinary people in his immediate surroundings, seeking out "the world of ordinary people, the minutiae of everyday life that so illuminate the deep structure of injustice and the essence of the people who imposed and also defied it." His earliest works coincided with the instigation of the apartheid policy that gave official sanction to the horrors of racial segregation. In his own fashion, Goldblatt testifies to this human catastrophe. One thing leading to another, his documentary reportages made their way into specialist magazines. An objective witness, over the last thirty years Goldblatt has gained an international recognition and is shown the world over.

## His work

Goldblatt never wanted to be defined as a photojournalist—indeed he does not like being pigeonholed at all. He prefers the bare term "photographer," since he takes all kinds of pictures. He has been putting together his clear-eyed description of South African society for some sixty years in a documentary that provides a sociological sample of the various communities making up a South Africa scarred by years of apartheid. Unconcerned with "scoops," the photographer prefers to collect the telltale signs of a culture that is founded on hatred for one's neighbor. Portraying the struggles and antagonisms that pervade the land he loves so much and to which he remains attached, Goldblatt became known in the 1970s for *Some Afrikaners Photographed*, an uncompromising series that holds up a mirror to the white middle class, both cordial and bigoted. He also carried out a spectacular plunge into the hell of the gold mines of Witwatersrand, from which he compiled a photo book, *On the Mines*, with a text by the writer Nadine Gordimer, with whom he has collaborated on several occasions. One of the few Whites to enter the townships (it was also during one of the country's most troubled periods), he confers a certain dignity on his sitters. His trademark? The way—through painstakingly composed shots in strong contrasts—this critical observer presents the buildings, streets, and quarters of the suburbs, be they impoverished or well-heeled, as symbolic reflections of the social, economic, and political interrelationships of the nation, thereby translating oppression into a language of space and territory.

FACING PAGE

*Incomplete Houses, Part of Stalled Municipal Development of 1,000 Houses. Lady Grey, Eastern Cape. August 5, 2006,* 2006. Digital print, pigment dyes on 100 percent cotton rag paper, 38⅜ x 49⅝ in. (98 x 126 cm).

## He said

**"I needed to grasp something of what man is and is becoming in all the particularity of himself in his bricks and this bit of earth and this place and to contain all this in a photograph."**

# NAN GOLDIN

## Who is she?

Born in Washington in 1953, Nan Goldin exposes every facet of her life in the raw. "I started taking pictures because of my sister's suicide," Goldin explains. "That's why I photograph. I miss so many people so badly." After this tragic event, which occurred in 1969 when she was just sixteen, Nan Goldin started taking photograph after photograph of those close to her. For three years she followed courses at the Sayta Community School in Lincoln, Massachusetts, completing her education at the School of the Museum of Fine Arts, Boston, whence she obtained an art degree.

With her accomplices David Armstrong and Jack Pierson, she formed a little group that was afterwards labeled the "School of Boston." In 1978 she moved to New York and drifted into the underground scene. Recording in a kind of photographic private diary, both sensitive and poignant, the excesses of her offbeat friends (drag queens and junkies), as well as her violent affair with her lover, Brian, *the Ballad of Sexual Dependency* is a no-holds-barred depiction of fifteen years spent on the edge. Exhibited at the Whitney Museum Biennial in New York in 1985, it was published in book form in 1987. Earning plaudits from every side, the piece was awarded the book prize at the prestigious international *Rencontres* in Arles, France. At the end of the 1980s, while she was trying to get off drugs, she saw many of her closest friends die of AIDS. Goldin traveled extensively in the 1990s, just as her oeuvre was beginning to win prizes. In 1994, she published *Tokyo Love*, a series on the youth of the Japanese capital in collaboration with Nobuyoshi Araki. In 1995, her film *I'll Be Your Mirror* and the exhibition of photographs that emerged from it earned her international acclaim.

## Her work

Nan Goldin's work is readily compared to that of Larry Clark, as both shared the everyday life of the men and women they photograph. Like Clark, Goldin portrays without censure or moral judgment what lies behind the façade, the forbidden zones, those on the margins of society. In her outsider friends, she captures so minutely a quiver, a sign of jubilation, or of melancholy: it is this sensitivity that stays with the viewer. She shows odd, exhibitionist beings who quickly veer from laughter to tears. Attempting to convey the sense of complicity that holds what she calls her "extended family" together, her work does not shy away from compassion or love. Capturing their lives at the best of times and at the worst, her pictures of these erstwhile party animals laid low by disease or on their deathbed made a deep impact. She has devised a method of showing most of her prints as a slideshow: forty-five minutes, a soundtrack, and some seven hundred photographs filing past. The result is an intensely disturbing narrative.

With their exemplary flair of light and color, Goldin's photographs often attain the philosophical depth of an old master painting.

FACING PAGE
*Jabalowe on a Felluca, Nile, Luxor, 2003,* 2003.
Cibachrome print,
27½ x 40 in.
(70 x 102 cm).

## She said

**"My work is mostly about memory."**

# PAUL GRAHAM

## Who is he?

The master of "snapshot aesthetics" was born in Stratford, England, in 1956. Starting out as an independent photographer in the late 1960s, Paul Graham now shuttles between London and New York. With Martin Parr, and then Paul Seawright, Anna Fox, Paul Reas, and Nick Waplington, he is one of the British photographers who, in the 1980s, returned to a subjective and critical vein of social documentary in color. A bitter witness of the deteriorating living conditions of the most deprived in society following the Thatcher government's radical reforms, in 1985 he published *Beyond Caring* (a study of unemployment offices) and, in 1987, *Troubled Land* (on the Northern Ireland question). His work quickly characterized itself by an exceptional sense of composition. With their focus on a detail, gesture, or glance, his photographs were snapped up by private and public collections alike. His work has garnered many awards, in particular in 2009 for his book *A Shimmer of Possibility*, inspired by a collection of Chekhov short stories.

## His work

Crisscrossing the globe for many years, Graham has constructed a kind of historical and poetical fresco of unfortunates who cling desperately on to the least scrap of existence. Strongly influenced by William Eggleston's use of color, Graham was also impressed by the unsighted characters in *Blindness* by the Portuguese writer José Saramago, a novel that gave him the idea of photographing landscapes behind a piece of gauze. In the backgrounds to these figures he photographs in situ, Graham always provides a space that defines them, sometimes identifiable, sometimes indistinct. Expansive framing and unexpected angles conveying unspoken tension or unbearable discomfort seek to transcend a sense of solitude, emptiness, silence, and hopelessness that is tangible. His subjects wander about the streets, along freeways, in front of fast-food outlets; they hang around at bus stops or on deserted intersections. His series *American Night* deploys subtle variations of light and shade in a dreamlike ensemble that confers something like a soul on the disinherited of the earth. One picture in *A Shimmer of Possibility*, for example, has a thoughtful-looking man waiting for a bus, shot from various angles a few seconds apart, as to suggest a single, continuous action. Graham's intention: to convey a slice of life, to show the precariousness of each situation, to open the beholder's eyes.

FACING PAGE
*Graffiti on Motorway Sign*, 1985.

## He said

"Perhaps, instead of standing at the river's edge scooping out water, it's better to be in the current itself, to watch how the river comes up to you, flows smoothly around your presence, and reforms on the other side like you were never there."

# ANDREAS GURSKY

### Who is he?

The leading artist producing grand, splashy, visually impactful photographs, and an auction room star, Gursky benefited from a solid training. Born in Leipzig in 1955, this son and grandson of photographers had already absorbed the visual codes of advertising from his father and grandfather even before entering the Folkwangschule in Essen, an intitution that offered courses in photoreporting postwar. In 1981, he enrolled at the Kunstakademie Düsseldorf, taking courses with Bernd Becher. From the encyclopedic scope preached by his professors, what he retained above all was its systematicness. Unlike the Bechers, however, who proceeded by series, Gursky strives to synthesize his material into a single image in formats that expand to immense size. Taken from a high vantage point, the sheer grandeur of the field of view and the teeming details (further enhanced by the artist's use of digital manipulation) in these high-definition, glossy pictures is captivating.

Since the 1990s, Andreas Gursky has been regarded the figurehead of what is now known as the Düsseldorf School and his photographs have entered many of the most important public and private collections, regularly attaining record prices. In 2007, *99 Cents II Diptych* (2001) was sold for 3,346,456 US dollars at an auction at Sotheby's, London.

### His work

Gursky specializes in bird's-eye panoramas of places devoted to shopping, tourism, work, leisure, power, and money. His photographs measuring up to 6 $\frac{3}{4}$ x 16 $\frac{3}{4}$ feet (2 x 5 m) hold up a dizzying mirror to postmodern society in the age of globalization. Every one demonstrates how architecture and spatial organization—be they of a giant supermarket, the Hong Kong Stock Exchange, the frontage of an office building, a private beach, or a rock concert—betray our convictions and control our behavior. Like an entomologist, he peers down his microscope at a swaying crowd, at the arrangement of objects in a space, or at some must-see tourist spot. From New York to Cairo, from Düsseldorf to Shanghai, from Paris to Tokyo, Gursky scours the world for images of the economic effects of globalization and the standardization of life that has come with it. The iconic pictures he draws from his observations are at once real and artificial, though, many of them being the result of a number of shots reworked with CGI software. Gursky, as a conceptual artist, thus transforms reality to expose the cruel truth lying behind it.

FACING PAGE
*Rimini*,
2003.
C-print,
117$\frac{1}{4}$ x 81$\frac{1}{4}$ x 2$\frac{1}{4}$ in.
(298 x 207 x 6.2 cm).

### He said

"What I'm interested in, in the end, is not the invention of reality, but reality itself. To highlight, emphasize reality seems legitimate to me. No picture should therefore look like being retouched ... nevertheless nothing was as it seems here. These pictures are perfectly artificial."

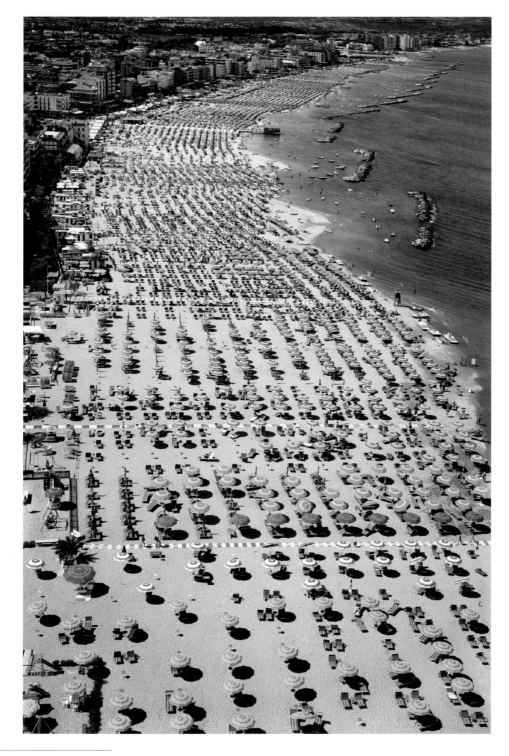

# CANDIDA HÖFER

## Who is she?

An exemplary product of the Düsseldorf School, the work of Candida Höfer is inspired by a range of personal interests. Born in Eberswalde in 1944, she studied at the Kölner Werkschulen, before enrolling in 1973 at the Kunstakademie Düsseldorf, where she studied film for three years with Ole John, before embarking on courses in photography with Bernd Becher. Concentrating on deserted collective spaces, her oeuvre quickly came to prominence, and its artistic evolution can be traced in the many one-woman and group exhibitions to which she has been, in particular at the 2002 Kassel Documenta and the 2003 Venice Biennial.

## Her work

Candida Höfer's highly individual photographs represent centers of culture, religion, or power (libraries, museums, theaters, embassies, banks, offices, churches). These public spaces are treated as much as focal points for aesthetic contemplation, reflection, and meditation, as guardians of encyclopedic knowledge, memory, and history. These tableaux are characterized by monumentality, depth of field, chromatic intensity, compositional rigor, and sharpness. So imposing is their visual presence that standing before these views constitutes a remarkable physical and intellectual experience. Filled with a sense of plenitude, the beholder sweeps their eyes over the vast interiors like some special visitor let in after closing time, sensing the peculiar spirit of places that are for the most part enwrapped in silence. These quiet yet eloquent images display the magnificence of structures with painted or carved interiors and emptied of all occupants: archetypes expressing the sheer power of the organization of knowledge, power, and belief.

FACING PAGE

*National Building Museum, Washington, DC, 1992.*
Color print, 24⅘ x 32 in. (63 x 81 cm).

## She said

"What has always fascinated me are the two phases in the process: getting accustomed to a space, getting to know it, trying to be objective, and then, afterwards, creating the picture in the lab when there's nothing left, when the image just needs to emerge in color, form, and balance."

# WILLIAM KLEIN

### Who is he?

The turbulent photographer and filmmaker William Klein was born in New York in 1928. After obtaining a diploma in sociology, he moved to Paris in 1948 to study painting, first entering the studio of André Lhote, and then that of Fernand Léger. He began showing abstract geometric canvases from 1951, but at the same time discovering the full potential of photography that he was already practicing with a painter's eye, in the course of time becoming a staff photographer for the magazine *Vogue*. After an absence of eight years, he returned to New York, taking snapshots of the city and its inhabitants, and compiling a series of unprecedented, often out-of-focus and off-center images that also made use of printing accidents, distortions, and double exposures. A style was born. After obtaining the Nadar Prize for the photo book *New York*, published in 1956, a year later Klein landed a job as assistant to Federico Fellini and left for Rome. While waiting for the shoot to begin, he took his camera into the city, deploying the same formal freedom as he did in New York. This was followed by projects in similar vein in Moscow, Tokyo, and, finally, Paris. At the beginning of 1960, Klein embarked on a parallel career as a film director. He has made a large number of commercials, some documentaries, as well as full-length movies including *Who Are You, Polly Magoo?* (1966), *Eldridge Cleaver, Black Panther* (1970), *Muhammad Ali, The Greatest* (1974) and *The Little Richard Story* (1980), in which his condemnation of social and racial injustice and cliquey snobbery pulls no punches. On the photography side, his work gained a new lease of life with the adoption of color. Exhibited at the MoMA in 1980, and then in 1982 and 2006 at the Centre Pompidou, Paris, he has been awarded the prestigious Hasselblad Prize.

### His work

A rare energy courses through the photographic output of the man they call "Bad Boy." Klein's hard-hitting work captures, and sometimes cruelly disfigures, "the ambient electricity" of the city—the constant flow of cars, the stress on the faces of passersby, the fever of consumerism: his supple treatment of depth of field is exacerbated by the use of wide-angle lenses. Lightning-fast shots of a world in perpetual transformation, they remain a vibrant testimony to the deep changes that have affected society over the last fifty years. Inventing new forms, rewriting the codes—from the outset Klein, rather in the surrealist manner, rode roughshod over the rules of documentary photography. Shifting back and forth between the worlds of art, fashion, and film, his work acquired a boundless and unique freedom of expression. By eschewing neutrality and all sense of visual remoteness, Klein "feels" his way as he reorganizes and reinvents each assignment. His prints translate his undiminished interest in the vanishing point at the end of an avenue or in the structure of a building. Forever calling his own work into question, Klein has even exhibited old contact sheets scrawled with colored lines, papering them all over the walls of the museum. For Klein, a photograph is first and foremost a malleable material.

FACING PAGE
*Club Allegro Fortissimo, Paris,* 1990.
Black-and-white print with highlights.

### He said

**"Taking a picture is an excuse for being an idle onlooker. I'm giving myself the impression of doing something so I feel less guilty."**

# SZE TSUNG LEONG

## Who is he?

Sze Tsung Leong was born in Mexico City in 1970 and spent his childhood in Mexico, England, and the United States. Today, he lives and works in New York. He began his studies at the Art Center College of Design, Pasadena, Los Angeles, before obtaining a degree from Berkeley, followed by a masters from Harvard. In 2005, he received a grant from the Guggenheim, and the Museum of Contemporary Art in Monterrey, Mexico, devoted a significant one-man exhibition to his work. He has also taken part in many international events and has notably presented his work at the Taipei (2004) and Havana (2006) biennials. The publisher Steidl has brought out his *History Images* (2006) and *Horizons* (2011).

## His work

Sze Tsung Leong's abiding theme is the city and urban development. Devising comparative systems from shots taken, for example, over a single year at various world locations, his painstaking modus operandi unfolds in series. *Cities* presents several kinds of urban configurations, from medieval towns to the most recent conurbations, offering a 360-degree panorama of the structures that cohabit on our planet over a specific period. He extended his range in *Horizons*, covering images of urban, rural, and industrial landscape, taken from a distance, as if viewed from a boat, plane, or train. Positioning the horizon always on the same line, when the prints are presented next to one another they describe a single contrasting but continuous line. The tops of Dubai's high-rises extend, for example, into the domes of Venice, before leading to the Egyptian pyramids. *History Images* represents a long-term assignment for Sze Tsung Leong. Since 2002, he has been exploring the history of China, photographing the nation's immense construction projects at various stages in their development, as well as showing the progressive obliteration of historic sites. In images taken in Beijing, Nanjing, and Chongqing, the photographer insists on the similarity of buildings and shopping centers that conform to a normative, functionalist aesthetics. His razor-sharp views testify to the brutal shift to a collective economy that reifies the environment and to a market economy that remodels it unceasingly.

## He said

"Beauty can take so many forms.... There is beauty that arises from the unexpected, when our familiar perspectives are thrown off balance. There is also the beauty that paradoxically comes out of the tragic, that emerges because we are reminded of what is no longer there, that becomes powerful because of what is absent."

# BORIS MIKHAILOV

## Who is he?

The nefarious Boris Mikhailov was born in the Ukraine in 1938. As an engineer in a military factory, and taking pictures as a hobby, he was charged with drawing up a report on the company. Seizing this as an opportunity to improve his technique, he found himself training on the job at the age of twenty-eight. As he later confessed, he started taking photography seriously when took a picture "of a woman holding a cigarette. That was a radical break from the norms: you were only supposed to show Soviet women as an ideal." Thus, from the outset, Mikhailov chose to express himself outside the straitjacket of the USSR propaganda machine. Photographing, among other things, his naked wife, from the very first time his work was presented, the KGB came down on him hard, destroying pictures it considered indecent or subversive. To make a living, Mikhailov then became a technical photographer at the Project Institute, continuing to take clandestine and highly critical pictures of real life. Experimenting widely (for instance, superimposing slides and color photographs or intervening directly on the negative), his series are always raw, grating, and provocative. The *Red Series* (1968–75) debunks official Communist imagery, *Unfinished Dissertations* (1985) unfolds like a private diary, while *Salt Lake* (1986) shows bathers blithely frolicking in a lake's polluted waters. In 1995, he stirred up a scandal with *If I Were a German*, sadomasochistic erotic tableaux that starred the photographer himself in Nazi uniform, and in 1999 produced *Case History*, which delineates those left behind by the reforms of perestroika—the homeless, half-naked and impoverished—in images showing them as horrific creatures, filthy and malevolent. Over the last ten years Mikhailov has acquired an international reputation, winning the Hasselblad Prize in 2000 and the Citibank Private Bank Photography Prize the following year.

## His work

In spite of sometimes catching sight of a photograph by Cartier-Bresson or an American photographer working in color, at an early stage Mikhailov realized that access to models from abroad, inevitably at odds with his immediate surroundings, was never going to further his aims. Western photographers, he remarks, "have a really strong aesthetic, which corresponds to technology and the Western environment. In my life there is dirt, things are broken. I needed to concentrate on what was real." Mikhailov's genius resides precisely in resisting the norm, and in seeking instead a means of capturing the dark, rough-and-ready reality that surrounds him. At once vulgar and grotesque, heartless and joyous, unjust and vital, the originality of this maverick's oeuvre owes much to his deeply held conviction that truth lies there, before his very eyes, vibrant and violent. It is then from this tension, and with the makeshift means at his disposal, that he has forged his idiom. Strongly contrasted, tautly framed images of a grayish texture saturated with information reflect a knowingly lurid view of a no less obscene reality.

## He said

"I think it's very difficult to find themes these days. You have to look around and ask yourself: What is my life about?"

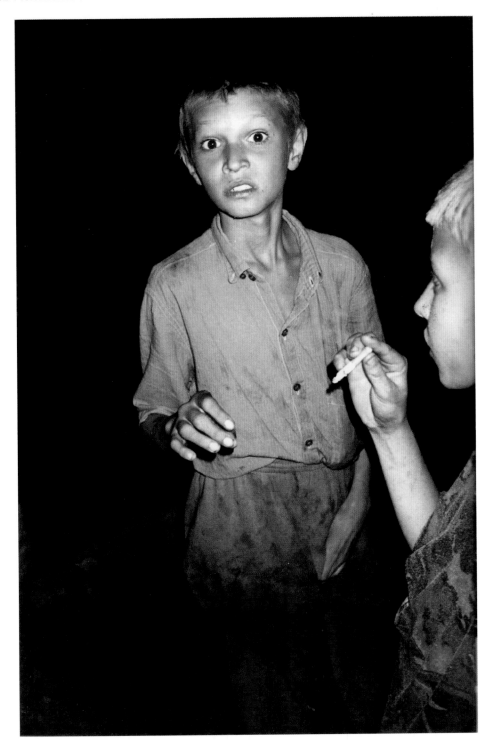

# SANTU MOFOKENG

## Who is he?

To be born black in 1956, in the Soweto of segregated South Africa, did not provide much of a spring-board for a photographic career. In the land of apartheid, the trade of picture hunter was, like many others, a purely white preserve. As a child, Mofokeng watched fascinated as traveling photographers would come to his district on special occasions to take pictures. On finishing secondary school, he decided to devote his life to his passion, and, like the men he admired, he started covering christenings, weddings, or popular festivals. As vocational schools were closed to him, he got a job as an assistant in darkrooms on various newspapers. Luckily, the magazine *Drum* accepted mixed-race teams, and one of its members, David Goldblatt (see page 200), taught him the rudiments of photojournalism. In the 1980s, Santu Mofokeng became a freelance photographer and joined a group of white and black reporters documenting the misery and violence of the townships for the international press. In 1985, he joined Afraprix, a multiethnic militant collective, denouncing the racist policies of the South African government. But Mofokeng discovered that he did not possess the heart of a true photoreporter: he wanted rather to transcribe the reality beyond the raw event. Pursuing a more personal quest, he started exhibiting early in the 1990s, coming through as one of the major figures on the contemporary South African photography scene. Sparked by his contribution to the Kassel Documenta in 2002, his international recognition has since progressed in leaps and bounds.

## His work

Infused by an epic feel, Santu Mofokeng's black-and-white pictures impose their presence through poetry and the close attention they pay to the men and the women that they capture in intimate moments. They trans-late the noise, the smell, sweat, laughter, and tears in their tense, pre-carious existence. In slightly off-center compositions and light effects that ring a figure or underscore an atmosphere, Mofokeng searches out the little trials and tribulations of a harsh daily existence, as well as the impact of the immediate environment on lives that often hang by a thread. Combining the rigor of documentary with the vitality of a snapshot taken on the fly, the artist has forged a style by concentrating solely on what really interests him, confessing that, when he used to take photos to order, he failed to pay sufficient attention to the stories and aspirations of his subjects. Changing tack, he adopted a less event-driven, more intuitive approach, based on his lived experience. *The Black Photo Album, Johannesburg, 1890–1950* features original variations on images taken from family albums belonging to black workers to build into a dignified monument to their memory.

## He said

"Landscape is the mute witness to histories and narratives."

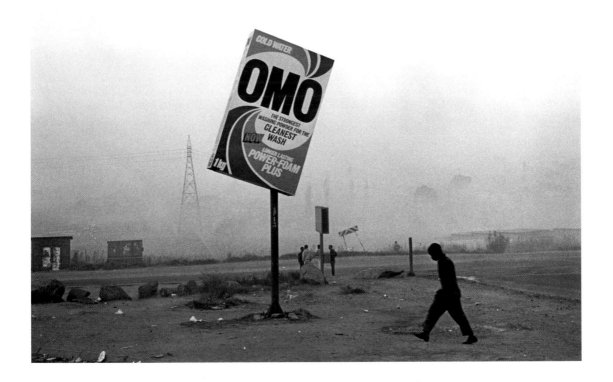

# JEAN-LUC MOULÈNE

## Who is he?

Born in Rheims in 1955, he has lived and worked in Paris since 1973. After studying fine art and literature, Jean-Luc Moulène set out as an art director, entering the world of advertising. In 1990, he decided to devote his time entirely to art, and taught for some ten years. His oeuvre is highly diverse, moving from drawing, painting, and sculpture to focus on photography presented in the form of large-size tableaux, posters, booklets, books, and in newspaper supplements. He deals primarily in series: *Disjunctions* (1996), for instance, extended over a period of more than ten years. No less significant are *Monuments of Paris*, and *Document/Strike Objects* (1999), *Products of Palestine* (2002–05), *The Girls of Amsterdam* (2005), and *Flowers* (2008). Rigorous and demanding, Jean-Luc Moulène's impressive individual works have been taken up by many important public and private collections. They have also been regularly showcased at international exhibits, in particular at the Kassel Documenta in 1997 and the 2011 Venice Biennial, as well as in Paris, London, Berlin, Brussels, Tokyo, and New York, and shows have been held in his honor in the museum of the Jeu de Paume in Paris and at the DIA Foundation, New York.

## His work

Jean-Luc Moulène's processes upset the artistic codes of representation by using the tools of marketing and advertising language to expose the manipulative potency and seductive appeal of visual communication. This is a systematic approach, though not devoid of humor or derision. The artist invites viewers to open their eyes, to stop looking without seeing by perverting the techniques that promote consumer products, as well as those deployed in creating artworks. Emblematic of his work, *Objets de grève* (*Strike Objects*) were primarily acquired and collected by the artist for their intrinsic symbolic, political, and aesthetic values. What exactly are they? Propaganda articles made by workers involved in industrial disputes in the 1970s and 1980s—not to sell goods, but to make known their grievances. Showing, for example, in the idiom of an advertising billboard, a Lip watch, a supermarket frying pan, and a pack of Gauloises cigarettes belonging to striking workers, Moulène superimposes the concepts of archive and merchandise. He has also done portraits, nudes, and still lifes, as if dissecting his models the better to understand, analyse, and then monumentalize them. Invited to show at the Louvre in 2006, he subjected about twenty archaeological statuettes to the same type of treatment, presenting them as large-format photographs and in the form of full-page spreads in a complementary supplement of *Le Monde* newspaper. Just another vehicle for distributing his work.

FACING PAGE
*Spider Gilles, Nantes, October 24, 2003,* 2003. Cibachrome glue-mounted on aluminum, 15¾ x 20½ in. (40 x 52 cm).

## He said

**"Photography renders visible facts and signals which lie outside, or inside, the power relation."**

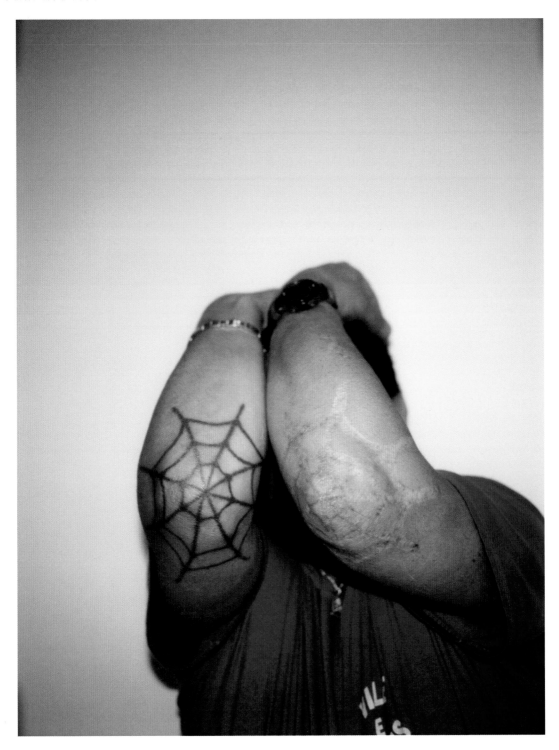

# MARTIN PARR

## Who is he?

This master of derision and irony was born in 1952 in Epsom, Surrey, a town in the commuter belt south of London. Encouraged by his grandfather, who enjoyed photography as a hobby, his interest in the medium dates from the early age of thirteen. Later, by then acquainted with the work of Bill Brandt and Henri Cartier-Bresson, he studied at Manchester Polytechnic from 1970 to 1973. The subject of his first photos was the northern city of Manchester, its working-class population and proletarian culture. In 1980, he moved with his wife to Ireland, publishing his debut work *Bad Weather* in 1982. The tone is set: its main targets are the lifestyles and manias of ordinary people, which he delineates with a corrosive, very British humor. The same year, he chose to live in Liverpool and started using color. A major change. At the same moment, Margaret Thatcher and her privatization policies begin steamrolling the working class, producing a seismic shift in English society that Parr wasted no time in portraying. After publishing several albums on the subject, in 1994 he joined the Magnum agency, where his sarcasm was hardly in keeping with house style. For, though admirably deadpan, Parr captures with a coruscating drollery the sheeplike activities of his compatriots, as well as the planetary standardization of tastes and aspirations in the wake of globalization. In 2004, his general curatorship of the international *Rencontres* of photography in Arles, France revealed his prodigious photographic culture and fondness for amateur work, and proved highly successful. A compulsive collector, for years Parr has been amassing all kinds of photographic souvenirs and memorials, as well as rare photo books and prints. Martin Parr had always been recognized as a documentarian: he is now internationally hailed as an artist.

## His work

Hordes of tourists crowd round the banks of the Niagara Falls, or line up in front of the pyramids of Egypt. Bathers gaze out over a vast, artificial sea, while skiers have the time of their lives on a synthetic piste. Vacationers dance surrounded by plastic palm trees, while others descend on a buffet, carrying off piles of sausages dripping with fat. Elsewhere men in dinner jackets dine on tables on the lawn and ladies in evening gowns nibble their petits fours. Parr's language is characterized by garish colors, bizarre settings, and succinct storylines. His talent? Making us smile and opening our eyes to the depredations of mass tourism, the lunacy of unbridled consumerism, and the new conformism. For more than thirty years, Martin Parr has been dealing in an amusing if often cruel satire of Western contemporary society, which he strips to the bone and shows as it really is. His tracking of grotesque events and the blindness of crowds, using (and misusing) flash, wide angles, and close-ups, is an edifying experience.

FACING PAGE

*Wedding Preparations, England*, from the series *The Cost of Living*, 1986–89.

## He said

"I looked around at what my colleagues were doing, and asked myself, 'What relationship has it with what's going on?' I found there was a great distortion of contemporary life. Photographers were interested only in certain things. A visually interesting place, people who were either very rich or very poor, and nostalgia."

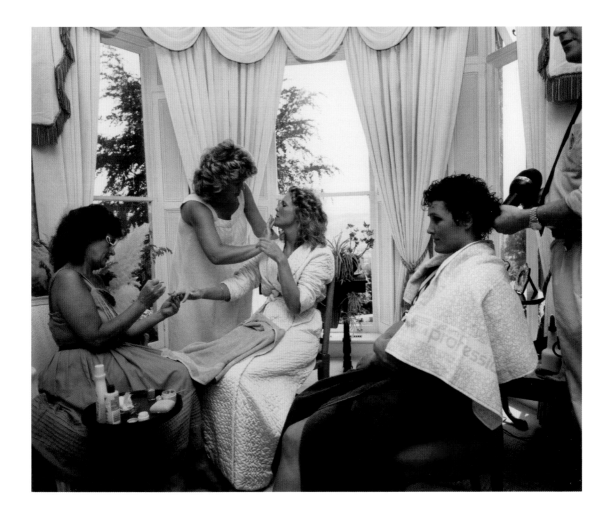

# PIERRE ET GILLES

## Who are they?

They were born to meet. Signing their works "Pierre et Gilles," they have been working together since they met in Paris in 1976, pooling their creativity and emotional lives in the service of a single work, a mix of photography and painting. Events take place in their large studio loft in Bagnolet, outside Paris, with a TV showing nonstop Chinese, Indian, and Korean comedies, or else Hollywood Technicolor classics. In the 1980s, they rubbed shoulders with the creatures of the trendy nightclub-theater Le Palace, meeting everyone who was anyone in the milieus of pop music, indie cinema, and fashion. Stars of showbiz adore their world: Boy George, Catherine Deneuve, Madonna, but also Jean-Paul Gaultier and Thierry Mugler, have all had their portrait taken in Pierre et Gilles's fairyland, kitsch, Liberace-like sets. Over the last few years, their work has come to prominence on both the French and the international art scenes, and is now exhibited, to great acclaim, at many art festivals and prestigious museums and institutions, including the Jeu de Paume in Paris.

## Their work

For Pierre et Gilles, the art of portraiture is generated by a long and complex process that reflects their private fantasies and desires. It all begins with a drawing they compose in tandem. Taking their inspiration from a wide range of sources, they flick through exotic photo books, erotic magazines, volumes on art, scientific documents, and watch movies of every conceivable kind. They then manufacture, generally by hand themselves, the set in which they sit model, a star, or a friend, surrounded by objects they have amassed on their many travels. They choose the costumes, put the finishing touches to the makeup, and adjust the lighting. Pierre then immortalizes the whole scene with his camera, and then Gilles gets to work on retouching, making the sitter look more and more beautiful, and more and more unreal, with successive layers of paint and glaze. Pierre et Gilles deal uniquely in one-offs, images inspired at once by pop art and a slick, butter-wouldn't-melt-in-its-mouth aestheticism, in a marriage made in heaven of highbrow and lowbrow culture. The images all say something, hint at a back-story, or address some theme. With blessed virgins, young sailors, or poor fishermen as recurrent figures of the pantheon, Pierre and Gilles's superficially enchanted world can also sometimes be a cruel and dangerous place, like in a real fairytale.

*FACING PAGE*
*Arielle Dombasle,*
*The Forbidden*
*Fruit,*
*2011.*

## They said

**"We like to idealize, but we also talk about death, mystery, and the oddness of life.
In our images there is as much violence as gentleness."**

# MIGUEL RIO BRANCO

## Who is he?

The Brazilian artist Miguel da Silva Paranhos do Rio Branco, known as Miguel Rio Branco, was born in the Canary Islands in 1946. The son of Brazilian diplomat, he spent his child-hood shuffling between various countries, cultures, and languages. Joining the Magnum agency in 1980, he has become a leading light on the Brazilian contemporary art stage, working in drawing, painting, video, and film, in addition to photography. He also makes collages and installations so as to tell stories and reveal what is a painful and highly charged social reality. Characterized by warm tones and often off-center framings, his images radiate tension. His work has already been widely shown in the United States, Japan, Latin America, and in southern Europe, and is present in many public and private collections.

## His work

Rio Branco started taking photographs in black and white. The move to color in the 1970s allowed him to powerfully emphasize the artistic dimension that fuels his work. A painter by training, he is keen to come across as a visual artist and not a photoreporter. Between painting and photography: "It comes and goes," he says, meaning that the one feeds the other. His strongly contrasted, baroque-inspired prints in saturated hues are bathed in artificial lighting, imposing their vision through memorable synthetic power. Using what can only be described as a palette, dominated by dark red, strident green, dense yellow, and deep blue, his pictures immerse the viewer in a kind of stage set: the content resides entirely in the relationship that models maintain with the space sur-rounding them and in their standoff with the photographer's lens. A rusty old car, a starv-ing stray dog, or the remnants of a makeshift encampment—all speaks of the plight of Brazil's poor and destitute, but also of the vitality of people rejected by the world. In a blend of the sensuous and the vicious, he captures the abused bodies of prostitutes in Salvador da Bahia, the unhinged, gratuitous violence of street urchins in Rio de Janeiro, the heady power of voodoo ritual. The same electric atmosphere reigns when Branco turns his camera on a boxing academy in Santa Rosa or ventures behind the scenes at the bullrings of Madrid. Turning the camera for once on the wretched, and translating the unspoken revolt of beings oppressed by a hostile world, this dark universe, full of earthly energy and burning sun, makes an explosive compound whose ingredients Branco holds under admirable control.

FACING PAGE
*Para State,*
*Kayapo Indian*
*Village, Gorotire,*
*Brazil,*
*1983.*

## He said

**"My photographic style is never predetermined. It depends a lot on the construction of the picture, on the poetic bonds forged between the images, and not on some pre-established principle of composition, light, or color."**

# SOPHIE RISTELHUEBER

### Who is she?

Sophie Ristelhueber's profile is somewhat atypical. Before devoting herself to photography, the Parisian, born in 1949, studied literature at the Sorbonne and at the prestigious École Pratique des Hautes Études. She began by working in publishing and in the press, in particular for the magazine *ZOOM*, specializing in the visual arts, before codirecting with Raymond Depardon the film *San Clemente* (1982), the name of a psychiatric hospital located on a small Venetian island. The same year, she left for Beirut where war was raging, not to observe the conflict as such, but to realize a piece on modern ruins. Her assignment spawned a photo book that came out two years later, affirming her singular position with respect to photoreportage: showing half-destroyed residential blocks pockmarked with bullet holes, her painstakingly taken prints are the polar opposite of hurriedly taken reels of war footage. After a sequence of orders and pursuing a series based a private memory, *Vulaines* (1989), Sophie Ristelhueber set off to cover operations in the Gulf. Among other series, *Fait* ("Fact," 1992), concentrates on views from a helicopter over battlefields that are scarred with tracks left on the sand by tanks, by shelling, and military camps; *Every One* (1994), which presents in impressive formats the devastating effects of war on the bodies of civilians who hold up their wounds and scars to the camera; *Iraq, 2001* (2001) focuses on mines half hidden in the earth; *VVB* (2005), centering on stone roadblocks in the West Bank, and *Eleven Blowups* (2006), showing the enormous craters left in the ground by fierce explosions. From early on, Sophie Ristelhueber's works appeared in international museums and centers of contemporary art.

## Her work

In deliberately referring to the pictorial tradition, Sophie Ristelhueber has perhaps reinvented history painting. Alluding to the memento mori, her work also tackles the ruin as a metaphor for the end of the world—a theme much in vogue among the nineteenth-century Romantics. She also harks back to those photographers who, at the turn of the 1900s, sailed the seven seas to compile quasi-scientific topologies of the world. But by utilizing photography and operating in the same places as war reporters, who are more subject to the vagaries of newsgathering, and by working in a manner at once distanced and peripheral, the artist's vision is impregnated with a philosophical approach to life and destiny, as well as to current events. For more than twenty years, Sophie Ristelhueber's reflections have focused on the question of the territory and its history, on man and his lands, inviting us to ask how a place can live at the same time in our bodies and in our souls. And then to inquire how the concept of trauma leaves wounds in skin and in walls, on earth and on sand.

*FACING PAGE*

*Fact No. 40*,
1992.
Color silver print,
39½ x 50 x 2 in.
(100 x 127 x 5 cm).

### She said

**"I started with a very precise idea, to do a piece on the ruins of modern architecture; not to testify to a conflict somewhere on the planet."**

# LISE SARFATI

## Who is she?

Born in Oran, Algeria, on April 12, 1958, she moved to Nice with her family two years later. She started taking photographs at the age of thirteen on the famous Promenade des Anglais seafront. Studying Russian at the Sorbonne, Paris, for her masters she chose the subject of Soviet photography of the 1920s. She became official photographer at the Académie des Beaux-Arts and her photographs with a view camera of old masters appeared in exhibition catalogs. She then obtained an extramural Villa Medici grant, leaving for Russia, where she traveled for ten years. On her return, her work was honored by the Infinity Award of the International Center of Photography, New York, and the Nièpce Prize in Paris. She enjoyed a debut solo exhibition at the Centre de la Photographie in 1996, and joined Magnum in 1997, serving as a full member from 2001 to 2011. Since 2003, Lise Sarfati has worked in the United States on series concerned with the figure of contemporary woman: *The New Life* (2003), *Immaculate* (2006–07), *Austin, Texas* (2008), *She* (2005–09), *Sloane* (2009), *On Hollywood* (2009–11). She has been the subject of numerous exhibitions in many museums, such as the Centre Pompidou and the Maison Européenne de la Photographie in Paris, the International Center of Photography, New York, the San Francisco MoMA, and the Photographers' Gallery in London. Her works can be seen in many collections, including at the Museum of Contemporary Art, Los Angeles, the San Francisco MoMA, the Brooklyn Museum, the Philadelphia Museum of Modern Art, and Bibliothèque Nationale, in Paris. In 2014, the latter institution is scheduled to present a complete overview of her oeuvre. She is represented by the Rose Gallery, Los Angeles, and by the Yossi Milo Gallery, New York.

## Her work

Each of Lise Sarfati's series radiates a restrained power that viewers perceive through its forceful coloring, atypical framings, and the tension established between camera and model, the whole immersed in a magic, an almost cinematographic light. It is hard not to be captivated by her portraits, in particular those in the series *The New Life, Austin, Texas,* and *She*, showing ill-at-ease teenage girls. Why do they seem so strange? How can they look so run-of-the-mill and yet at the same time so sophisticated? Something makes them tip over into uniqueness; it's almost imperceptible: the lipstick a little too red, the hairstyle too severe, the clothes too neat. At the antipodes of Larry Clark, Lise Sarfati's pictures do not record youth as it drifts from high to comedown: on the contrary, she places the emphasis on timelessness and normality. In rather awkward attitudes—a hint of a sulk, the eyes slightly clouded over—these girls on the cusp of life appear as one with their environment, inside or in front of their suburban middle-class homes in Berkeley, Oakland, and Austin. Lise Sarfati catches with searing authenticity this time of life when everything seems possible, extracting from their ordinariness women-to-be who are searching for an identity and who pose playing their own role. Magnifying them so as to reveal their sublime sense of interiority, the photographer manages to transcribe the unseen cataclysm affecting beings in the process of becoming.

## She said

"Perhaps adolescence is the only genuine moment in life."

# ANDRES SERRANO

## Who is he?

The artist whose work so regularly ignites the fuse of scandal was born in 1950 in New York into a family with Honduran and Afro-Cuban origins. A strict Catholic upbringing marked him deeply. Did he perhaps once think of taking religious orders? Finally, Serrano registered at the Brooklyn Museum Art School between 1967 and 1969, but his beginnings as a painter and sculptor proved problematic. His work started to attract attention when, in 1985, he exhibited a debut series of large-format color photographs already tackling highly controversial subjects like sex, religion, death, and racial tension. This combustible combination was pursued in series after series: in 1989, he was accused of blasphemy for creating a work entitled *Piss Christ*, thus joining his colleague Robert Mapplethorpe as the conservatives' bête noire. His series on the Ku Klux Klan did little to calm the waters, while *The Morgue*, focusing on corpses after accidents, stirred up another hornets' nest and was bitterly attacked. And yet the plastic quality of his pieces was admired by specialists and, from early in the twenty-first century, Serrano began exhibiting widely all over the world. Danger was never far away, though. In April 2011, the work *Piss Christ* was vandalized by fundamentalist Catholics at the Collection Lambert in Avignon.

## His work

"I use photography like a painter uses his canvas," Andres Serrano explains. Regularly paying tribute to Delacroix and Géricault, as well as to Dutch painting of the sixteenth and seventeenth centuries, his images betray the artist's meticulous care over composition, framing, lighting, and chromatic harmony. There lies a genuine paradox between the spiritual dimension released by the visual beauty of his prints—some of which are highly conducive to meditation—and the hysterical reactions they have sparked in some viewers. As the artist sees it, the controversy arises from a misunderstanding, the turbulent history of *Piss Christ* offering an eloquent example. This piece, carried out when the artistic milieu of New York was being decimated by the AIDS epidemic, forms part of a series inspired by the theory of humors that informed medieval medicine, simultaneously referring to the key role played by blood and sperm in the transmission of HIV. An appeal for mercy? Still, it must be admitted that Serrano's work is poised on a knife-edge. With his series *The Morgue*, he invites the viewers not so much to look at death head-on, as to meditate on life and its tragic end. Because Serrano is not a documentary photographer. Like the great painting masters of the past, he seeks to transcend reality, to go beyond the anecdotal, and sublimate his subjects.

FACING PAGE
The Church
(Sister Jeanne
Myriam),
1991.
Cibachrome,
32¼ x 45 in.
(82 x 114.3 cm).

## He said

"Artists do not tell the meaning of their pictures. If the meaning is that obvious, it is not art any more, it becomes propaganda."

# CINDY SHERMAN

### Who is she?

The high priestess of the conceptual self-portrait, Cindy Sherman was born in New Jersey in 1954, enrolling at the State University of New York in 1976. Reproducing the art of the past, or pictures taken from magazines, the experience was a discouraging one. "There was nothing more to say [through painting]," she later recalled. "I was meticulously copying other art and then I realized I could just use a camera and put my time into an idea instead." Her real passion? Slapping on the greasepaint, donning a disguise, adopting another identity: she would turn up at exhibition openings decked out extravagantly. Her at once intriguing and appealing debut photographic series, entitled *Untitled Film Stills*, comprises sixty-nine black-and-white prints that appear to have been taken "on set," inspired by the B movies of the 1950s, and show her playing a range of heroines.

In 1980, Cindy Sherman went over to color, attacking the stereotypes of femininity with impressive violence. Debunking fashion photography and subverting the codes of the genre, she depicts herself as grubby, unkempt, painfully submissive. She then embarked on an uninhibited exploration of a gorier vein, attaching prostheses to her body in series such as *Fairy Tales* (1985), *Disasters* (1986–89), *Civil War* (1991), and *Mask* (1994–96), and adopting outlandish postures and some horrendous makeup. Excrement, blood, and vomit meanwhile adorn the backgrounds of these compositions. Another of her targets concerns art history: in *History Portraits/Old Masters* (1988–90), Sherman reinterprets iconic figures from masterpieces of classical painting as caricatures. For *Sex Pictures* (1992) and *Broken Dolls*, dealing with sex and pornography, she uses wax dummies and disjointed puppets reminiscent of the manner of Hans Bellmer. For *Standard Hollywood/Hampton* (2000–02), the artist returned to the other side of the lens: sporting overdone makeup, she plagiarizes the artificial beauty of women who repeatedly resort to plastic surgery. In *Clowns* (2004–06), she dons the ultimate mask of parody. But is she really trying to make us laugh?

Today, Cindy Sherman's works line the walls of important museums and have been acquired by many prestigious collections. In May 2011, a work from the series *Untitled* attained a price of 3.89 million dollars at Christie's, so becoming the most expensive photograph in the world at that time. Sherman was a Hasselblad Award winner in 1999.

### Her work

For more than thirty years Cindy Sherman has been putting herself through a kind of self-analysis, extrapolating a tendency to narcissism to extreme lengths. Yet her works deal with far more than her personal problems. Tirelessly she explores the question of identity and appearance in general, and of female identity in particular. More broadly, she inquires into the complexity of the human subject, probing the psyche and excavating at the root of evil and fear.

FACING PAGE
*Untitled No. 408*,
2002.
Color photograph,
54 x 36 in.
(137.2 x 91.4 cm).

### She said

"I don't think I can see the world through other people's eyes, but I can capture an attitude or a look that makes others think I can. I have an appreciation for why people choose to look the way they do. But I can't know what they experience."

30 PHOTOGRAPHERS

232

# MALICK SIDIBÉ

### Who is he?

A key figure in African photography, Malick Sidibé was born in about 1935 in Soloba, a small village in Mali some 185 miles (300 kilometers) from Bamako. Thanks to a talent for drawing, he managed to enter the École des Artisans Soudanais in Bamako, where he obtained a diploma to work as a craftsman jeweler. The French photographer Gérard Guillat asked him to decorate the façade of his studio, Photo Service, subsequently taking him on as an assistant photographer. Sidibé accompanied him on assignments among the colonial population. Guillat frequently sent his young apprentice to cover local dance halls and private parties thrown by the youth of Bamako. Sidibé's earliest photos date to 1955, and, by the early 1960s, when Mali was gaining its independence, and following the closing of Photo Service, Malick Sidibé opened a studio of his own. He had already made a name for himself and was appreciated among the lower-middle and middle classes, often being commissioned to cover events and ceremonies: christenings, weddings, sports meetings, etc. He specialized in taking pictures of yéyé evenings—fun get-togethers at which the local youth, dressed to the nines in European-style bell-bottoms and floral frocks, danced to the latest hit tunes. Organized in the manner of a nightclub, each would adopt the name of their favorite star from the international top ten. A decade later, Malick focused on studio portraiture and repairing old cameras, becoming an avid collector. Over the years, Malick constituted an invaluable body of archives. In 1994, his work was successfully presented at the debut *Rencontres* in Bamako, igniting a meteoric ascent to international stardom. Later exhibiting in London, Tokyo, Paris, and New York, he received the prestigious Hasselblad Award in 2003, an honorary Golden Lion for lifetime achievement at the 2007 Venice Biennial, and the PhotoEspaña Baume & Mercier Prize in 2009.

### His work

A remarkable studio photographer, the style that Malick Sidibé created is less static than tradition demanded. In a studio lined with shelves creaking under the weight of old Rolleiflex and wall cupboards chock-a-block with precious archives, there stands, between the washbasin and a small corridor, a dais with a black-and-white striped cloth used as a backdrop. It is here that it all happens. Sidibé allows his models considerable freedom of pose, and, from long nights spent taking pictures of the young at play, he has kept a pronounced taste for spontaneity and naturalness. Today, the studio functions only sporadically, though, when he is not traveling to some exhibition or other, Sidibé likes to sit in front of his shop with his awards arranged on a little table. Passersby, many of whom he knows personally, often come to pay their respects to him as if he were royalty.

FACING PAGE
*Boys by the Roadside,*
1975.

### He said

**"I am recognized by people even in the villages, because I have taken portraits of many people in Bamako and they go back to their villages with my photographs; but there's nothing official about it."**

# THOMAS STRUTH

## Who is he?

He was born in Geldern, Germany, in 1954. In 1973, he entered the Düsseldorf Kunstakademie where he started out studying painting with Gerhard Richter, before following courses in photography with Bernd Becher. The latter taught him the concept of the photographic inventory and showed him how to take pictures using a view camera. The pupil soon surpassed the master, since, by the late 1970s, Struth was being noted for photographs of deserted, rectilinear streets that brought out the architecture and the disposition of the housing with relentless rigor. Proceeding by series and themes in accordance with a pre-established system, in addition to investigations on the specific characteristics of cityscapes all over the world, he has also taken relatively neutral, large-format, full-face portraits of seated subjects. In a like spirit, and in the course of his many journeys, he has also produced extremely posed family portraits. As the 1990s dawned, Struth was photographing with the same dispassionate austerity herds of visitors admiring masterpieces in vast museums. This was a series he prolonged with the façades of religious buildings, places dedicated to another form of meditation: Notre-Dame in Paris, the cathedral of Milan, churches in Venice, and the Buddhist monastery at Todai-ji in Nara, Japan. Other paths thoroughly explored by the artist include landscape, unspoiled forests, and flowers, in which he demonstrates how nature can become invasive and dangerous. Over the last twenty years or so, Thomas Struth has acquired international renown, and his works appear in many major public and private collections. On November 13, 2007, his photograph *The Pantheon, Rome* (1990) was sold for 1.049 million dollars at Christie's, New York.

## His work

Thomas Struth practices photography but conserves the mind and the eye of a painter: he calculates his framings to the millimeter, is painstakingly attentive to the internal composition of the image, and is prepared to push the chromatic intensity in order to achieve the required color balance. Yet in fact the principal axis of his work is not constituted by the deconstruction of the parameters of the photographic medium. On the contrary, his aim is to synthesize thought and to afford depth to what are chilly, glassy images. Is a photograph *una cosa mentale*? Absolutely. And if his groups tackle apparently very diverse subjects, they share the common aim of urging viewers to meditate, not only on the idea of construction (be it architectural or mental), but also on destruction: rather like in a sci-fi movie, an end-of-the-world shiver courses through these images of deserted streets dominated by gray buildings, these robot-like portraits, and this overly luxuriant foliage. Relentless.

FACING PAGE

*Vehicle Assembly Building Kennedy Space Center, Cape Canaveral, USA,* 2008.
C-print,
90 x 72 in.
(228.9 x 182.8 x 6 cm).

## He said

"I do not like the word 'series,' because it's misleading, since it could mean that the individual image isn't important. For me, however, every image is important. For this reason, I prefer the word 'group' to the word 'series.'"

# HIROSHI SUGIMOTO

## Who is he?

The master of black and white, Hiroshi Sugimoto was born in Tokyo in 1948. Aged twenty-two, he left Japan to study photography at the Art College of Design, Los Angeles, obtaining his diploma in 1974. He now lives between New York and Tokyo. His work remains strongly influenced by American conceptual and minimalist art, the dominant forces in the avant-garde of the 1970s, but equally by the traditional Japanese culture he grew up surrounded by. Displaying considerable interest in the photographic experiments carried out in the 1920s by the Dadaists and the surrealists, Sugimoto is constantly on the lookout for new ways to transcribe reality, working primarily with a view camera in large formats and opting for long—sometimes extremely long—exposure times. With a predilection for silverprint, some images look as if painted with a minute brush. He operates in series. *Diorama* (1976) shows the stuffed animal displays at the Natural History Museum in New York. Before his lens, the fauna starts breathing again—as do the wax effigies he captured at Madame Tussauds in London for *Portraits* (1999). Yet the artist surely owes his international fame to two series that have been reproduced and exhibited throughout the world many times. First, there is *Theaters and Drive-In Theaters*, started in 1978, which focuses on the luminous white screens of drive-ins and 1920s theaters, which were restored and converted into cinemas; and, later, *Seascapes* (1994), carried out around the world and showing the horizon between sky and sea viewed at different times and in varying meteorological conditions. There followed works concerned with modernist architecture or created by applying an electric current directly to the negative. A recipient of the Hasselblad Award in 2001, Sugimoto was awarded the Praemium Imperiale Prize in 2009.

## His work

The mainsprings of Hiroshi Sugimoto's creative drive are meditation and experimentation. Absorbing the writings of Duchamp, as well as precepts from Shintoism and Buddhism, the artist has forged an original and successful synthesis between Western pragmatism and Eastern thought, which dovetails two ostensibly antagonistic perceptions of time. His pictures are the fruit as much of a personal inclination for technical research as a desire to provide beholders with beautiful, uncomplicated zones in which to reflect. For example, in *Theaters*, the white screens penetrate into the darkness of the auditorium, illuminating the entire image. To obtain this almost hypnotic effect, Sugimoto adjusts the exposure time to coincide with the length of the film, thereby eliminating the images being screened. Proceeding in similar fashion, in *Seascapes* he obtains varied effects not unlike an abstract painting. In *Lighting Fields*, he places an electric charge directly on the negative to create dreamlike plant forms. The play of shadow and light in Sugimoto's work is worthy of a landscape by an ancient Japanese master or an abstract by a great American modern.

## He said

**"I try never to be satisfied, this way I will always be challenging my spirit."**

# JEFF WALL

## Who is he?

Jeff Wall, who—in an echo of Baudelaire's famous title—likes to be called a "painter of modern life," was born in Vancouver, Canada, in 1946. He has a doctorate in art history and taught aesthetics for several years. The artist's influence on contemporary art since the 1980s has been considerable. He is one of those—with Jean-Marc Bustamante, Cindy Sherman, and Hilla and Bernd Becher—who elevated photography to its privileged position within the visual arts. In images of impressive dimensions, the lion's share representing reconstructed scenes, often exhibited in light boxes, he redefines the paradigms of photography, calling into question in particular the idea of the "decisive moment," or the imprint of reality. Endowing his works with an iconic dimension, he brings out links between art history and the avant-garde. Though the images do indeed often refer or allude to masterpieces of traditional or modern painting, this effect is not apparent at first glance, since they more resemble snapshots taken from life. Anchored in the precepts of conceptual art that foregrounds the mode of development of a piece, the artist is nonetheless prepared to take inspiration from literary, film, and theatrical references. Jeff Wall received the Hasselblad Award in 2002.

## His work

At the same time intellectually sophisticated and perceptive, Jeff Wall's work can be read on many levels. Its power of attraction chiefly derives from how, in each superficially banal scene, something is not quite right: someone looks in the wrong direction, for instance, or stands awkwardly, reacts unexpectedly. In the center of *Milk* (1984), for example, a print measuring 73 1/2 x 90 1/4 in. (187 x 229 cm) presented in the form of light box, a man sits on the sidewalk, leaning against a red brick wall. His rather unkempt appearance is almost that of a dropout. In his right hand, he grasps a carton of milk from which the liquid shoots out. Curiously, though, the man seems to pay no attention to this mini-explosion. The white milk, the red brick building, the horizontal and vertical lines of the modern architecture offer a powerful counterpoint to the anecdotal feel. Jeff Wall's images also deal in latent memory, often referring to masterpieces of our shared intellectual heritage seen in a history book or on a museum wall. Thus *Destroyed Room*, produced in 1978, took its cue from Delacroix's *Death of Sardanapalus*, while *A Picture of Women* centered on Manet's *A Bar at the Folies-Bergère*. The process is not as in a cut-and-paste job, however, but rather an evocation of continuity–to be part of the long chain that explores the question of man and his fate.

FACING PAGE
*Milk*,
1984.
Cibachrome
on transparent
film, light box,
73½ x 90¼ in.
(187 x 229 cm).

## He said

"The essential model, for me, is still the painter, the artisan who has all the tools and materials they need right at hand, and who knows how to make the object he or she is making from start to finish. With photography this is almost possible."

# ZHANG XIAO

## Who is he?

Zhang Xiao was born in 1981 in Yantai, in the province of Shandong, China, and currently lives in Chengdu. Obtaining a diploma in architecture from the University of Yantai in 2005, for four years he worked as a photographer for the *Chongqing Morning Post*. In 2009, his work was spotted at the Three Shadows Photography Art Center in Beijing, subsequently exhibiting in various cities in China, as well as in France and England. His series *Coastline*—an attempt to recreate the friendly environment of the beaches that line the coast running from the estuary of the Beilun River to that of the Yalu—was a universal success. In 2010, Zhang Xiao received the Houdengk Documentary Photography Award and, in 2011, the HSBC Prize for Photography.

## His work

A hazy glow covers Zhang Xiao's pictures, bestowing, at first sight at least, an impression of weightlessness. From these scenes of daily life caught with infinite gentleness, there emanates an atmosphere of unreality. Oozing with poetry, his photographs appear to emerge as from a dream. Subtle in coloring, airy in composition, and with enviable depth of field, they seem to "breathe." These bathers on the seashore, couples gazing out at the horizon, fishermen hauling a boat out of the water are all part of an ideal, yet lucid, vision. Other images, showing building sites, half-finished houses, abandoned cars, refuse strewn on the ground, testify to a far less idyllic world, one undergoing radical transformation. The artist himself has explained how this coastal revolution reflects the upheavals affecting an entire nation. "There are great changes every day in China.... All of this appears particularly in China's coastal areas. A multitude of countrymen leave their native place to go there. The urbanization drive is continually accelerating."

For all this, Zhang Xiao continues trying to capture that magical line where the sky meets the sea. What he has described as a "hometown for his soul" has fascinated him since childhood. It is this dichotomy between an unalterable mental fixation and the fragile reality that creates such a singular impression of strangeness.

FACING PAGE
*Coastline No. 2*, 2011.

## He said

"Already when I was a child, I was eager for the sea. I knew that it was mysterious and vast. And I'm sure that this mystery owes nothing to the fact I can't swim.... I came here to seek strong emotional conflicts and rich images, and perhaps, for the sadness and disenchantment. The sea is the beginning of lives and dreams. I am looking here for a hometown in my heart."

# APPENDIXES

# GLOSSARY

## ADOBE PHOTOSHOP ©

Everybody's heard of Photoshop! This professional standard software, used mainly for treating digital photographs, allows every conceivable variant of image editing. Taken up by professional computer graphics technicians and fine art students alike, the suite has also found favor among a majority of creative agencies and studios. Devised by Thomas and John Knoll in 1987, Photoshop 1.0 was released in 1990 for Macintosh 3 and distributed under license to Adobe.

## C-PRINT

A matte or gloss print printed manually from a color negative or positive on chromogenic (silver halide) photographic paper.

## CARBON PRINT

Printed on special light-fast paper of a particular grain, the carbon process produces subtle velvety textures. It has been deployed, for example, by Bernard Plossu and Bernard Faucon. One of its variants, the Fresson process, invented at the beginning of the twentieth century by Théodore-Henri Fresson, is still used by his descendants in the family's studio located in a Paris suburb.

## CONTACT SHEET

A contact sheet is a piece of photographic paper featuring all the shots on a roll of film. A great resource for photographers, it is employed to view an entire sequence of small contact prints on a single sheet and to select the interesting ones worth printing up full size. Photographers like William Klein and Brion Gysin have used the process to create independent exhibited artworks.

## COPY ART

An avant-garde art movement that sprang up in the United States in the mid-1960s that produced images on photocopiers, either by placing the object or a part of the body directly onto the glass, or Xeroxing drawings, photographs, or printed matter.

## DIAPORAMA

A photographic slide show, possibly accompanied by a soundtrack. Nan Goldin first attracted widespread attention with a famous sequence entitled *The Ballad of Sexual Dependency*, comprising more than eight hundred pictures taken over a period of sixteen years and screened with some heart-rending music.

## DIASEC

Invented in the 1960s, Diasec is a patented process for protecting the surface of large unframed photographic images, by face-mounting the print on a layer of transparent anti-UV methacrylate and gluing the back to a rigid support (aluminum plate, for example). The process presents two major advantages: for one, it protects the artwork against dust, air, and light, and also it reinforces chromatic contrast and visual depth. The downside is that acrylic surfaces scratch relatively easily.

## DIGITAL IMAGE

The availability of image-making and -manipulating technologies using electronic media has brought about a revolution in the field of photography. The code on a computer for a digital image is generated by a sensor comprised of photosensitive elements. Digital cameras record a file for each photograph on an internal storage device (card).

Not only do these image files not require developing, they display other significant advantages: they can be saved and subsequently opened, shown on a screen, printed, sent, shared, copied, altered or retouched, and deleted.

## DIGITAL PRINT

A print made from a computer file. The image is sent directly to the printer in the form of a digital file such as a PDF or created onscreen by graphic software of the Illustrator or InDesign type. The advantages: low cost and rapid turnaround (no need to create an offset printing plate). Digital printing has gradually replaced lithography for everyday work.

## DOCUMENTARY STYLE

The documentary approach preaches a direct confrontation with reality and demands a level of neutrality on the part of the photographer. Eugène Atget and Walker Evans are among the great historical figures of the documentary style, a current that remains strong in contemporary photowork.

## DYE TRANSFER

A legendary printing process commercialized since 1946 by the Kodak firm, dye transfer owes its reputation to the excellent standard of conservation it ensures for color pictures. Obtained from slides, the prints can readily be retouched. The dyes used in the process possess the advantage of being extremely pure, providing a broader color range than with any other printing technique. William Eggleston, considered a color photo genius, for example, used the dye transfer process. It is slow and expensive, though, and Kodak stopped marketing the process in 1993.

## FLICKR

A phenomenally successful image-sharing environment (including video) on the Internet. Developed in 2002 by Ludicorp, a Canadian company in Vancouver (bought out in 2005 by Yahoo!), the website allows registered users to download their pictures into personalized albums, classify them, post them publicly, and leave comments. The space is also used by professional photographers. By 2011, Flickr was hosting more than five billion photographs.

## FRAMING

As for a "frame" round a traditional painting, in photography to frame an image means to fix its limits: top, bottom, and either side (as in a "frame" of a reel of film). Framing the image corresponds to the picture's final form as constructed by the artist—whether it is chosen behind the camera, or, subsequently, in the darkroom or when printing, etc. In today's digital universe, with appropriate software, to reframe (crop) an image after taking it is child's play. Many artists rely on the elements within the frame to hint at things beyond it, stimulating the viewer's imagination by suggestions of what is unseen.

## ILFOCHROME (FORMERLY, CIBACHROME)

A process of positive printing from a slide carried out on, not paper, but a plastic base incorporating color pigment. Cibachrome is famous for its chromatic quality and the longevity of pictures made using it.

## INK-JET PRINTING

A print technique that consists in spraying liquid ink onto paper. The printer heads constituted by a large array of nozzles are heated, expelling minute droplets of ink in cyan, magenta, yellow, and black onto the sheet. The droplets are small enough to allow "photo quality" printouts.

## LAMBDA PRINT

An analogue print derived from a digital file.

## LASER PRINTING

The extremely complex technique of laser printing appeared in the 1970s. Today, the output derives from a digital file. This process does not use ink as such but an extremely fine powder, called toner, resulting in superior image resolution and reduced splash. Because the page is treated as a single unit, print speeds tend to be higher than with other systems. There are two types of laser printing: some independent drum designs require the printer to pass four times to create the image (one for each primary color, and another for black). Transfer-belt technology allows all four colors of the image to be printed in a single pass.

## LIGHT BOX

This visual device frequently used in advertising backlights a poster with neon or LEDs. In 1979, Canadian artist Jeff Wall was the first to use light boxes (that he called "transparencies") to increase the impact of large format photographs (up to four meters long). Glowing from within and divorced from their commercial purpose, Wall's uncanny tableaux are surprising installations. This form of presentation possesses the added advantage of providing the image with volume.

## NEW TOPOGRAPHICS

An American art trend of the 1970s whose adherents articulated an ecological and ideological critique of humankind's impact on the natural landscape. Advocating an objective, documentary standpoint, their landscapes tended to be nondescript or "without quality." Poles apart from the glorification of the legendary American West as practiced by photographers like Ansel Adams and Edward Weston, they show dull suburbs and anonymous motels, rows of warehouses, car parks, factories, etc. The term originated from the exhibit *New Topographics*, conceived in 1975 by William Jenkins for the cradle of the Kodak firm, George Eastman House, Rochester. Showcasing ten photographers (Robert Adams, Lewis Baltz, Joe Deal, Frank Gohlke, Nicholas Nixon, John Schott, Stephen Shore, Henry Wessel Jr., and Bernd and Hilla Becher), the exhibition's subtitle, *Photographs of a Man-Altered Landscape*, speaks volumes.

## PALLADIUM PRINT

Highly stable, this manual printing process on paper uses palladium salts, as a less costly industrial alternative to platinum.

## PANORAMIC

Panoramic views can be obtained either by employing a wide-angle lens or by assembling several separate photographs. There also exist special panoramic apparatuses capable of taking pictures that equate to a camera angle of 100° to 180°, or even 360°. Such views have become a favorite device with the artist Mariko Mori.

## PIXEL

From the English expression "picture element," a pixel is the dot employed as the basic unit for measuring the definition of a digital image. Now counted in millions, the larger the number of pixels, the higher the quality and sharpness of the image. Roughly rectangular, their dimensions can be changed by adjusting screen resolution or the properties of the graphics card. The contemporary Catalan photographer Joan Fontcuberta has created a diptych on the attack on the Twin Towers that makes use of a pixelated effect.

## PRINT TONING

Changing the tone (color) of an analogue print by treating it, either during or after development, by modifying the chemical composition of the image or else by adding a solution of a special compound (toner).

## SCREEN-PRINT

This printing technique (serigraphy) deploys a silk mesh (screen), the image zones of which are soaked in colored ink. Supports can be extremely varied, ranging from paper, textile, and wood, to glass and metal. Reasonably economical, the process can be applied to large-sized surfaces and permits loud, flashy colors that keep their vibrancy. Andy Warhol used serigraphy abundantly, making series based on press photos and photographic portraits.

## STRAIGHT PHOTOGRAPHY

Straight Photography, and its German equivalent, the New Objectivity (Neue Sachlichkeit), was an international movement initiated by the Americans Alfred Stieglitz and Paul Strand at the turn of the twentieth century, whose aesthetic approach amounts to a complete break with the then dominant pictorialist movement. Doing away with drawing on the negative and manipulating the image in any way, they ushered in a clear, documentary objective, and resolutely modern type of photography. Sharp detail, structure of light, and shades of gray of awe-inspiring depth define a chilly formalism. Thanks to lightweight cameras and more sensitive films, the favorite subject of Straight Photography was urban life ("street photography"). In the darkroom, photographers of this movement produced large-format negatives, contact prints, most of the time uncropped.

## SUPERIMPOSITION

Superimposition is an umbrella term designating the artistic technique of double exposure, overlaying, or montage—any process that results in a combination of several photographs in a single picture. Widely used in traditional analogue work, it was greatly appreciated by surrealist artists. Today, digital image-editing software has made the process readily available to all. Nancy Burson provides a splendid demonstration with her composite portraits created by superimposing hundreds of photographs.

## TABLEAU

A term used in the literature to describe large images constructed in accordance with a precise preconceived idea. Enshrining the union between photography and contemporary art, the image presents itself frontally, as in a traditional painting. At the beginning of the 1980s, the artists Jean-Marc Bustamante and Jeff Wall employed respectively the terms "tableau photographique" and "photo tableau" in commenting on their works, and the concept was adopted and theorized by the French critic Jean-François Chevrier to define the ambition of certain practitioners to turn photography into a full-fledged conceptual artwork.

# Where to see photography

## Australia
**Australian Centre for Photography**
257 Oxford Street, Paddington
Sydney, NSW 2021
www.acp.org.au

**Centre for Contemporary Photography**
404 George Street, Fitzroy
Melbourne, VIC 3065
+61 (0) 3 9417 1549
www.ccp.org.au

**Museum of Contemporary Art**
140 George Street, Sydney, NSW
+61 (0) 2 9245 2400
www.mca.com.au

## France
**Bibliothèque Nationale de France**
Quai François-Mauriac, 75013 Paris
+33 (0)1 53 79 37 29
www.bnf.fr

**Galerie Nationale du Jeu de Paume**
1 place de la Concorde, 75008 Paris
+33 (0) 1 47 03 12 36
www.jeudepaume.org

**Maison Européenne
de la Photographie**
5 rue de Fourcy, 75004 Paris
+33 (0) 1 44 78 75 00
www.mep-fr.org

## Germany
**Museum für Fotografie**
Staatliche Museen zu Berlin
Jebensstraße 2
Berlin-Charlottenburg
+49 (0) 30 266 42 42 42
www.smb.museum/smb

## South Africa
**Museum Photographic Art Gallery**
Upper Eastside, 31 Brickfield Road,
Salt River, Cape Town
+27 (0) 21 801 5064
www.museum-gallery.co.za

## United Kingdom
**National Museum of Photography
Film and Television**
National Media Museum
Bradford, West Yorkshire BD1 1NQ
+44 (0) 844 856 3797
www.nationalmediamuseum.org.uk

**National Portrait Gallery**
2 St Martin's Place
London WC2H 0HE
+44 (0) 20 7306 0055
www.npg.org.uk/about/organisation

**The Photographers' Gallery**
16–18 Ramillies Street
London W1F 7LW
+44 (0) 845 262 1618
www.photonet.org.uk

**Victoria and Albert Museum**
Cromwell Road
London SW7 2RL
+44 (0) 20 7942 2000
www.vam.ac.uk/page/p/photography

## United States
**Brooklyn Museum**
200 Eastern Parkway
Brooklyn, NY 11238-6052
+1 718 638 5000
www.brooklynmuseum.org

**California Museum of Photography**
3824 Main St, Riverside, CA 92501
+1 951 827 4787
www.cmp.ucr.edu

**Guggenheim Museum**
Solomon R. Guggenheim Museum
1071 Fifth Avenue
New York, NY 10128-0173
+1 212 423 3589
www.guggenheim.org/new-york

**International Center
for Photography**
1133 Avenue of the Americas
New York, NY 10036
+1 212 857 0000
www.icp.org

**The J. Paul Getty Museum**
1200 Getty Center Drive
Los Angeles, CA 90049-1679
+1 310 440 7300
www.getty.edu/museum

**LACMA (Los Angeles County
Museum of Art)**
5905 Wilshire Blvd.
Los Angeles CA 90036
+1 323 857 6000
www.lacma.org

**Metropolitan Museum of Art**
1000 Fifth Avenue
New York, NY 10028-0198
+1 212 535 7710
www.metmuseum.org

**MOCA (Museum of Contemporary
Art, Los Angeles)**
250 South Grand Avenue
Los Angeles, CA 90012-3007
+1 305 893 6211
www.moca.org

**Museum of Modern Art**
11 West 53 Street
New York, NY 10019-5497
+1 212 708 9400
www.moma.org

**New York Photography Festival**
www.newyorkphotofestival.com/site

# Selected Bibliography

Bajac, Quentin. *La Photographie. L'époque moderne 1880–1960.* Paris: Gallimard, 2005.

—. *Après la photographie ? De l'image argentique à la révolution digital.* Paris: Gallimard, 2010.

Baqué, Dominique. *La Photographie plasticienne. Un art paradoxal.* Paris: Éditions du Regard, 1998.

—. *Photographie plasticienne. L'extrême contemporain.* Paris: Éditions du Regard, 2004.

Baqué, Dominique et al. *Qu'est-ce que la photographie aujourd'hui ?* Paris: Beaux Arts Magazine éditions, 2009.

Barthes, Roland. *Camera Lucida: Reflections on Photography.* Trans. Richard Howard. New York: Hill and Wang, 1981.

Benjamin, Walter et al. *The Work of Art in the Age of Its Technological Reproducibility.* Trans. E. F. N. Jephcott. Cambridge, MA: Harvard University Press, 2008

Benjamin, Walter. *The Work of Art in the Age of Mechanical Reproduction.* Trans. J. A. Underwood. London: Penguin UK, "Penguin Great Ideas Series," 2008.

Bourdieu, Pierre, ed. *Photography: A Middle-brow Art.* Trans. Shaun Whiteside. Palo Alto, CA: Stanford University Press, 1996.

Cartier-Bresson, Anne, ed. *Vocabulaire technique de la photographie.* Paris: Marval/Paris-Musées, 2008.

Cartier-Bresson, Henri. *The Decisive Moment.* New York: Simon and Schuster, 1952.

Chevrier, Jean-François. *Entre les beaux-arts et les médias: photographie et art moderne.* Paris: L'Arachnéen, 2010.

Cotton, Charlotte. *The Photograph as Contemporary Art.* London: Thames & Hudson, 2004.

Didi-Huberman, Georges. "La Ressemblance par contact. Archéologie, anachronisme et modernité de l'empreinte," in *L'Empreinte.* Paris: Centre Georges-Pompidou, 1997.

Dubois, Philippe. *L'Acte photographique.* Paris: Nathan, 1983.

Evans, Walker. *Dans le temps et dans l'histoire.* Paris: L'Arachnéen, 2010.

Frizot, Michel, ed. *A New History of Photography.* London: Könemann, 1998.

Gattinoni, Christian and Yannick Vigouroux. *La Photographie contemporaine.* Paris: Nouvelles Éditions Scala, 2005.

Krauss, Rosalind. *Le Photographique. Pour une théorie des écarts.* Paris: Macula, 1990.

Lemagny, Jean-Claude. *Photographie contemporaine. La matière, l'ombre, la fiction.* Paris: Nathan/Bibliothèque nationale de France, 1994.

Lemagny, Jean-Claude and André Rouillé. *A History of Photography.* Cambridge: Cambridge University Press, 1987.

Nori, Claude. *French Photography from its Origins to the Present.* London: Thames and Hudson, 1979.

Nurisdany, Michel. *Ils se disent peintres, ils se disent photographes.* Paris: ARC/Musée d'Art moderne de la Ville de Paris, 1980.

Perlein, Gilbert and Michèle Brun. *Human.* Paris: Skira Flammarion, 2010.

Poivert, Michel. *La Photographie contemporaine.* Paris: Flammarion, 2002.

Rouillé, André. *La Photographie: Entre document et art contemporain.* Paris: Gallimard, 2005.

Sontag, Susan. *On Photography.* London: Picador, 2001.

Soulages, François. *Esthétique de la photographie. La perte et le reste.* Paris: Nathan Université, 1998.

**General catalogs**

*Mois de la Photo à Paris,* photography festival

*Rencontres d'Arles,* international photography festival

*Printemps de Cahors,* annual exhibition

*Printemps de septembre à Toulouse,* festival of contemporary arts

*Paris Photo,* annual photography fair

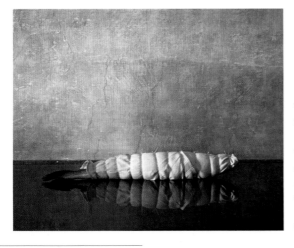

VÉRONIQUE ELLENA, *The Bound Fish,* from the series *Still Life,* 2008. Color print, 37¾ x 47¼ in. (96 x 120 cm).

# INDEX OF PROPER NAMES

Page numbers in bold refer to illustrations

# PHOTOGRAPHIC CREDITS

p. 1: © Nobuyoshi Araki/Courtesy the artist and Kamel Mennour, Paris; p. 2: © Erwin Olaf/Courtesy Rabouan Moussion Gallery, Paris; p. 3: © Kimiko Yoshida; p. 4: © Bert Sissingh, Adagp/Courtesy Cokkie Snoei Gallery; p. 5: © Valérie Belin/Adagp; p. 6: © Nan Goldin/Courtesy Yvon Lambert; p. 10: © John Baldessari/Courtesy the artist and Marian Goodman Gallery, Paris/New York; p. 13: © Barbara Kruger/Courtesy Sprüth Magers, Berlin London; p. 14, above: © Roni Horn/Courtesy Roni Horn and Hauser & With Gallery, Zurich; below: © Christian Boltanski, Adagp; p. 15: © Bertrand Gadenne/Adagp; pp. 16–17: © Florence Chevallier, Adagp; pp. 18–19: © JR; p. 20: © Natacha Lesueur, Adagp/Courtesy Charlotte Moser Gallery; p. 21: © Dennis Oppenheim; p. 22: © Charles Ray; p. 23 © Nils-Udo; p. 24: © Larry Clark/Courtesy the artist and Luhring Augustine, New York; p. 25 © Denis Darzacq/Agence VU; p. 26: © John Baldessari/Courtesy the artist and Marian Goodman Gallery, Paris/New York; pp. 26–27: © David Goldblatt/ Courtesy the artist and Marian Goodman Gallery, Paris/New York; p. 28: © Nan Goldin/Collection Centre Pompidou, distr. RMN/Philippe Migeat; p. 29: © Bert Sissingh, Adagp/Courtesy Cokkie Snoei Gallery; p. 30: © William Klein/Collection Centre Pompidou, distr. RMN/Georges Meguerditchian; p. 31: © Alexander Rodchenko/Collection Centre Pompidou, distr. RMN/Jacques Faujour; p. 32, above: © August Sander/Collection Centre Pompidou, distr. RMN/Adam Rzepka; below: © Aperture Foundation, P. Strand Archive/Collection Centre Pompidou, distr. RMN/René-Gabriel Ojéda; p. 33: © Walker Evans Archive/The Metropolitan Museum of Art; p. 34: © Cindy Sherman/Courtesy Metro Picture; p. 35: © Jeff Wall / Centre Pompidou, distr. RMN/photographer unknown; p. 36: © Arnulf Rainer/Photo André Morin; p. 38: © Elina Brotherus/Photo André Morin; p. 39: ©Roman Opalka, Adagp/Collection Centre Pompidou, distr. RMN/Philippe Migeat; p. 40: © Dieter Appelt/Courtesy Gallery F. Paviot; p. 41: © Joachim Schmid/Courtesy Gallery Alain Guthorc; p. 42: © Georges Rousse, Adagp/Collection Centre Pompidou, distr. RMN/Jean-Claude Planchet; p. 43: © Désirée Dolron; p. 44 left: © Vik Muniz/Photo André Morin with Dolorès Marat; right: © Susan Derges/Courtesy the artist and Ingleby Gallery, Edinburgh; p. 45: © Nobuyoshi Araki/Courtesy the artist and Kamel Mennour, Paris; p. 46: © Gábor Ösz/Courtesy Gallery Loevenbruck, Paris—p. 47: © Wolfgang Tillmans/Courtesy Gallery Daniel Buchholz, Cologne / Berlin; p. 49: © Victor Burgin/Courtesy Gallery Campagne Première, Berlin; p. 50: © Philippe Gronon, Adagp; p. 51, above: © Jean-Luc Moulène, Adagp/Collection Centre Pompidou, distr. RMN/Jean-Claude Planchet; below: © Hans Eijkelboom, www.photonotebooks.com; p. 53: © Bernd and Hilla Becher/Centre Pompidou, distr. RMN/photographer unknown; p. 55 © Jean-Marc Bustamante/Studio Bustamante; pp. 56–57: © Peter Fischli David Weiss, Zürich/Courtesy Sprüth Magers, Berlin London, Matthew Marks Gallery, New York, Gallery Eva Presenhuber, Zurich; p. 58: © Valérie Jouve, Adagp; p. 59: © Richard Billingham/Courtesy Anthony Reynolds Gallery, London; p. 60: © Jeff Wall/Courtesy the artist and Marian Goodman Gallery, Paris/New York; p. 61: © Gregory Crewdson/Courtesy White Cube; p. 62: © Sandy Skoglund; p. 63: Courtesy Succession Édouard Levé/Gallery Loevenbruck, Paris; p. 64: © Rip Hopkins/Courtesy Gallery Le Réverbère, Lyon; p. 65: © Erwin Olaf/Courtesy Gallery Rabouan Moussion, Paris; p. 66: © Lise Sarfati/Photo André Morin with Dolorès Marat; p. 69, above: © Susanna Hesselberg/Courtesy School Gallery/Olivier Castaing; below: © Anni Leppälä; p. 70: © Santeri Tuori/Courtesy Gallery Anhava; p. 71: © Joachim Eneroth/Courtesy School Gallery/Olivier Castaing; p. 72: © Mohamed Camara/Courtesy Gallery Pierre Brullé; p. 73: © Malick Sidibé/Courtesy André Magnin; p. 74: © Samuel Fosso/Courtesy Jean Marc Patras/Gallery, Paris; p. 75, above: © David Goldblatt/Courtesy the artist and Marian Goodman Gallery, Paris/New York; below: © John Kiyaya/Photo André Morin; p. 76: © Youssef Nabil/Courtesy Gallery Nathalie Obadia, Paris; p. 77: © Seydou Keïta/Photo André Morin; p. 79: © Martin Parr/Magnum Photos; p. 80: © Richard Billingham/Courtesy Anthony Reynolds Gallery, London; p. 81: © Paul Graham/Collection Centre Pompidou, distr. RMN/Philippe Migeat; p. 83: © Andreas Gursky, Adagp/Courtesy Sprueth Magers, Berlin London; p. 84: © Candida Höfer, Adagp; p. 85: © Thomas Ruff, Adagp/Collection Centre Pompidou, distr. RMN/Jean-Claude Planchet; p. 86: © Thomas Demand, Adagp/Courtesy Sprueth Magers Berlin London; p. 87: © Wolfgang Tillmans/Courtesy Gallery Daniel Buchholz, Cologne / Berlin; p. 88: © Allan Sekula/Photo André Morin avec Dolorès Marat; p. 89: © Helen Levitt/Frac Rhône-Alpes, Villeurbanne; p. 90: © Dan Graham/ Courtesy the artist and Marian Goodman Gallery, Paris/New York; p. 91: © Philip-Lorca diCorcia/Photo André Morin; p. 92: © Dan Graham; p. 93: © Cindy Sherman/Courtesy Metro Pictures; p. 95: © Luc Choquer; p. 96: © Patrick Tosani, Adagp; p. 97: © Bernard Plossu; p. 98: © Raymond Depardon/Magnum Photos; p. 99: © Valérie Belin, Adagp; p. 101, above: © Zhang Huan/Courtesy the Rubell Family Collection, Miami 2009 ; below: Courtesy 18gallery/Gallery Magda Danysz (Shanghaï); pp. 102–103: © Hong Hao/Courtesy Gallery LOFT, Paris; p.104: © Jeff Wall/ Courtesy the artist and Marian Goodman Gallery, Paris/New York; p. 105: © Roy Arden/Courtesy Monte Clark Gallery, Vancouver & Toronto; p. 106: © Lucas Samaras/Courtesy The Pace Gallery; p. 109: © Thomas Ruff, Adagp/Collection Centre Pompidou, distr. RMN/Jacques Faujour; p. 110: © Orlan, Adagp; © 110: © Andres Serrano/Courtesy Yvon Lambert; p. 112: © Rip Hopkins/Courtesy Gallery Le Réverbère, Lyon; p. 113: © The Helmut Newton Estate/all rights reserved; p. 114: © Dieter Appelt/Courtesy Gallery F. Paviot; p. 115: © Dany Leriche, Adagp; p. 117: © Sophie Ristelhueber, Adagp; p. 118: © Jean-François Rauzier; p.119: © Jordi Colomer, Adagp/ Photo André Morin; p. 121: © Saverio Lucariello; p. 122: © Patrick Tosani; p. 123: © Valérie Belin, Adagp; p.125: © Thibaut Cuisset/Photo André Morin; p. 126: © Darren Almond/Courtesy White Cube; p. 127: © Nicolas Dhervillers Courtesy School Gallery/Olivier Castaing; p. 128: © Nadav Kander; p. 129: © Joel Sternfeld/Courtesy Luhring Augustine, New York and Buchmann Gallery, Berlin; p. 131: © Gilbert Garcin; p. 132: © Cindy Sherman/Courtesy Metro Pictures; p. 133: © Clark and Pougnaud; p. 135: © Jacques Bosser, Adagp; p. 136: © Joachim Eneroth/Courtesy School Gallery/Olivier Castaing; p. 137: © Boris Mikhailov/Courtesy Gallery Suzanne Tarasieve, Paris; p. 138: © John Batho; p. 139: © Karen Knorr/Courtesy Gallery Les filles du Calvaire, Paris; p. 141: © Bernard Plossu; p. 142: © Nobuyoshi Araki/Courtesy the artist and Kamel Mennour, Paris; p. 143: © Jean-Baptiste Huynh; p. 144: Véronique de Viguerie/Reportage by Getty Images; pp. 148-149: © OlivieroToscani; p. 151: © William Klein/Collection Centre Pompidou, distr. RMN/Adam Rzepka; p. 153: © Patrick Demarchelier/Dior; p. 155: © Gamma; p. 156: © Luc Delahaye/Courtesy Gallery Nathalie Obadia; p. 157: © Alfredo Jaar/Courtesy Gallery Lelong, New York; p. 158: © Bruno Serralongue/Courtesy Air de Paris; p. 159: © Philippe Chancel, Adagp; pp. 160–161: © Éric Baudelaire/Fonds Cnap; p. 162: © Patrick Tosani, Adagp; p. 164: © Studio Robert Doisneau; p. 165: © Gian Piero Frassinelli/Collection Centre Pompidou, distr. RMN/Georges Meguerditchian; p. 166: © Man Ray Trust; Adapg– p. 167: Collection Centre Pompidou, distr. RMN/Georges Meguerditchian; p. 168: © RMN - Author rights management/French Ministry of Culture - Médiathèque du Patrimoine, distr. RMN/André Kertész; p. 169: © David Hockney; p. 171: © Andy Warhol; p. 172: © Per Barclay/Courtesy rue Visconti; p. 181: © Anna and Bernhard Blume, Adagp/Cnap. p. 182: © Jean-Marc Bustamante, Adagp; p. 185: © Nobuyoshi Araki/Courtesy the artist and Kamel Mennour, Paris; p. 187: © Bernd and Hilla Becher; p. 189: © Valérie Belin, Adagp; p. 191: © Mohamed Bourouissa/Courtesy the artist and Kamel Mennour, Paris; p. 193: © Larry Clark/Courtesy the artist and Luhring Augustine, New York; p. 195: © Thomas Demand, Adagp/Courtesy Sprueth Magers, Berlin London; p. 197: © Raymond Depardon/Magnum Photos; p. 199: © Rineke Dijkstra/Courtesy the artist and Marian Goodman Gallery, Paris/New York; p.203: © Nan Goldin/Courtesy Yvon Lambert; p. 205: © Paul Graham/Collection Centre Pompidou, distr. RMN/Jean-Claude Planchet; p. 207: Andreas Gursky, Adagp/Courtesy Sprüth Magers Berlin London; p. 209: © Candida Höfer, Adagp/ Collection Centre Pompidou, distr. RMN/Philippe Migeat; p. 211: © William Klein; p. 213: © Sze Tsung Leong/Courtesy Yossi Milo Gallery, New York; p.215: © Boris Mikhailov/Courtesy Gallery Suzanne Tarasieve, Paris; p. 217: © Santu Mofokeng/Courtesy Lunetta Bartz, MAKER, Johannesburg; p. 219: © Jean-Luc Moulène, Adagp/Courtesy Gallery Chantal Crousel, Paris; p. 221: © Martin Parr/Magnum Photos; p.223: © Pierre et Gilles, Adagp; p. 225: © Miguel Rio Branco/Magnum Photos; p. 227: © Sophie Ristelhueber, Adagp; p. 229: © Lise Sarfati, Adagp; p. 231: © Andres Serrano/Courtesy Yvon Lambert; p. 233: © Cindy Sherman/Courtesy Metro Pictures; p. 235: © Malick Sidibé/Courtesy André Magnin; p. 237: © Thomas Struth/Courtesy the artist and Marian Goodman Gallery, Paris/New York; p. 239: © Hiroshi Sugimoto/Photo Courtesy the artist and Yhe Pace Gallery; p. 241: © Jeff Wall/Courtesy the artist and Marian Goodman Gallery, Paris/New York; p. 243: © Zhang Xiao; p. 244: © Jean-Luc Mylayne/Courtesy Sprüth Magers, Berlin London; p. 251: © Véronique Ellena/Courtesy Gallery Alain Guthorc.

**The author would like to express her gratitude to:** Pierre Desfons for his attentive support and encouragement; her editor, Julie Rouart, for her enlightened observations and unflagging energy; Sophy Thompson and Kate Mascaro, for their enthusiasm and backing; and Marion Doublet, for her patience and consideration. I am grateful to François Huertas, the talented designer of the *Talk About* series, for ideas at once brilliant, elegant, and to the point, and to Henri Coudoux, chief librarian at the Maison Européenne de la Photographie, for his invaluable advice. For their efficiency, I thank Marie Sanson and Julien Brocard, as well as Catherine Bonifassi and Thomas Bonnouvrier, for their valuable assistance. And last but not least, the author and publisher express their thanks to all the artists, agents, and gallery owners who, with the aim of increasing public awareness of photography, generously waived rights for the present volume.

Élisabeth Couturier,
photographed by Malick Sidibé
in his studio in Bamako, 1990.

Translated from the French by David Radzinowicz
Copyediting: Penelope Isaac
Design: François Huertas
Typesetting: Thierry Renard
Proofreading: Chrisoula Petridis
Editorial Assistance: Joshua Wilson
Color Separation: Reproscan
Printed in Portugal by Portughesa

Originally published in French as *Photographie contemporaine: mode d'emploi*
© Flammarion, S.A., Paris, 2011

English-language edition
© Flammarion, S.A., Paris, 2012

ISBN: 978-2-08-020097-6

Dépôt légal: 04/2012